S0-BRJ-940

# NATIVE AMERICAN ART

William C. Ketchum, Jr.

# TODTRI

Copyright © 1997 by Todtri Productions Limited.
All rights reserved.

No part of this publication may be reproduced, stored in a retrieval system or transmitted in any form by any means electronic, mechanical, photocopying or otherwise, without first obtaining written permission of the copyright owner.

This book was designed and produced by
TODTRI Book Publishers
P.O. Box 572, New York, NY 10116-0572
FAX : (212) 695-6984

e-mail : todtri@mindspring.com

*Printed and bound in Singapore*

ISBN 1-57717-036-9

Visit us on the web!
www.todtri.com

*Author:* William C. Ketchum, Jr.

*Publisher:* Robert M. Tod

*Editorial Director:* Elizabeth Loonan

*Book Designer:* Mark Weinberg

*Senior Editor:* Cynthia Sternau

*Project Editor:* Ann Kirby

*Photo Editor:* Edward Douglas

*Picture Reseachers:* Meiers Tambeau, Laura Wyss

*Production Coordinator:* Jay Weiser

*Desktop Associate:* Paul Kachur

*Typesetting:* Command-O Design

## PICTURE CREDITS

**Art Resource, New York**
*Werner Forman Archive* 56
*National Museum of American Art, Washington, D.C.* 5, 27, 100, 111, 118 (top), 119
*Smithsonian Institution, Washington, D.C.* 88–89, 91

**Buffalo Bill Historical Center, Cody, Wyoming**
87, 95, 96, 97, 99
*Lucille Warters* 81

**Esto Photographics**
14, 15, 16, 17, 23, 26, 28, 29, 30 (top & bottom), 31 (top & bottom), 32, 36, 37, 38 (top & bottom), 49 (top), 54, 59, 60 (top), 63, 65, 68, 69, 70, 71 (top & bottom), 72–73, 76, 85, 94, 102 (bottom), 104–105, 114, 118 (bottom)
*Schecter Lee* 6, 7, 10, 11 (top & bottom), 12 (top & bottom), 13, 46, 47, 48, 49 (bottom), 50, 51,52 (top & bottom), 53, 55, 61, 77

**The Heard Museum, Phoenix, Arizona**
20, 22, 33, 39, 40–41, 83, 84, 90, 112, 113, 116–117, 124, 125 (top & bottom), 126, 127

**Institute of American Indian Arts Museum, Santa Fe, New Mexico**
*Walter Bigbee* 93
*Larry Phillips* 42, 43, 44, 45, 92, 101, 102 (top), 103, 106, 107

**June Kelly Gallery, New York**
122

**Museum of the American Indian, New York**
58, 60 (bottom), 64, 66–67,74, 80 (top & bottom), 82, 110, 123

**The Philbrook Museum of Art, Tulsa Oklahoma**
8–9, 18–19, 34, 78–79, 98, 108, 115, 120–121

**Picture Perfect**
*Dave & Les Jacobs* 63

**University of South Dakota Art Galleries**
24–25

# CONTENTS

INTRODUCTION
4

CHAPTER ONE
BASKETRY—THE EARLIEST ART FORM
6

CHAPTER TWO
THE POTTER'S CRAFT
20

CHAPTER THREE
TEXTILES IN TRADE
34

CHAPTER FOUR
DOLLS AS TOYS AND RITUAL OBJECTS
46

CHAPTER FIVE
SCULPTURAL FORMS
56

CHAPTER SIX
COMMUNITY ARTS: HOUSEHOLD AND HUNT
74

CHAPTER SEVEN
BEADWORK AND JEWELRY
88

CHAPTER EIGHT
THE NATIVE AMERICAN ARTIST
108

INDEX
128

# INTRODUCTION

While the concept of "art" as understood in Western and Oriental cultures was unknown to Native Americans, their crafts, from ceramics to weapons making, were often imbued with an artistic intention: artistic quality was regarded as a by-product of good workmanship and fundamental to the purpose an object was intended to serve. Thus a Navajo sand painting was designed to induce the Holy People to restore harmony to the life of one for whom a ritual "sing" was being given. The more accurate and more beautiful the painting, the more the gods would feel compelled, in a spirit of reciprocity, to cure the patient.

In a very real sense this direct correlation between merit and reward is far more honest and, indeed, artistic than that which exists within much of the contemporary art scene, both academic and folk, where quality of work is usually secondary to the social and economic connections that an artist can make with the patrons, critics, and galleries whose judgment (typically financial) can make or break a career.

Additionally, Native American art, rather than being a hobby or mark of social position, was (and is) part of a living tradition. Since it was bound up in the social, ceremonial, and economic life of the community, it was a true "folk art." The craftsmanship employed, which varied greatly from one region to another, was the product of an extended period of local development and refinement in highly specialized techniques.

The forms, patterns, and procedures were well known and universally accepted within the region or society. Artists might have more or less leeway for independent judgment and creation; but for most craft objects—whether Southwestern geometric-decorated ceramics or Plains Indians beadwork—there were prescribed conventionalized formats. The mark of the superior artist was the ability to apply these to create a sensitive and well-executed design. Thus the great Hopi potter, Nampeyo, is hailed not for any radical changes in technique but for her sensitive adaptations of forms and decorations based on fifteenth-century Sikyatki ceramics.

The symbolic abstraction found in much Native American art has proven highly attractive to outsiders. Yet this is often misunderstood. At one level, as in the pictographs found on earlier Plains Indian hide drawings, the figures represent a primitive form of pictorial writing. At a very different level the Northwest Coast carver who "sees" all around an animal and symbolizes the whole though a part or parts shows no less creative sophistication than, say, Picasso.

The difference, moreover, is in the ceremonial content. With the decline of religious art in advanced societies, painting and sculpture ceased to have any "power." Only the most untutored and naive would seriously expect that prayers to a painting of Saint Joseph would result in something substantial; but to this day much Native American art is believed by its makers and others within the community to have the power to affect events and individuals. The Iroquois still put on their carved and painted false faces for the Winter Dances designed to purify the community and drive out evil.

However, it must be noted, these masks are made for sale to tourists as well, just as are Navajo rugs, Northwest Coast model totem poles, Maine Penobscot baskets, Pueblo pots, and countless other Indian-made craft objects. Contemporary Native American artists have found a middle way where they may perpetuate community beliefs and, at the same time, provide a means of economic sustenance for their people.

## Hopi Snake Dancer

*c. 1917–25. Awa Tsireh (Alfonso Royball), Hopi, San Ildefonso Pueblo; watercolor on paper. National Museum of American Art, Washington, D.C.* The Snake Dancer is a traditional participant in the Hopi seasonal dances and ceremonies.

4

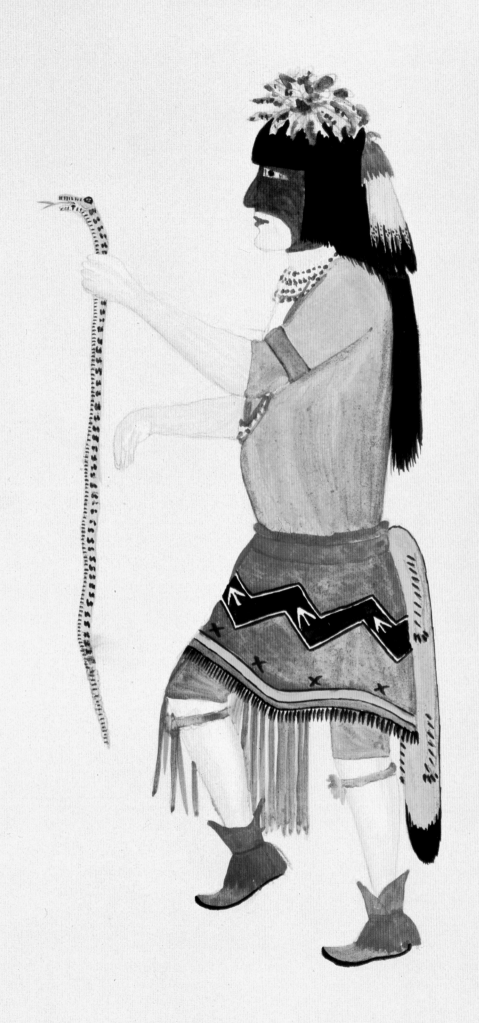

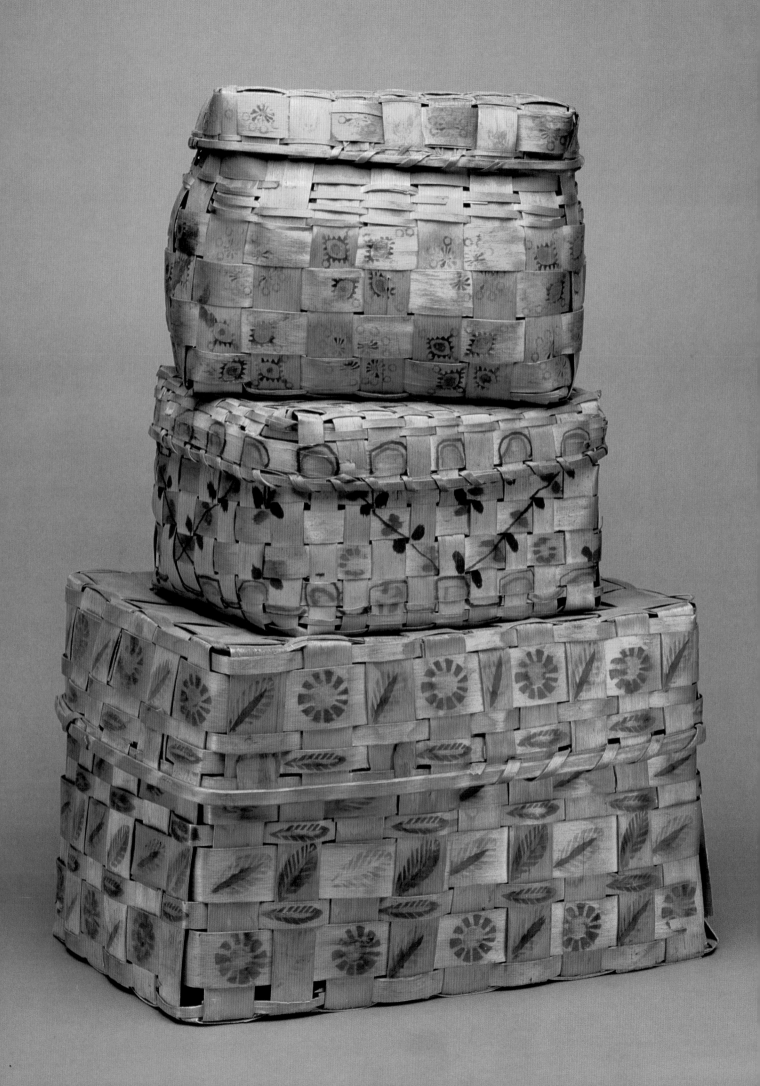

# BASKETRY– THE EARLIEST ART FORM

**T**hough baskets were being made in North America eleven thousand years ago little is known of the wares of those people of the southwestern region now referred to, appropriately enough, as the Basket Makers. They have left behind a few vessels of coiled and plaited yucca leaves as well as a surprising variety of woven fiber sandals. By 600 A.D., however, the traditional conical burden basket with sophisticated geometric surface decoration had appeared, and by the time the first Europeans arrived in the Americas basketry was a highly sophisticated craft varying greatly from one area of the continent to another and from one tribal group to the next.

## EASTERN WOODLANDS BASKETRY

Dutch traders in 1609 found the Iroquois of central New York State making baskets from elm bark, vegetable fibers (especially corn husks), and buffalo hair; but materials and techniques changed under the influence of the Europeans. By the eighteenth century, both the Iroquois and the Algonquin of New England and Canada were weaving baskets of strips cut from the hickory, ash, or maple. So-called splint basketry, which originated in Scandinavia, remains today the Eastern

woodlands Indian tradition.

Initially heavy-pack, storage, and utility baskets were made, but traders encouraged the production of more delicate and colorful containers for sewing, laundry, and household use and for sale to tourists. The Oneida, among the most skillful practitioners, began in the 1860s to decorate their splint containers by weaving in a series of twisted and sharply pointed splints, a technique that became known as "porcupine work." About the same time they began to dye individual splints in various colors or to employ stamps cut from

### Covered Storage Basket

*c. 1830–70. Eastern woodlands Indians; paint-decorated woven splint. Private collection.* The abstract floral designs and large heart are unusual for baskets made by Native Americans.

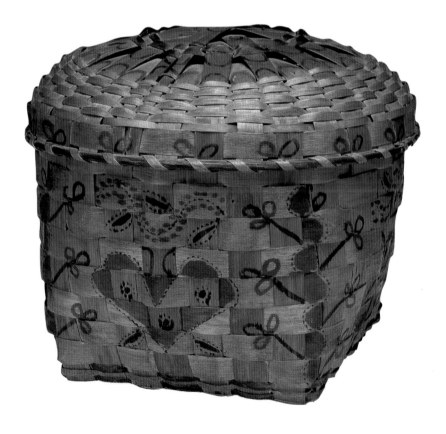

### Three Covered Storage Baskets

*c. 1870–1900. Iroquois; woven splint with polychrome colored "potato stamp" decoration. Private collection.* Potatoes cut into stamplike forms and dipped in natural dyes were used to decorate many baskets sold to tourists.

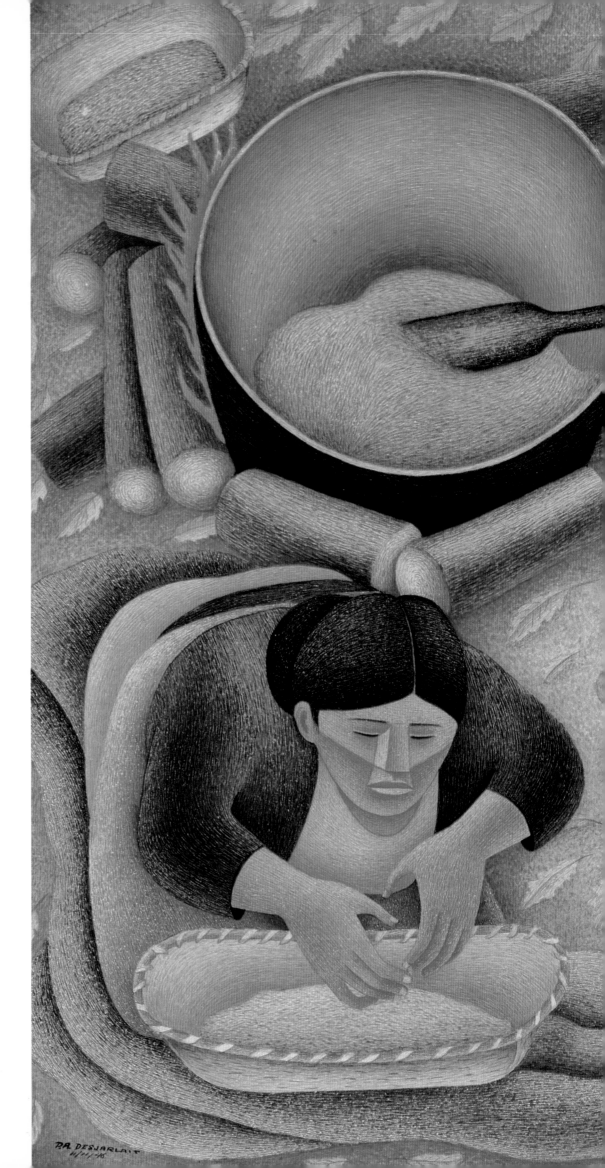

### Making Wild Rice

*1947.* PATRICK ROBERT
DESJARLAIT, *Ojibwa
(Chippewa); watercolor on
paper. Philbrook Museum
of Art, Tulsa, Oklahoma.*
DesJarlait's works re-
semble murals and
reflect his artistic debt
to Mexican masters
such as Diego Rivera.

8

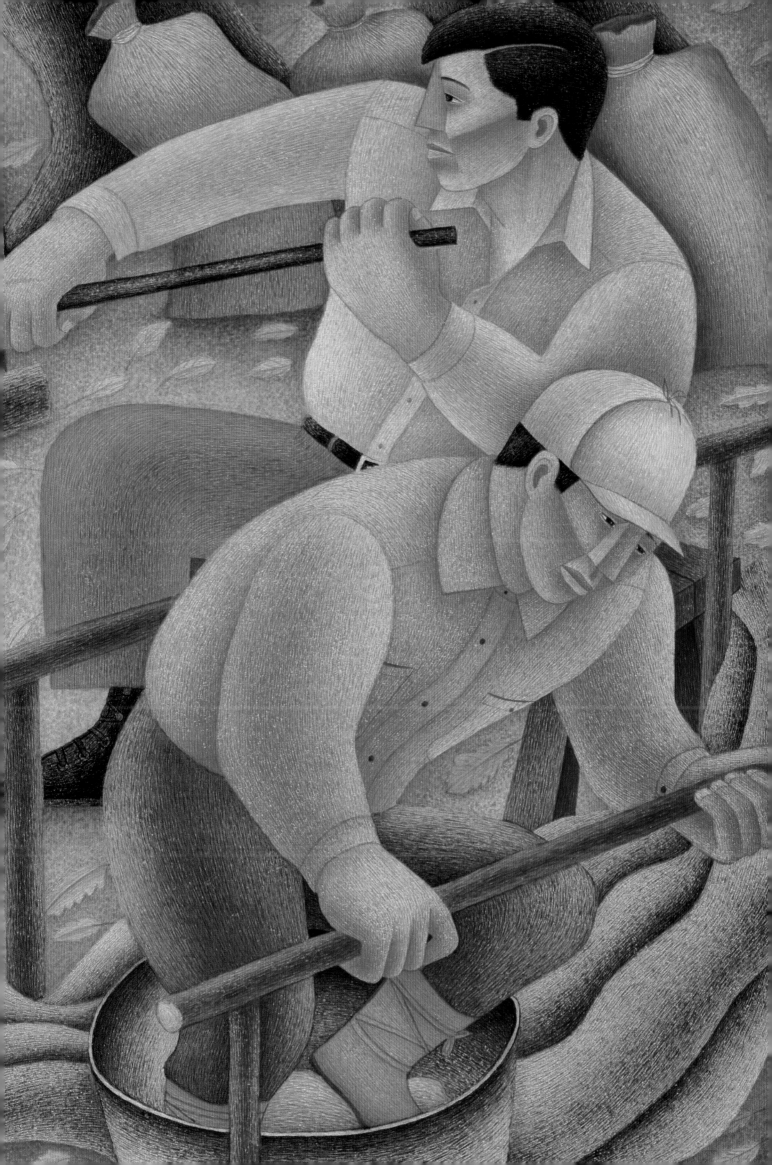

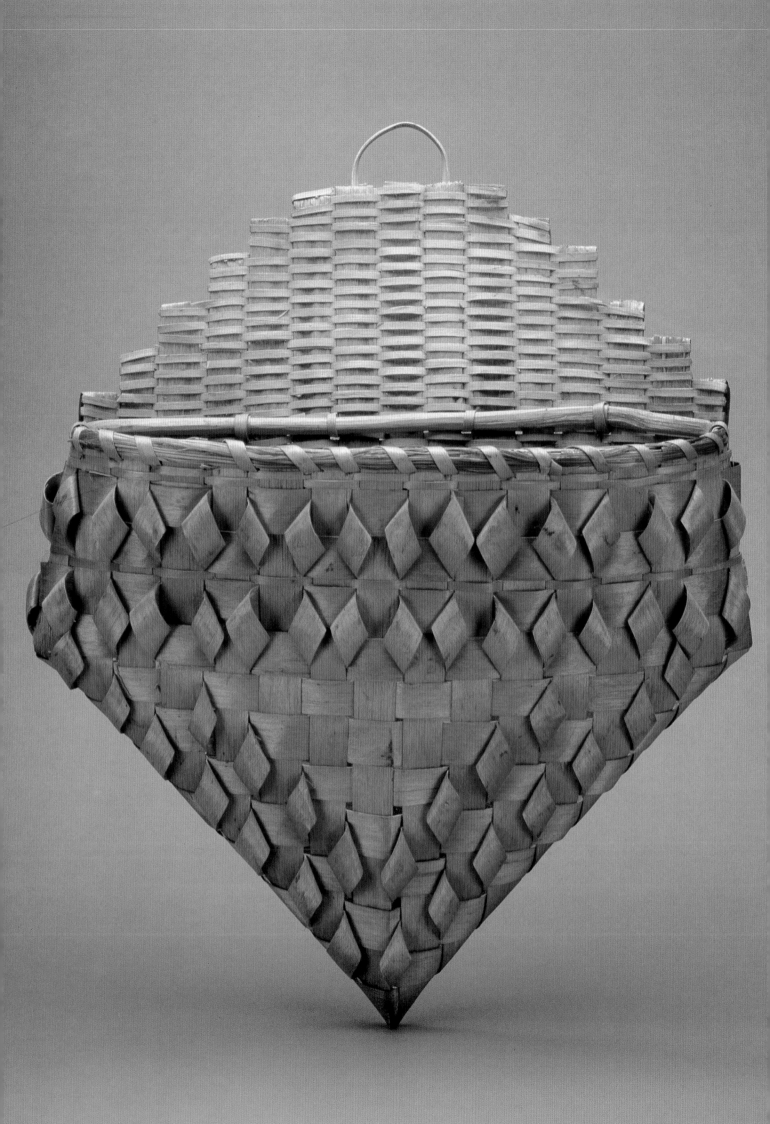

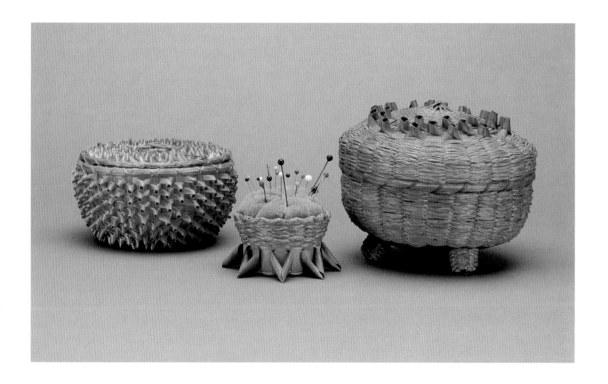

### Two Sewing Baskets and a Pin Cushion

*all c. 1900–30. MicMac or Penobscot; woven sweet grass and splint. Private collection.*
Note that these articles have a twisted splint or "curlique" decoration.

### Three Basketry Vases

*c. 1900–30. MicMac or Penobscot; woven splint, some pre-dyed. Private collection.*
Designed for the tourist trade, these vases held dried flowers or, with the addition of an interior glass or tin vessel, fresh flowers.

### Hanging Wall Basket

*c. 1880–1930. Eastern woodlands, probably Penobscot; woven splint. Private collection.*
Baskets like this were widely circulated; they were used in Victorian homes to hold combs, brushes, and the like.

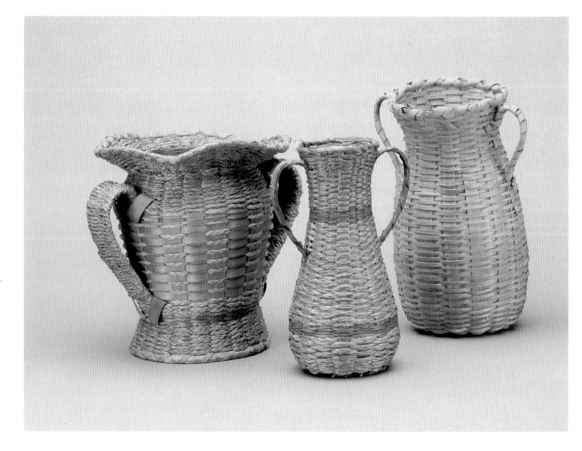

### Miniature
### Tea Set

*c. 1880–1910. Southeastern
Native American; dried
cloves strung on coarse
thread. Private collection.*
This unusual material
was used rarely and
then only for items
to be sold to tourists.

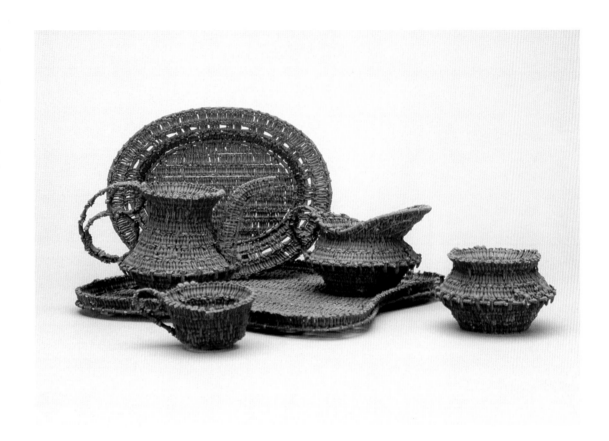

### Doll Cradle

*c. 1880–1930. MicMac
or Penobscot; woven
splint, some pre-dyed or
decorated with dots of
color. Private collection.*
Based on the
traditional non-
Native cradle form,
this item was made
in several sizes.

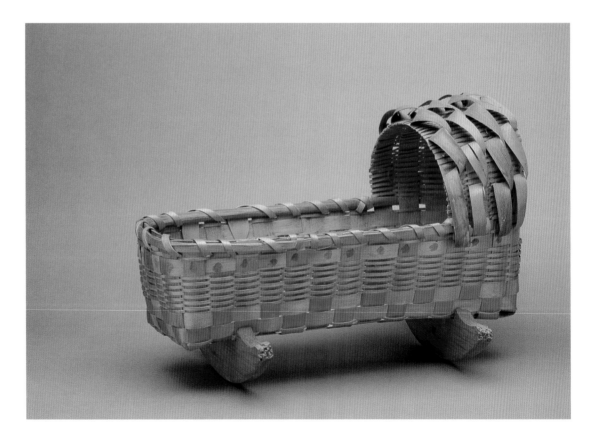

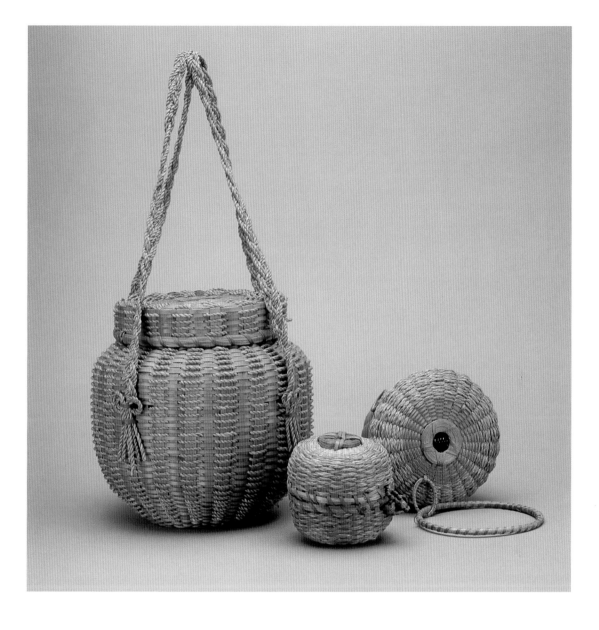

**Covered Novelty or Sewing Baskets**

*c. 1900–30. MicMac or Penobscot; woven sweet grass and splint. Private collection.* The Indians of Maine and New Brunswick, Canada, often combined wild sweet grass with commercially cut splint to create a variety of delicate baskets.

raw potatoes to embellish their work with bands of dots, diamonds, or stylized leaflike designs. These painted "potato stamp" baskets date largely from the 1870s to the 1920s and are eagerly sought after by collectors.

The Algonquins, particularly the MicMac and Penobscot of Maine and New Brunswick, combined splint basketry with sweet grass, a sweet smelling but tough swamp grass which was woven into a great variety of small containers, from sewing and "notions" baskets to handkerchief cases, pencil holders, and even ring- or thimble-sized baskets. Today basketmaking remains a productive craft among these people, as sweet grass or sweet grass and splint wares are still being sold through several tribal stores.

Splint basketry spread throughout the upper Midwest wherever the woodlands

tribes found suitable materials and a ready market. It was also practiced to a limited extent by those few Native Americans in the South who were not driven out by advancing settlers. Tribesmen in this area wove baskets from coils of grass and from the needles of the long-leaf pine as well, a technique later adapted by non-Native hobbyists. On the whole, though, there is little significant Native American basketry from the Southeast.

In fact, for most collectors, the term "Indian baskets" is synonymous with the work of the master craftsmen (or, more accurately, "craftswomen," since nearly all were female) of the Southwestern and Pacific rim states. Basketmaking history is longest here and refinements in technique most pronounced.

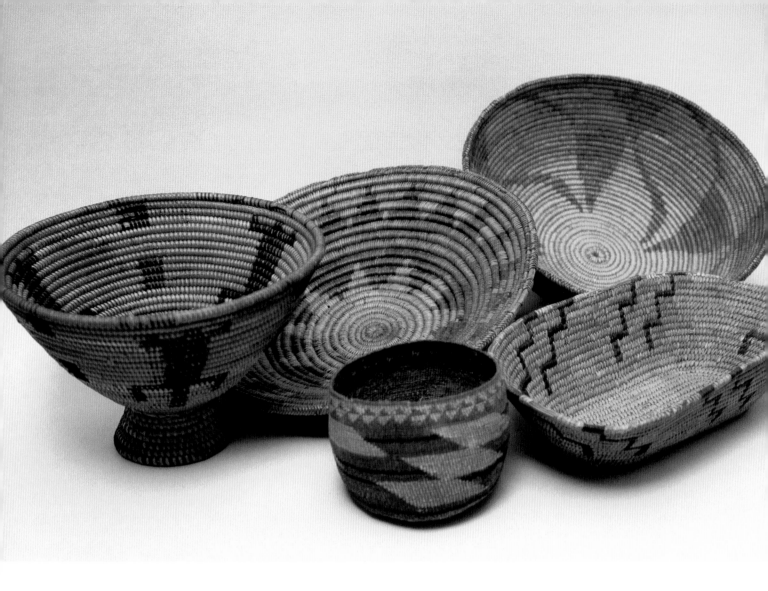

## A Group of Western and Southwestern Woven Willow, Root, and Devil's Claw Baskets

*c. 1880–1910: left to right, Maidu pedestal basket; Navajo wedding basket; Tlingit basket; Apache oblong trencher; and California Mission basket. From the author's collection.*

## BASKETRY IN THE WEST

While the contemporary collector focuses almost exclusively on baskets, the tribes of the West initially produced a much greater variety of objects: hats, cradles, bedding, moccasins, and bags, to name but a few. As in the East, most of these were replaced by comparable objects in other materials made available by Anglo traders. That basketmaking continued to be practiced and, indeed, thrived in the late nineteenth and the twentieth centuries is due primarily to the demands of non-Native purchasers.

The numerous Southwestern basketmakers shared a similar climate—high arid plains or mountains where vegetation and, consequently, basketry materials were limited. The predominant source was the narrow leaf of the yucca plant, which when split produced long, stringy fibers that could be plaited or coiled about rods made from the split, peeled twigs of the willow, sumac, or cottonwood trees. A common decoration consisted of interwoven strands from the jet black seed pods of the Martynia or Devil's Claw bush. The foot-long hook-shaped pods are split into thin strips or splints which provide a bold contrast to the off-white yucca. Where

further embellishment was desired, the craftsperson might stain the materials with dyes made from such natural substances as mountain mahogany, which produces red, or barberry root, which yields a yellow dye. Today, these natural dyes for the most part have been replaced by a variety of commercial aniline colorants.

Southwestern basketmakers frequently decorate their work with geometric designs which symbolize a wide variety of objects: stars, the sun and moon, trails, and home sites of importance to the tribe, or with abstract representations of human beings and native plants and animals, such as the horse or lizard.

The Navajo trace one form of decoration—the stylized juniper sprig pattern seen in their well-known wedding baskets—to divine inspiration. According to tradition, a woman was sitting beneath a juniper tree weaving such a vessel when the hunting god, Hastseyalti, appeared before her and tossed a sprig from the tree into her basket. Assuming this to be a sign of favor she promptly incorporated the leaflike motif into her design. There it has remained ever since.

The Navajo wedding basket is but one of the many traditional Southwestern basketry

types, most of which have been long associated through form, decoration, or function with specific tribal groups. Analogous to the Navajo form is the Hopi meal plaque, a flat coiled tray decorated with abstract representations of the four sacred directions. Just as it would be unthinkable for a Navajo to marry without ceremonials involving the wedding basket, many Hopi males feel that they must be accompanied into the hereafter by a meal plaque. This should serve to remind us that decoration on Native American baskets is seldom merely style; it often reflects long held religious beliefs that collectors, drawn by artistic merit, often fail to recognize or understand.

Basketry, once universal in the Southwest, is now practiced by relatively few groups. The Navajo do not even make their own wedding trays; they purchase them from the Utes. And only at Second Mesa do the women still make the sacred Hopi meal plaques. But those who carry on the tradition—the Pima and Papago of southern Arizona; the Apache and some Yuman-speaking groups like the Yavapai and Havasupai of the lower Colorado River valley—produce some splendid examples.

Among the most desirable are the round shallow winnowing trays and deep bowls made by the Pima. Such objects are tightly coiled and decorated only with Devil's Claw worked in variations of a fret and terrace design adopted from the painting on ancient Hohokam Culture ceramics.

The design in black radiates up and out from a central point (often an abstract representation of the Devil's Claw seed pod) and incorporates geometric abstractions of animal or vegetal elements. To their makers, these are instantly recognized as specific

symbols, such as "coyote tracks," "turtle," or "juice falling from saguaro cactus." Another common Pima motif is the tasita (or swastika shape); and, in response to customer demands, more recent baskets have incorporated readily recognizable images of men, deer, lizards, rabbits, and even the American flag.

Papago baskets differ substantially from those of the Pima. They are more coarsely made with thicker coils, and vessels may be oblong, sometimes with covers, as well as round. Yucca or agave leaves are bleached to a stark white, and the contrasting Devil's Claw geometric patterns are frequently quite simple. Since they produce large numbers of baskets for the tourist trade, Papago wares are encountered frequently in the market.

### Small Basket and Handled Tray

*both c. 1920–40. Hopi; woven willow and devil's claw. Private collection.* The hard, shiny black husk of the devil's claw seed pod was used by many basketmakers of the Southwest to add color to their products.

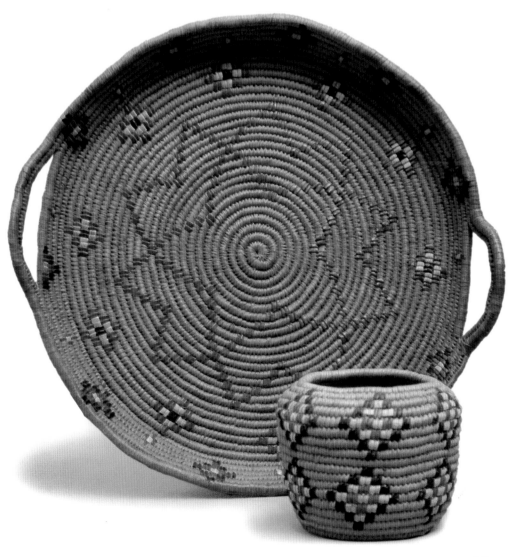

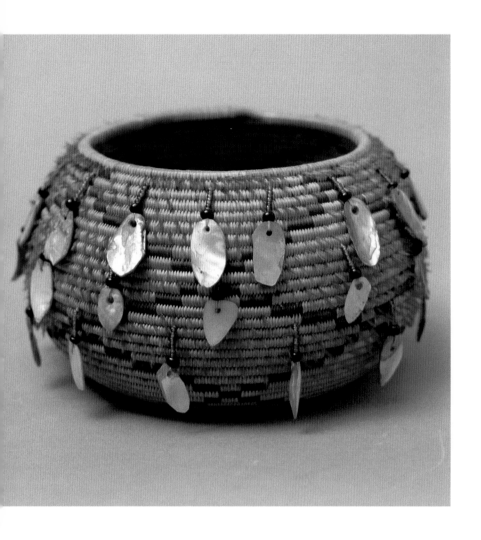

**Feather
or "Treasure"
Basket**

*c. 1900–10. Pomo; roots,
abalone shell, trade beads,
and woodpecker feathers.
Private collection.*

Among the most
sought after of Native
American baskets,
this type was made
by mothers as gifts
to their daughters.

## APACHE BASKETS

The masters of Southwestern basketmaking are the Apache, particularly the Jicarilla and the Mescalaro. They produce two primary forms: shallow bowls or trays and large vase-shaped storage jars for seeds or grain. Both are decorated in black Devil's Claw with a combination of geometric designs usually radiating from a black central element and often including stylized life forms such as men and women, dogs, horses, deer, birds, and fish.

Apache designs are often extremely complex, and quality of construction is excellent, with narrow rods tightly sewn together. While the trays, which play an important part in the puberty ritual of tribal girls, are attractive, it is the monumental storage jars—often as much as three feet high and covered with decoration—

that command the highest prices among collectors.

It is also interesting to note that the Jicarillo Apache, who make some of the most decorative baskets, also make more practical items, particularly jug-shaped water jars coated inside and out with piñon pine pitch, which has been boiled to make it viscous.

## WEST COAST BASKETMAKERS

Despite the Southwest's long basketry tradition many collectors and dealers regard baskets made on the western coast, particularly in California, as the finest indigenous examples of the art. Blessed by a largely benign climate, these diverse but usually small tribal groups did not farm until forced into agricultural communities by the Spanish conquerors but depended for their sustenance upon hunting, fishing, and gathering of wild fruits, berries, and seeds, especially the acorn which they reduced to a nutritious meal.

All were basketmakers, techniques and products differing somewhat among the three main tribal groups: the Pomo, Maidu, Hupa, Shasta, Karok, Klamath, and Washoe of the north; the Yokuts, Mono, and others of central California; and the Chumash and various "mission Indians" who lived in southern coastal areas.

The varied climate produced numerous materials used for basketry, so vessels from this region may be made of tree bark or roots, grass, willow twigs, wild grape vine, sedge, dyed black bullrush, or flax. Techniques, coiling, and twining, did not differ from those practiced in the Southwest, and the use of abstract geometric designs representing natural and supernatural phenomenon (such as the rattlesnake skin–pattern favored by the Tulare) would not have been unfamiliar to the Pima or Navajo.

One tribe, however, produced remarkable baskets that differed greatly from those made elsewhere. Though they also made coiled vessels with geometric decorations, the specialty of the Pomo was the feather basket, known variously as "jewel," "gift," or "presentation" baskets.

These usually small vessels (less than 10 inches [25 centimeters] in diameter) were of

two types. The first, tapica, were shallow, saucerlike baskets entirely covered with red woodpecker feathers and festooned with tiny buttonlike clamshell disks and pendants, often in the shape of fish, the sun, or the moon, and cut from abalone shell. These baskets were of a purely ceremonial character.

The great number of bowl-like baskets, referred to as epica, were also decorated with clamshell disk "money" and abalone pendants but might also incorporate trade beads, while the feathers—in greater variety (black from the quail, meadowlark yellow, green from the mallard duck, blue from the bluebird, etc.)—were tufted into the coiled body rather than completely covering it.

Pomo feather baskets are regarded as among the finest examples of the craft. However, other California basketry is also prized. The work of the Washoe artist Dat So La Lee (active, c. 1895–1925) featured bold geometric compositions based on complex triangular structures, while Tulare baskets often featured bands of figures with linked hands—hence the term "friendship baskets." The Hupa made bowl-shaped basketry caps with stepped geometric designs in several colors, and the Maidu of northern California produced vessels with more than fifty different designs representing animals, plants, and natural forces such as lightning.

## BASKETRY IN THE NORTHWEST

Farther north along the coast baskets were made from cedar bark and the long slender roots of the spruce tree, which were dyed with natural colors. Though geometric designs were common, more popular with collectors are highly illustrative figural compositions, including such dramatic epics of coastal life as whales swallowing boats and bears attacking fleeing hunters.

Because of their spruce-root composition and fine twining, the baskets of such tribes as the Tlingit of Alaska and the Salish of British Columbia are unusually soft and supple. The Tlingit are also known for "rattle lids," produced by concealing seeds within a boxlike arrangement on the lid of a vessel, and for their "false embroidery," a technique whereby dyed ferns and grasses were worked

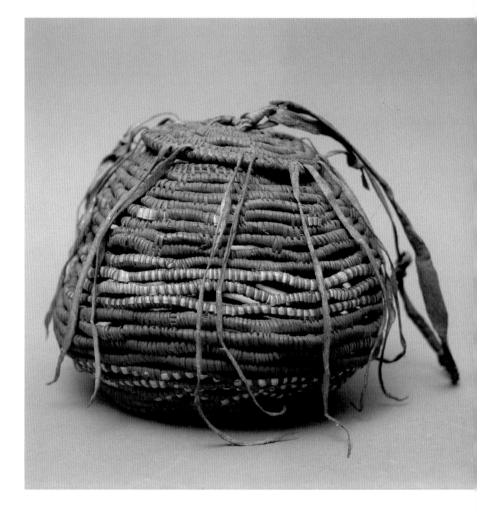

into the vessel in such a way as to create a design only on its exterior.

The Attu, who live in the islands of the same name off the Alaskan coast, make their delicate baskets from sea grass, often decorating them with embroidery in silk or wool in the European fashion. And the inhabitants of Vancouver Island employ ribbons of colored cedar bark to weave baskets and bags.

Perhaps the most remarkable thing about this remarkably varied basketry production within groups of Native Americans stretching from one coast of North America to the other is that it exists at all; that despite the inroads of non-Native cultures the indigenous peoples have maintained and in some cases even expanded their craft, adapting it to a growing external market while at the same time preserving, where appropriate, its ritual and religious significance.

## Covered Storage Basket

*c. 1900–20. Apache;*
*willow, leather, and roots.*
*Stoller Collection.*
Baskets like this were used for family food storage and were not intended for sale to tourists.

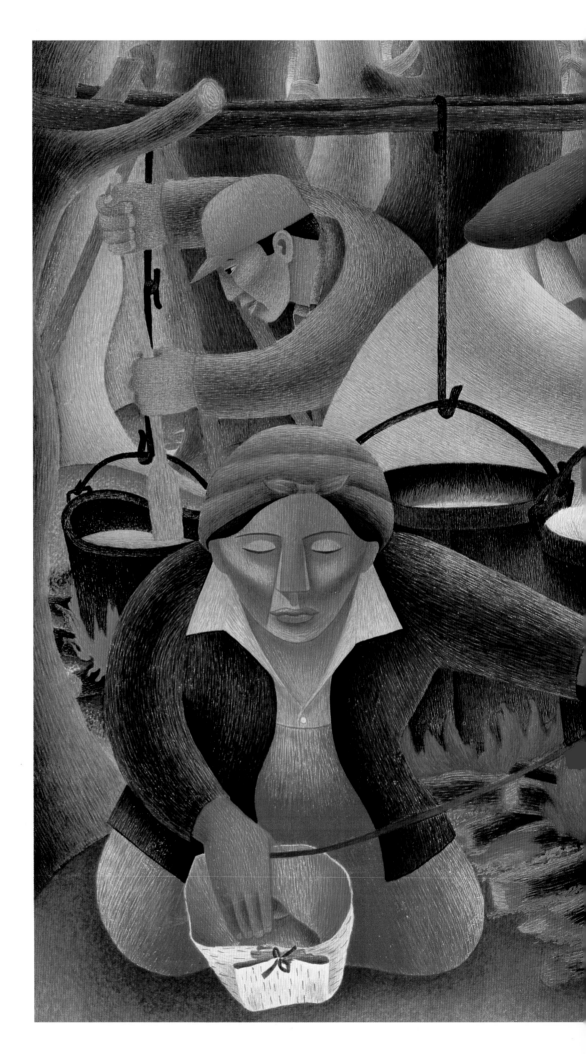

### *Maple Sugar Time*

*1946.* PATRICK ROBERT DESJARLAIT, *Ojibwa (Chippewa); watercolor on paper. Philbrook Museum of Art, Tulsa, Oklahoma.* In his time DesJarlait was rejected by the Native American art establishment because his work was non-traditional in both technique and subject matter. Today, he is considered to be a master.

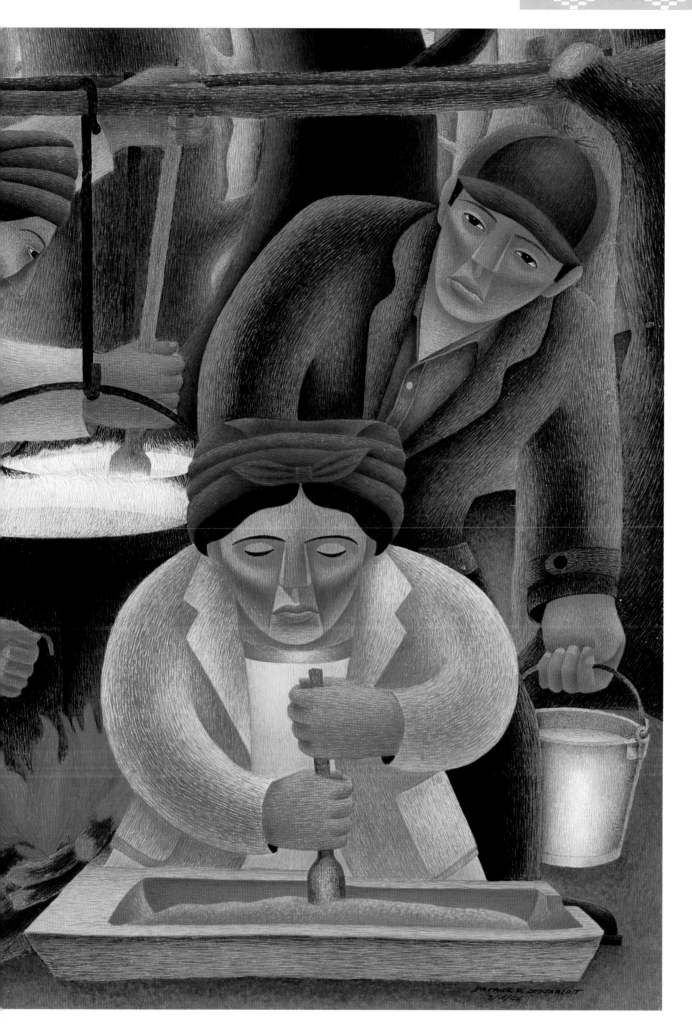

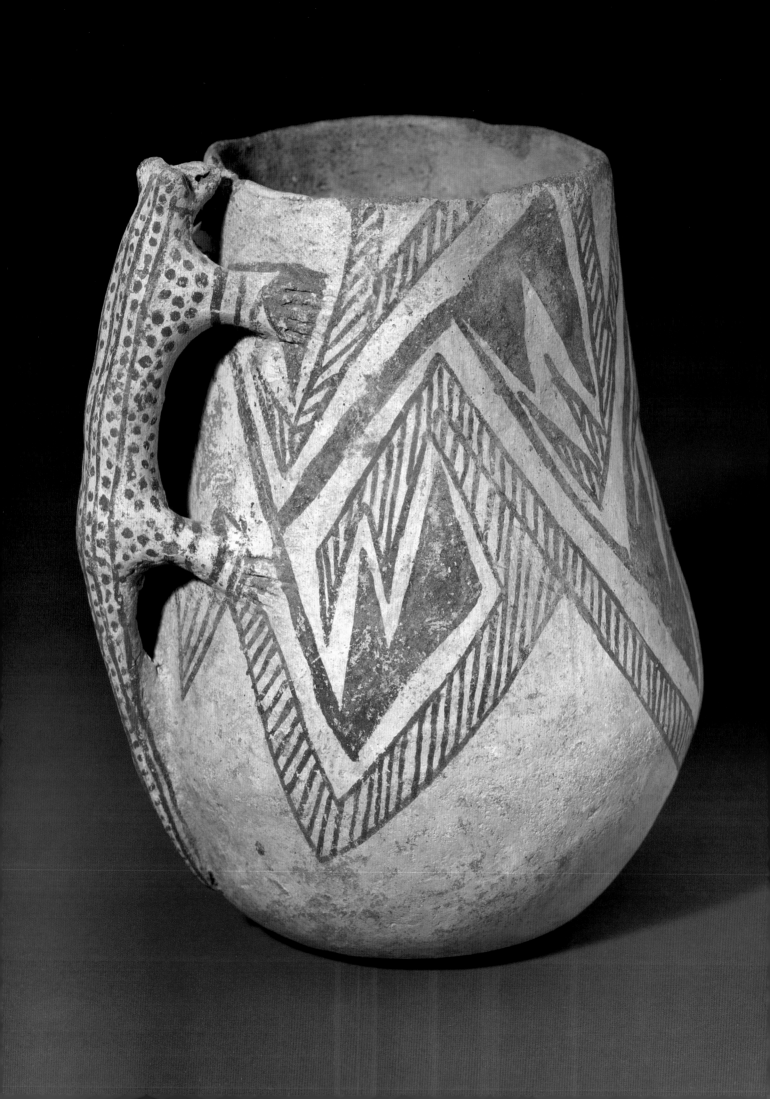

# THE POTTER'S CRAFT

Pottery making, though neither as ancient nor as widespread as basketry, was practiced by nearly all nations of Native America. Only on the Northwest coast is the technique absent. However, as European trade goods became available tribe after tribe abandoned the art so that today it is carried on only in the Southwest. It is from this area as well that the most sophisticated and, from the collector's point of view, most desirable examples, ancient or modern, come.

## EASTERN POTTERY

From Maine through the eastern woodlands and into the upper Mississippi basin archaeological excavations have uncovered vast quantities of what some experts term "Eastern" pottery. Though varying widely from site to site, this ware is generally characterized by a rather muted gray color, a coarse surface, and incised decoration. The common utilitarian form is the bulbous pot with rounded base and a flaring collar, the latter often decorated with incised cross-hatching mimicking the earlier basketry from which the design is taken. By 1700 the Iroquois, Penobscot, and other tribes had ceased to make this pottery, preferring to trade for non-Native–made iron and brass vessels.

More sophisticated wares were produced by the Caddoan culture in Louisiana and other parts of the lower Mississippi valley, where potters continued to be active into the eighteenth century. Caddoan ceramics had a polished black surface skillfully incised in various scrolling patterns, sometimes with red pigment added. Though they lacked knowledge of the potter's wheel, like all Native Americans, the Caddoans were able to produce attractive, well-rounded bottles, bowls, and pots, in designs which reflect contact with Mexican and Central American forms.

Perhaps the most interesting of all Eastern ceramics are the pottery effigy jars which have been found, principally, in Arkansas and Tennessee. These well-modeled vessels are fired from a buff clay and take various forms: human heads, animals, fish, frogs, or birds native to the area. In some cases a conventional bowl or jar is simply decorated with raised elements depicting the head or limbs of an animal; in the most sophisticated, however, the whole vessel is shaped like the creature's body. Most effigy jars have been discovered at burial sites and they are thought to have been associated with rites for the dead.

## POTTERY FROM THE ANCIENT SOUTHWEST

By far the most extensive pottery making region is the Southwest, principally the areas where today lie the states of Arizona and New Mexico. The first pottery was made here around 300 A.D. by three ancient cultures—the Mogollon of southwestern New Mexico, the Hohokam of southern Arizona, and the Anasazi, forefathers of the present-day pueblo dwellers of northern Arizona.

All three produced buff or brown pottery, often carefully polished and decorated with complex geometric patterns in a contrasting red slip made from iron oxide. This use of painted slip decoration stood in sharp contrast to the generally unpainted Eastern

**Black-On-White Pitcher**

*c. 1070–1130. Anasazi; decorated ceramic. The Heard Museum, Phoenix, Arizona.* This fanciful design features the effigy of a spotted cat shaped to form a handle.

21

### Bowl

*c. 1100–1200. Mogollon, Mimbres Valley, New Mexico; decorated ceramic. The Heard Museum, Phoenix, Arizona.* This Mimbre classic design consists of a conventionalized horned toad with hatch-filled steps, scrolls, and jagged lines.

wares, but the inspiration for the designs is a familiar one. Like their eastern brethren the Southwestern craftsmen copied prior basketry styles.

While all three cultures employed the coil construction technique and fired their wares in open, aboveground temporary kilns, one of them, the Hohokam, developed a new method of smoothing and stabilizing the walls by striking them on the exterior with a wooden paddle while holding a stone on the interior surface, a method known as paddle-and-anvil. Unlike their contemporaries, the Hohokam often relieved their geometric decoration with charming stick-figure representations of men and animals.

The next important development from the Southwest was the Mimbres pottery of the twelfth and thirteenth centuries. Evolving from the three prior cultures, these people produced wares such as food bowls and jars that were not only decorated with geometric compositions but also with stylized, remarkably lifelike representations of men, animals, and, particularly, insects. Such objects were painted in dark brown or black against a white slip, which coated the brown clay.

The striking sophistication of Mimbres ceramics has long appealed to collectors; and examples, when available, bring high prices. Most pieces have been found in graves (it has only been in the past few decades that serious attempts have been made to prevent desecration of burial sites). "Kill" holes can be seen in the bottoms—punctured so that they might accompany the deceased to the hereafter, a practice common to many Native American tribes.

## POTTERY DEVELOPMENT IN THE SOUTHWEST

Though cultures waxed and waned over a period of a thousand years, the quality of the ceramics produced remained remarkably high, climaxing in the thirteenth through the fifteenth centuries with the bold, abstract pieces in polychrome decoration produced by the pueblo-dwelling ancestors of contemporary Hopi potters. Painted in red, brown, and black on a yellowish ground with conventionalized figures, usually of birds, these wares serve as a direct link to modern Hopi pottery.

It came about in the following manner. Under the impact of Spanish and Anglo intrusion into the area, Southwestern ceramic production declined throughout the eighteenth and nineteenth centuries. However, in 1895 an archaeological excavation at Sikyatki, a ruined village on First Mesa in Arizona, brought to light numerous examples of the fifteenth-century ware.

One of the laborers at the site was Lesou, the husband of a Hopi potter named Leah Nampeyo (c. 1860–1942). When Leah saw the excavated ware she adopted the Sikyatki forms and decoration and revived a style which continues to this day. Nampeyo is generally regarded as the greatest of all modern potters from the Southwest, but her work is rivaled by that of another woman, Maria Martinez, of San Ildefonso Pueblo.

### Pueblo Pottery

*c. 1910–30. Hopi, fire-baked clay with polychrome decoration. Left to right: bowl, olla or jar, bowl, vase by* Jeanette Nampeyo; *bowl by* Nellie Nampeyo. *Private collection.* Both of these women are descendants of the greatest of Hopi potters, Nampeyo.

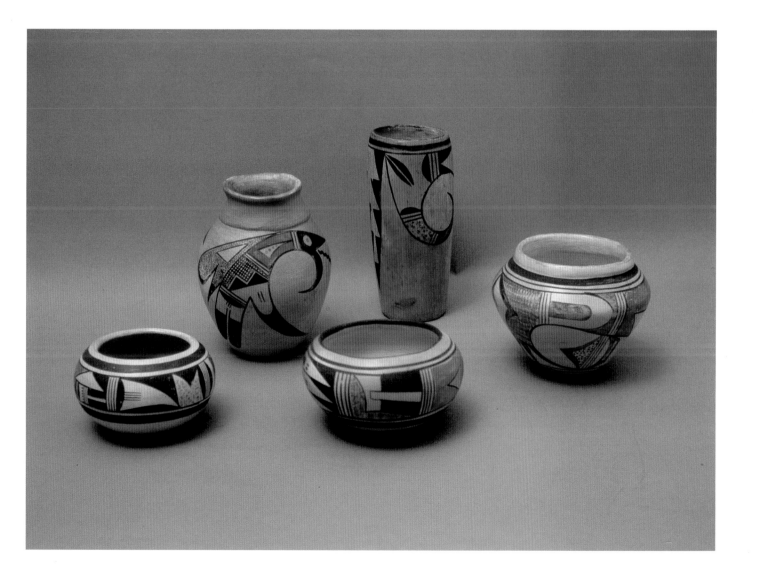

## Double Woman

*1983. OSCAR HOWE,
Yanktonai Sioux; watercolor
on paper. University of South
Dakota Art Galleries.*
Considered one of the
greatest painters in the
modern Native Ameri-
can art movement,
Howe has worked
in Cubist, colorist,
and abstract styles.

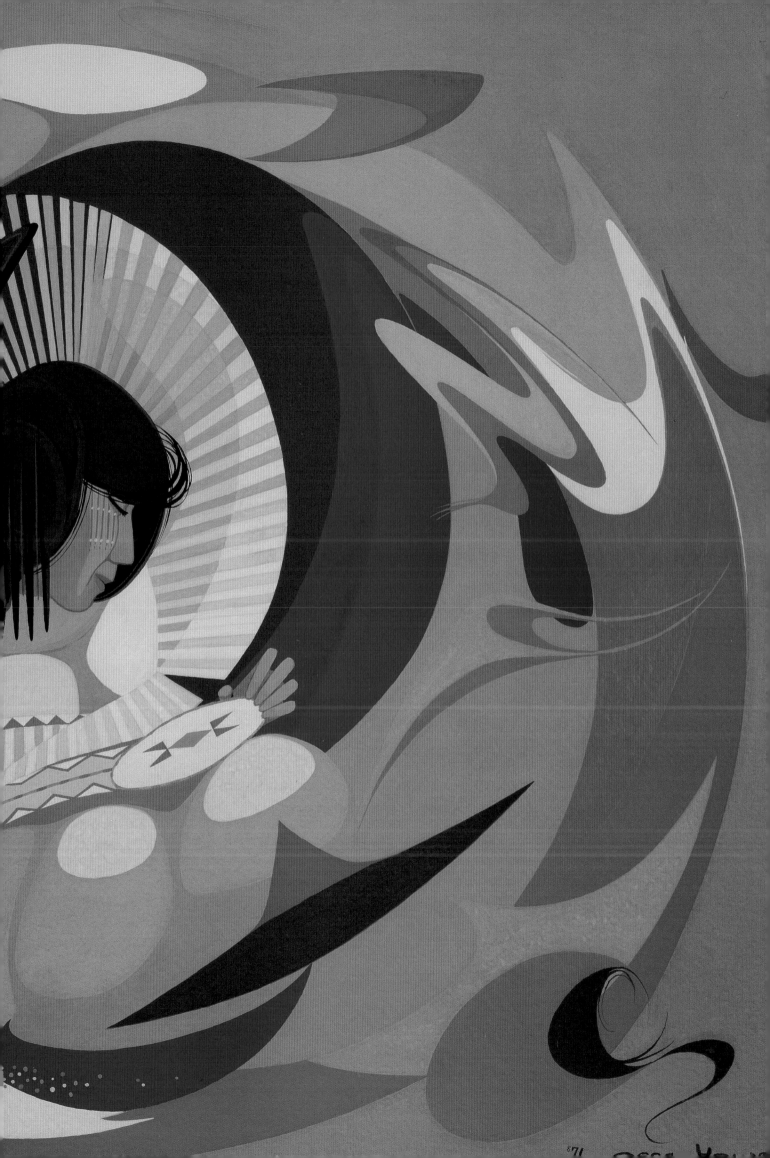

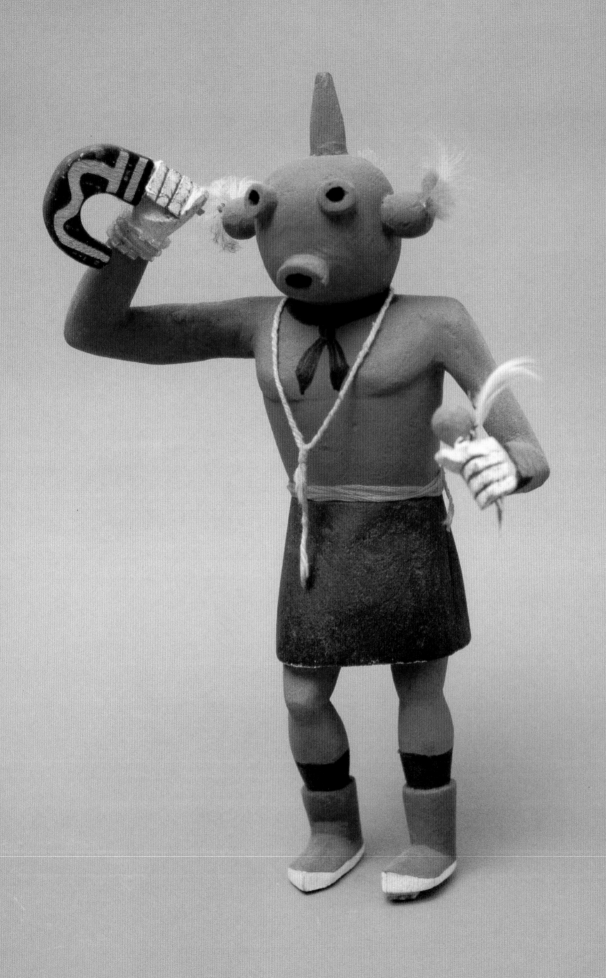

**Animal Designs**
*c. 1917–20.* Awa Tsireh
*(Alfonso Royball), Hopi,
San Ildefonso Pueblo; water-
color on paper. National
Museum of American
Art, Washington, D.C.*
Tisreh's earlier works,
such as this example,
reflect the influence
of traditional Hopi
pottery decoration.

Though Maria and various members of her family produced, over several decades, a variety of polychrome pottery, she is best known for her polished black-on-black wares. She and her husband, Julian, also a well-known artist, first created this ware around 1913 by smothering the kiln fire, thus depriving the baking pieces of oxygen. Other Native Americans had employed this technique, but the Martinez family combined it with designs painted on areas left unpolished (matte) to create striking contrasts.

While Nampeyo and Maria Martinez may be said to be the "mothers" of contemporary Southwestern ceramics, they have had many followers, almost all of them female; for, traditionally, pottery making is women's work. In fact, as Hopi legend tells:

> It was Spider Woman who first taught the women how to use clay to make storage jars for food and water. In the beginning the jars were easily broken because the people did not have fire to harden them. Then, Butterfly came and showed them how to make fire with a bow-drill. And one time they were careless and their fire burned down a house. When the people searched the ashes, they found their clay pots had become hard. And so it happened that the people learned to use fire to make their pots hard and not so easily broken.

Not only is potting women's work it is also highly communal with extended families assisting better-known artists in the shaping, firing, and decorating. In fact, once it became acceptable in the 1920s for potters to sign their work, it was common for women such as Nampeyo or Maria Martinez to sign pieces made by other family members (to their standards, of course) in order to enhance their value. It is often extremely difficult to ascertain when this has been done, much as it is sometimes hard to sort

**Koyemsi
or "Mudhead"
Kachina**
*c. 1950–60. Hopi; fire-
baked clay with polychrome
decoration, twine, and
feathers. Stoller Collection.*
A popular visitant
at Hopi seasonal
dances, the Koyemsi
is a clown who
both entertains and
instructs spectators.

## Southwestern Pueblo Polychrome Pottery

*c. 1910–40. Left to right: San Juan bowl; scratch decorated blackware bowl, Santa Clara; Acoma miniature plate; Santo Domingo olla or jar; San Juan bowl; Acoma bowl; miniature turkey, Acoma; and tile plaque by the Hopi potter* EDITH NASH. *Private collection.*

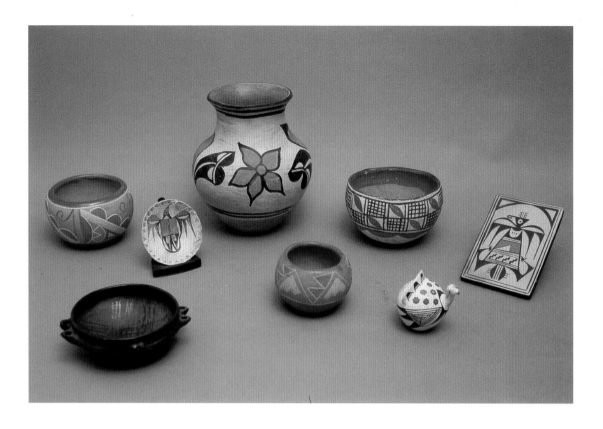

## Storyteller Doll

*c. 1930–50. Cochiti; fire-baked clay with painted decoration. Stoller Collection.* This figure is by Helen Cordero, who originated the form among the Cochiti. It has been copied widely by other artists.

out the work of famous European artists from that of their students or "school."

Following Nampeyo's and Martinez's example, a variety of styles have emerged from the pueblos. At Santa Clara and Cochiti human- and animal-form ceramics dominate, the best-known of which is the work of Helen Cordero of Cochiti, who initiated the making of charming "story teller" figures—representations of a man to whom numerous small children cling as he recites ancient Hopi legends. Santa Clara, on the other hand, is known for colorful owl figures (also, a product of Zuni) as well as those of others animals, from turtles to sheep. Another pueblo, Tesuque, produces "rain god" figures, the form of which recalls ancient pueblo pottery.

Since they sell well, many pueblo artists have turned to producing figural ceramics, but the majority of the ware is still traditional in form: food bowls, large round ollas, or storage jars, mugs, plates, ladles, pitchers, and the like. Best known of the latter are the double-necked or "wedding" pitchers made in several communities. Also appealing to collectors are the round water canteens made primarily at Zia, Zuni, and Acoma. While to the Anglo buyer these are simply attractive forms, to the pueblo potter they signify both the mother's life-giving breast and the importance of water in an arid environment.

Despite their close physical proximity, pottery form and decoration vary greatly from one pueblo to the next. Santa Clara and San Ildefonso continue to produce polished black or red vessels, the former village best known for pieces in which geometric designs have been deeply cut. Acoma ware is distinguished by vessel walls of extreme thinness and sophisticated decoration ranging from the abstract to a combination of realistic animals and geometric borders, while that of San Juan shows a red and tan body often incised with cross-hatching. Maricopa pieces are also fired to a deep red, but they are decorated with strong geometric designs in black slip. The micaceous pottery of Taos and Picuris, though, is entirely different. Ancient in appearance, its orange-brown surface sparkles from the mica crystals present in the clay.

As pottery making provides much needed income, it has proliferated during the past several decades. Nearly every pueblo village as well as the Navajo and some other nearby tribes produce their own wares. Young potters are now employing kilns and wheels and new methods of decoration, such as inlay in turquoise and other semiprecious stones. The ancient traditions, however, remain healthy.

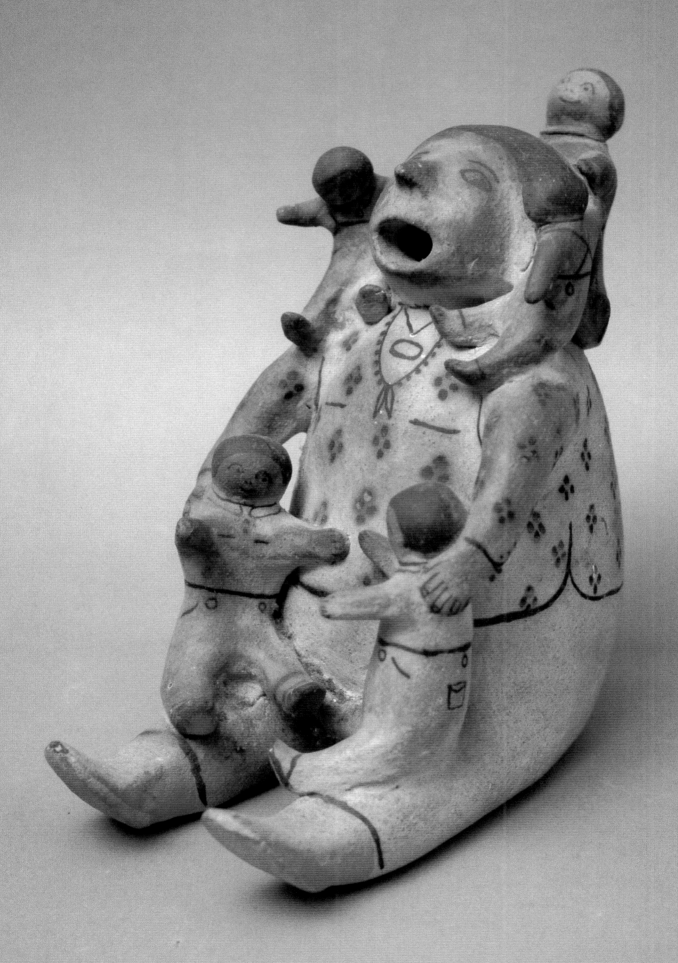

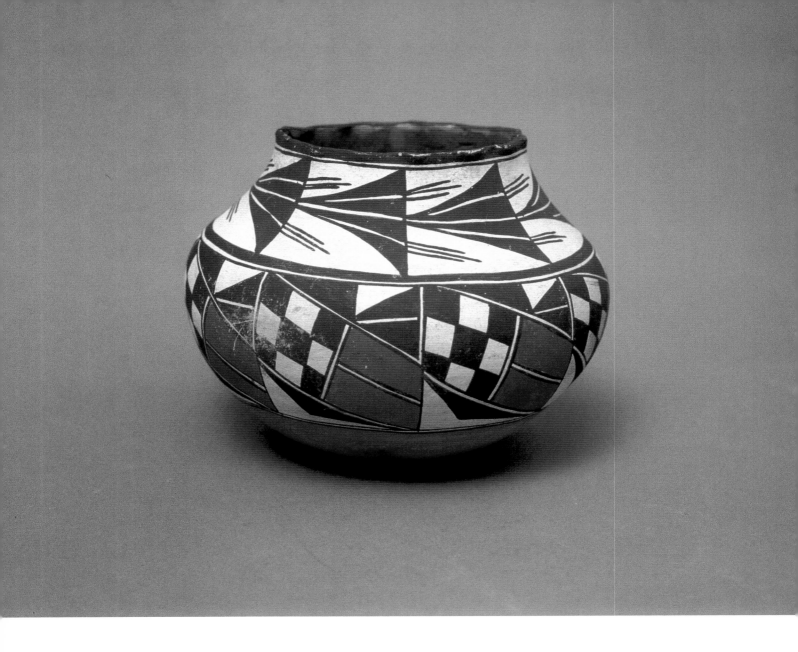

## Storage Jar

*c. 1910–20. Acoma; fire-baked clay with polychrome painted decoration. Private collection.* Acoma wares, with their extremely thin and delicate walls, are among the most finely potted of Native American ceramics.

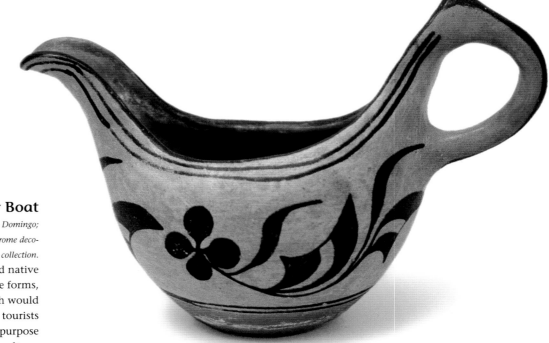

## Gravy Boat

*c. 1930–40. Santo Domingo; fire-baked polychrome decorated clay. Private collection.* Traders encouraged native potters to produce forms, such as this, which would be popular with tourists though they had no purpose within the Indian culture.

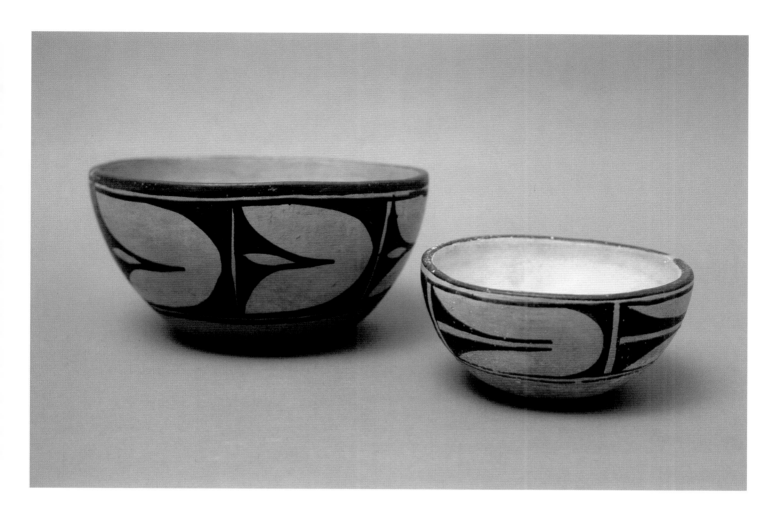

### Two Bowls

*c. 1920–40. Santo Domingo;*
*fire-baked clay with black on white*
*decoration. Private collection.*
Both the form and the bold
abstract decoration are tra-
ditional among potters of
the Santo Domingo pueblo.

### Decorative
### Handled Bowl

*c. 1930–40. Zuni; fire-baked polychrome*
*decorated clay. Private collection.*
While the abstract floral
decoration is typical of tradi-
tional Zuni wares, the form
reflects non-Native influences.

31

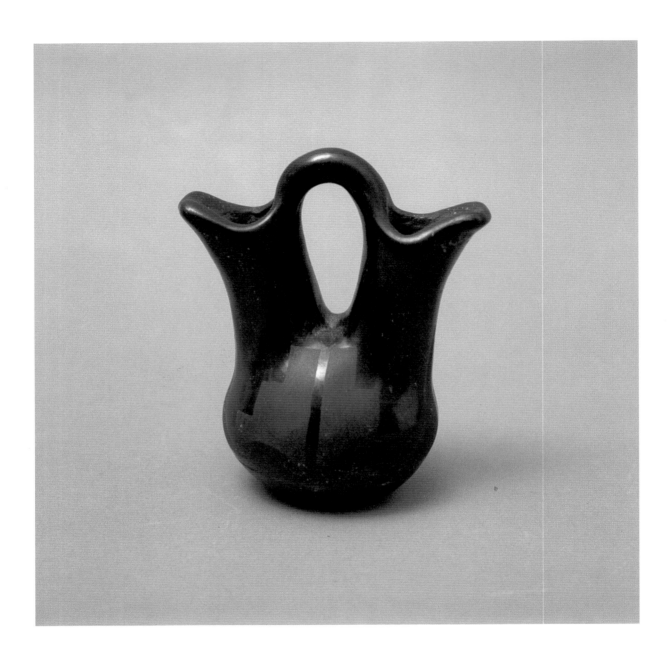

## Wedding Vase

*c. 1950–70. Santa Clara; fire-baked*
*polished clay. Private collection.*
Developed by Maria and Julian Martinez,
the technique of combining matte and
polished black surfaces has been highly re–
fined among the Santa Clara Pueblo artists.

## Jar

*c. 1880–90. Acoma; fire-baked clay with polychrome*
*decoration. The Heard Museum, Phoenix, Arizona.*
A stylized exotic bird is central to this sophis-
ticated design in black, white, and orange.

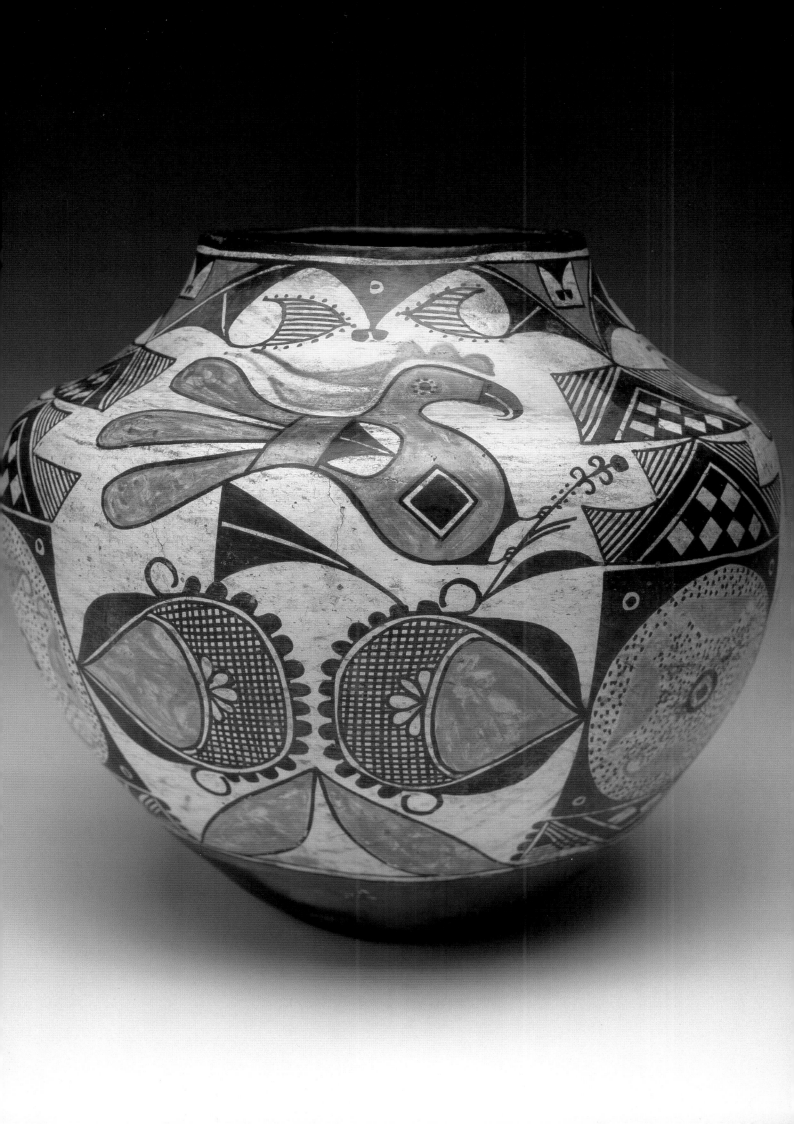

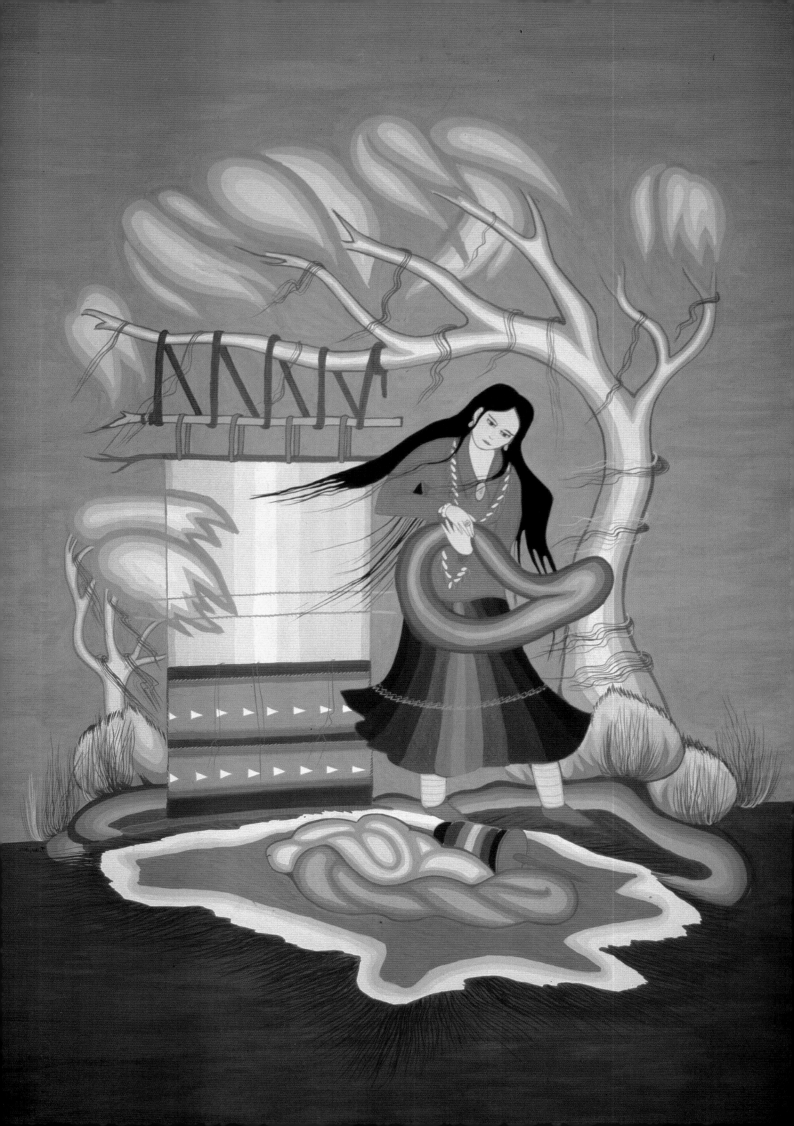

# TEXTILES IN TRADE

**T**extile weaving—unlike basketry, pottery making, and other crafts—was not widely practiced among Native Americans; only among the Hopi and Navajo of the southwestern United States did it become firmly established.

## HOPI TEXTILES

Sedentary farmers dwelling in the mesa-top pueblo communities of Arizona, the Hopi people learned to use the upright loom as early as 700 A.D., inheriting the necessary techniques from the Basket Makers' culture, members of which hand-wove yucca fibers into coarse but attractive fabric decorated with complex geometric designs in a damask or twilled weave.

By the fourteenth century the Hopi had learned to weave cotton, which had already been cultivated in the area for over a thousand years, and substituting this for yucca they established a weaving tradition that continues to this day. The variety of garments produced, however, seems to have been limited. A mummified body dating to the fourteenth century and found in the so-called Canyon del Muerto area was clad in an oblong robe or manta woven in a diagonal pattern from cotton dyed red, black, and yellow. In the nineteenth century Pueblo women were still wrapping themselves in similar garments, though the fabric was now woolen.

Sheep herding and wool manufacture were introduced in the late sixteenth century by Spanish settlers, and since then both cotton and wool have been employed in weaving. A common woman's garment was gownlike of blue or black wool or of cotton embroidered in wool. A kilt-form male garment as well as trousers, vests, leggings, and shirts were also made to some extent, but in recent years Hopi weaving has declined due to the availability of non-Hopi fabrics in addition to the ubiquitous Navajo textiles.

However, the craft continues to be practiced on the mesas, primarily for sacred purposes—producing ceremonial sashes, headbands, and kilts worn by Kachina impersonators in the ritual seasonal dances. Also, a traditional Hopi male is obliged to weave wedding garments for his fiancée, particularly the all-white manta or nuptial shawl.

Unlike the neighboring Navajo, weaving is traditionally men's work. Carried out on looms set up in the underground kivas or holy places, it is imbued with religious significance under the patronage of the Moon Goddess. As a consequence of this, perhaps, the Hopi have never woven to any extent for sale to outsiders. Nearly all of what they make is used within the community.

## NAVAJO WEAVERS

The Navajo, whose vast reservation (nearly as large as New England) covers parts of Arizona and New Mexico and whose population exceeds all Native American groups at 100,000, are recognized as the foremost of Indian weavers.

Hunters and gatherers before the coming of the Spanish, they quickly adopted sheep herding as the central facet of their economy; weaving techniques, previously unknown, were learned from Hopi fleeing Spanish reprisal after the great pueblo uprising of

*Navajo Woman Weaver*
*1952.* ANDREW TSINAHJINNIE, *Navajo; watercolor on paper. Philbrook Museum of Art, Tulsa, Oklahoma.* A practitioner of the so-called Santa Fe Studio style of painting, Tsinahjinnie's work has a fluid surrealistic, almost Oriental quality.

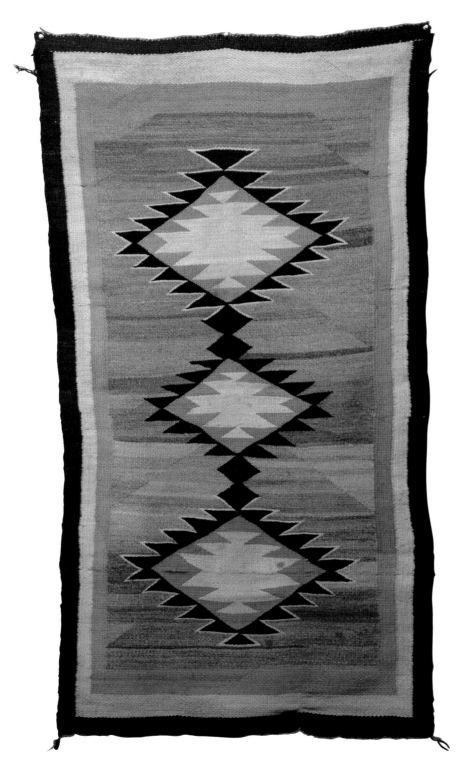

### Rug

*c. 1930–40. Navajo, Chinle type; dyed woven wool. Private collection.*
Many twentieth-century textiles are made with
muted colors, reflecting a tribal reaction against the
often garish hues favored at the turn of the century.

1680. Weaving among the Navajo, unlike
their Hopi neighbors, is women's work, while
the men and boys tend the flocks which are
dispersed over a wide, often arid landscape.

The earliest known Navajo weaving dates
to the early 1800s and consists of several
striped woolen blankets found on the bodies
of a group of Navajo murdered by the Span-
ish in 1804 when trapped in a cave at Canyon
de Chelly in Arizona. These blankets are
undyed; color variations of tan, brown, and
white reflected natural differences in the raw
wool. At this point and for the next several
decades the Navajo wove wearing blankets
for their own use and for trade with sur-
rounding tribes.

As the reputation of their blankets spread
north to the Plains, the Sioux, Cheyenne,
and Pawnee came to barter, and their weavers
introduced a greater variety of colors (either
natural or imported). The Navajo began to
add new designs, based on Mexican examples
from Saltillo and Oaxaca, to their traditional
banding. Diamonds and zigzag patterns were
combined with stripes, and a new form,
wider than it was long, was introduced.

"Chief's blankets" first appeared around
1850, attracting the attention not only of
natives but also of settlers struck by the
bright colors and intricate patterns of the
new weavings. Though not, of course, re-
stricted to wear by chieftains alone, these
new blankets were expensive.

Regarded as the crowning achievement of
the so-called classic period of Navajo weaving
(1800–1900), the chief's blanket passed
through three phases of development. The
earliest, c. 1850–70, had broad horizontal
stripes in black and white alternating with
patterned bands. In a second phase, c. 1870–
80, this banding was elaborated through the
addition of darker colored bars or ribbonlike
designs. In the final phase, 1880–1900, the
bands were overlaid with serrated or terraced
diamonds or triangles, set in groups of three.

By this time the craft had undergone other
changes as well. The replacement of more
somber natural hues by bright aniline dyes
obtained through American or Mexican
traders and the growing demand for rugs
(for sale outside the tribe) rather than

blankets led to larger, heavier, and more colorful products.

These "modern" rugs were given borders—something traditional wearing blankets never had—and, in some cases, fringes. Owners of trading posts eager to expand their tourist business provided native weavers with patterns resembling the Oriental or European rugs more familiar to their clients and encouraged the manufacture of small "model" rugs or mats which could be sold for less than a dollar. They also commissioned rugs with subject matter such as the Yei (Navajo deities) and sacred sand paintings that for many Navajo bordered on the sacrilegious. Worst of all, by 1900, some traders were buying textiles by the pound, promoting the weaving of coarse, heavy pieces in which bulk was regarded as more important than craft or visual quality.

Despite all this, the craftswomen persisted in turning out some wonderful examples. One such innovation was the "eyedazzler," a brightly colored rug with diamond-shaped motifs set in a variety of contrasting color blocks and featuring multidirectional design elements, creating optical compositions that changed their form as the viewer moved about them. These startlingly modern rugs are a great favorite with contemporary collectors.

Moreover, in the early twentieth century (particularly after 1935) there were traders who opposed the more garish excesses of consumer driven design and urged the weavers with whom they worked to use traditional designs and even natural dyes. The former led to a proliferation of regional rugs, among the better known of which are those from the Wide Ruins, Chinle, and Two Gray Hills areas. The latter resulted in finely woven textiles featuring the browns, grays, and natural whites found in the earliest Navajo examples. Today, rug- and blanket weaving remains a source of pride and income among the Navajo people.

**Wearing Blanket**

*c. 1910–30. Navajo; dyed wool, hexagonal twill weave. Private collection.* More complex weaves such as this one are not generally employed among the Navajo and may not be recognized as their style of manufacture.

## Rug

*c. 1970–80. Navajo, Three Grey Hills area; dyed woven wool. Private collection.*
Contemporary Native American weavers are producing rugs of a high quality which are in great demand among collectors.

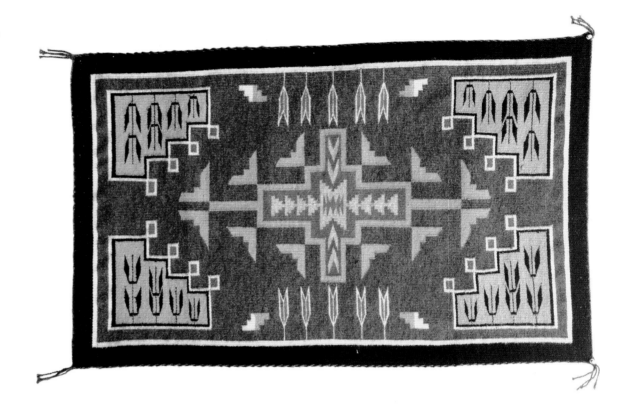

## Rug

*c. 1910–30. Navajo; dyed woven wool. Private collection.*
The stripes and the lack of borders on all four sides indicate that this is an early textile.

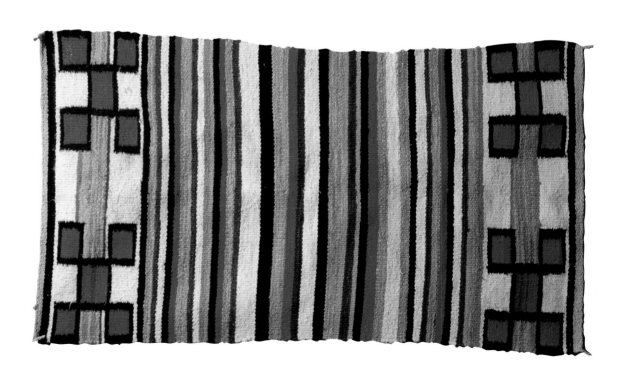

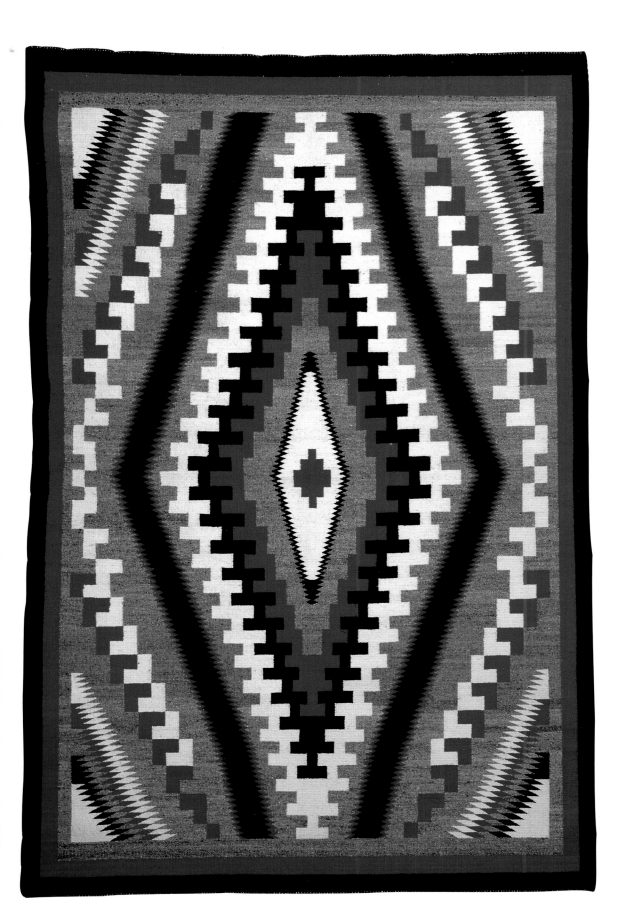

**Rug**

*c. 1910–20. Navajo, Ganado area, Arizona; natural and dyed woven wool. Read Mullen Collection, The Heard Museum, Phoenix, Arizona.* Textiles from the Ganado area are characterized by fine weaving and complex geometric patterns.

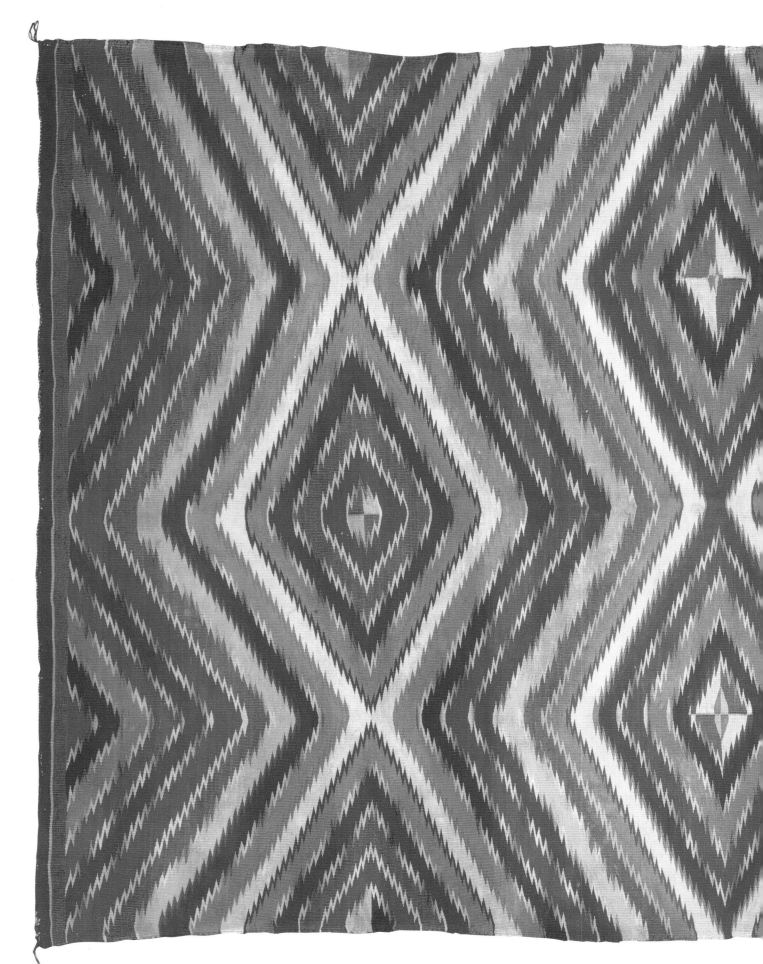

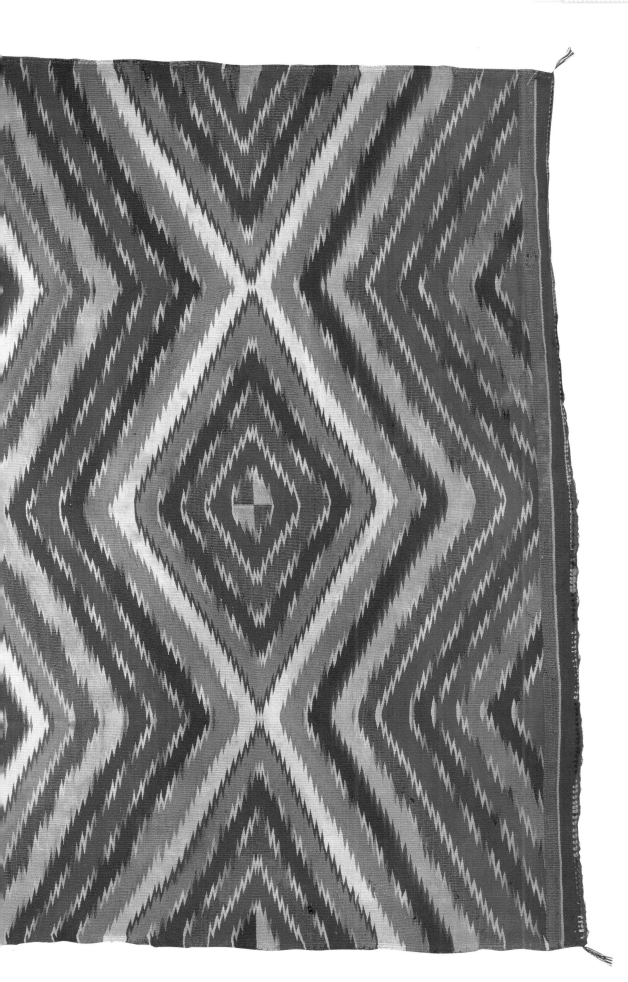

## Rug

*c. 1890–1910. Navajo; Germantown-type dyed wool and cotton in a plain tapestry weave. Fred Harvey Collection, The Heard Museum, Phoenix, Arizona.* Aniline-dyed yarns from the Germantown, Pennsylvania, mills were introduced into the Southwest around 1875.

41

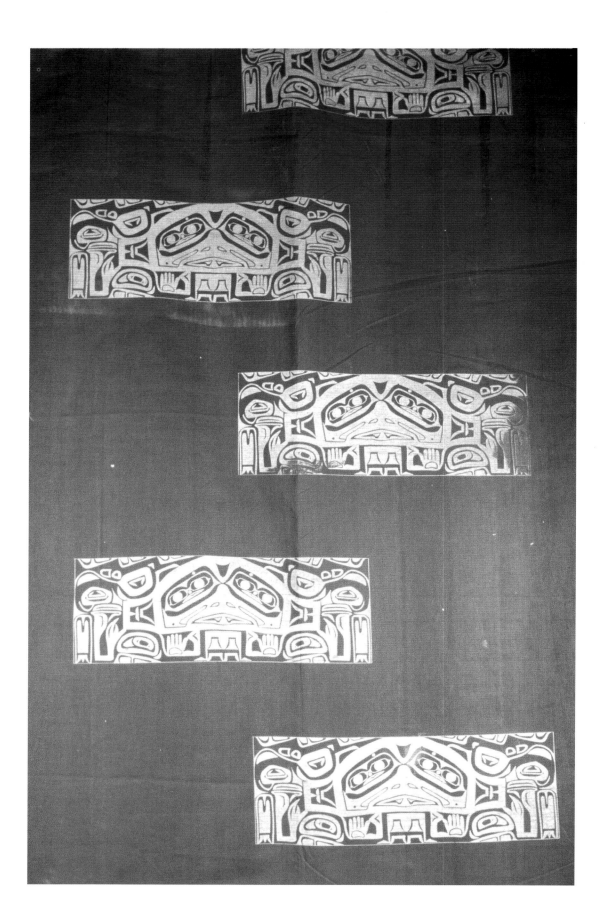

## Textile

*n.d. Northwest Coast;*
*white printed design*
*on dyed cotton. Institute*
*of American Indian*
*Arts Museum, Santa Fe,*
*New Mexico. NW-34.*
The Northwest
Coast tribes are
noted for their
exquisite textitles
which often served
to show wealth
or special status.

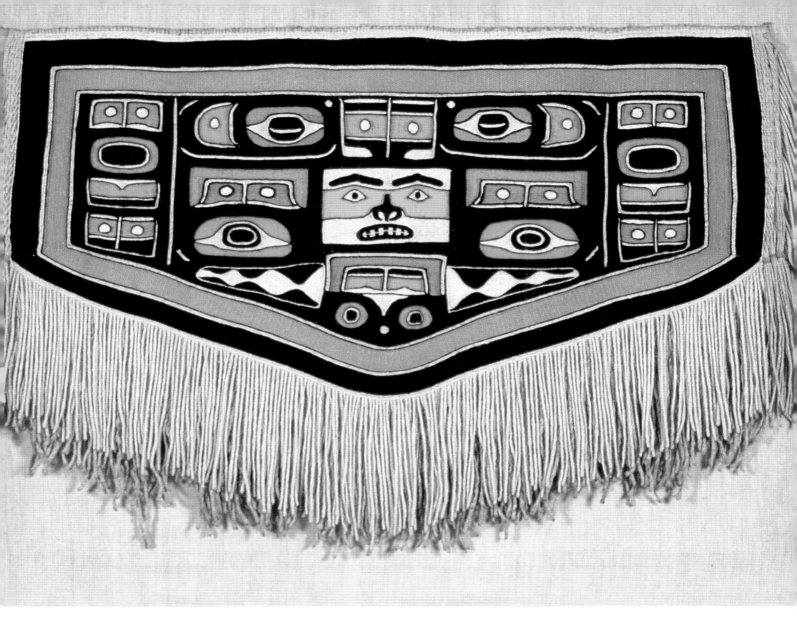

## PACIFIC COAST TEXTILES

The only other significant center of Native American textile manufacture was the Pacific Coast. Certain California tribes such as the Pomo and the Yurop-Hupa wove headbands and other narrow pieces by hand without use of a loom. The materials, which ranged from strips of bark to the woven rush or seagrass employed in making the capes worn by fishermen and even to rabbit fur, were those that might be gathered in the wild or acquired through hunting.

The highest level of development in this craft took place among the Tlingit of Alaska, who wove ceremonial blankets and costumes from a weft of wool gathered from mountain goats and a warp composed of finely threaded cedar bark fiber. Women did the weaving but, as they were forbidden to deal in ritual, the abstract decorative patterns were created by men. These typically were painted on wooden pattern boards which the weavers then followed.

In most instances the completed fabric would consist of small, individually woven units, each composed of a stylized representation of animal, human, or deity or a part thereof, generally in blue, black, and yellow, which were then sewn together to make the whole. The weaving technique was a combination of twilling and twining performed on a simple roller-type loom.

These weavings, referred to as Chilkat blankets (the Chilkat were a subgroup of the Tlingit), are of considerable antiquity. An American sailor reported trying (and failing) to buy one in 1791, and one example at Boston's Peabody Museum dates to 1832. With the introduction of commercial woolen blankets which could be reworked and decorated to serve the same purpose, the making of Chilkat blankets gradually ceased, only to be revived in the late twentieth century by native weavers such as Cheryl and Alena Samuel of Victoria, British Columbia. They are among those who carry on the rich tradition.

### Chilkat Blanket

*n.d. Tlingit; dyed and woven mountain sheep wool and cedar-bark fiber. Institute of American Indian Arts Museum, Santa Fe, New Mexico. NW-41.*
A greatly prized product, the Chilkat blanket was 6 feet (1.8 meters) long with an uneven bottom. Supposedly, if one knew how to listen, the faces on the blanket could talk.

43

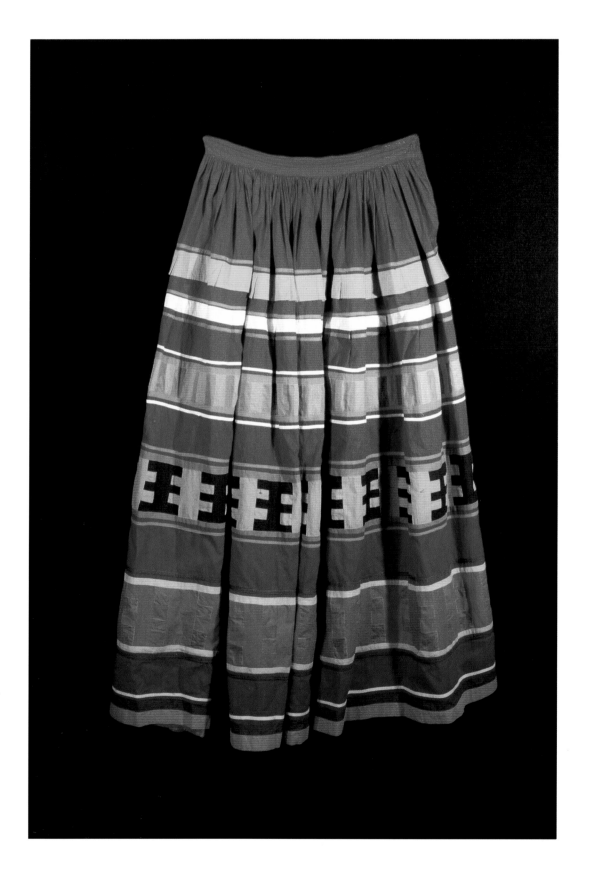

## Woman's Skirt

*modern. Seminole; patchwork and rickrack design of dyed cotton. Institute of American Indian Arts Museum, Santa Fe, New Mexico. SE-14.* Using only scraps of brightly colored fabric, the Seminoles were able to patch together intricate designs.

## Man's Shirt

*modern. Seminole; patchworth and rickrack design of dyed cotton. Institute of the American Indian Arts Museum, Santa Fe, New Mexico, SE-48.* The unique style of clothing developed by the Seminoles was loosely based on European models.

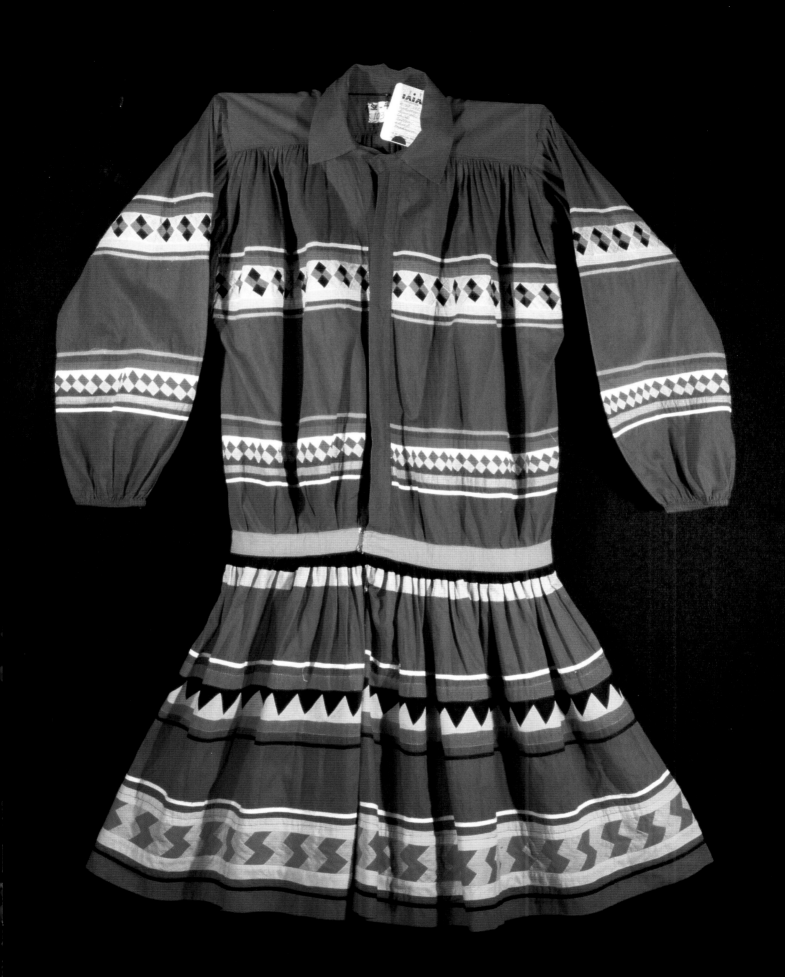

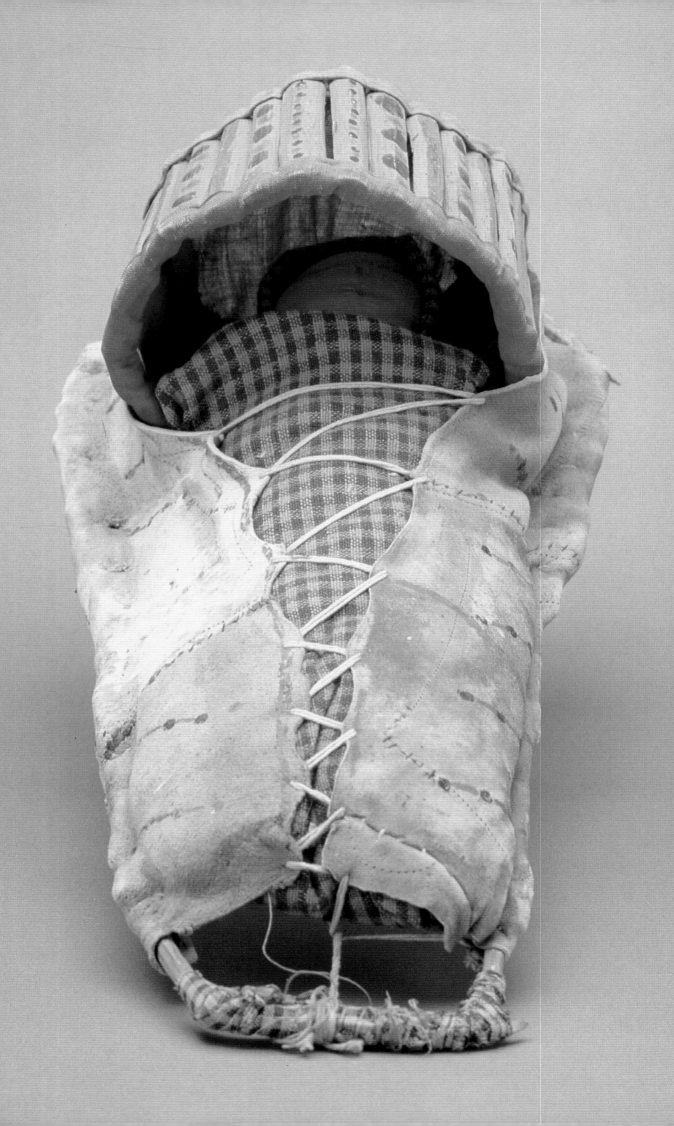

# CHAPTER FOUR

# DOLLS AS TOYS AND RITUAL OBJECTS

**I**n the late 1960s the aged Crow medicine woman Pretty-Shield, in describing her tribal life for the author Frank B. Linderman, noted that as a child

> I tried to be like my mother . . . I carried my doll on my back just as mothers carried their babies; and besides this I had a little teepee that I pitched whenever my aunt pitched hers . . .

That Native Americans made dolls and that their children played with them is hardly surprising; such playthings are almost but not quite (the Kiowa banned dolls for fear that they might come to life and harm their owners) universal.

Settlers arriving in the Northeast found Iroquois girls playing with dolls fashioned from corn shucks, while in other areas carved wood, bone, hide, or baked clay might be the preferred material. Among the sad mementos of the massacre at Wounded Knee Creek in December 1890, were several simple dolls made of deer skin wrapped about roughly shaped sticks.

Very few examples of early Native American dolls have survived, in part because they were so fragile and, also, because their young

owners wherever possible obtained more desirable European examples. As early as 1585 one of the Roanoke Island, Virginia, settlers, John White, could report that the native inhabitants were "greatlye dilighted with puppetts, and babes which were brought oute of England."

Moreover, it is doubtful that doll making was an important aspect of Native American culture until the late nineteenth century when a revival in the craft was spurred by the demand from tourists for examples dressed in appropriate tribal costumes. Thereafter, and continuing to the present day, Native Americans from Maine to Florida and west to Washington State have vied to produce the most appealing (but not always most authentic) examples. Though some of these were undoubtedly owned by Indian and non-Indian children alike, the majority of the finest specimens have become adult collectors' items.

## DOLL MAKING IN THE EASTERN WOODS

The first Native American dolls to attract the attention of collectors were those produced by the Eastern woodland Indians, particularly the Iroquois. While some of these were fashioned from husks of the corn which was their dietary staple, earlier examples were unclothed. By the 1800s garments of deer- or rabbit skin or trade cloth began to appear, and as the tribes adopted certain articles of European-style clothing so did their dolls.

The fragility and artistic limitations inherent in corn shucks led to the use of other materials. The Oneida and Seneca added

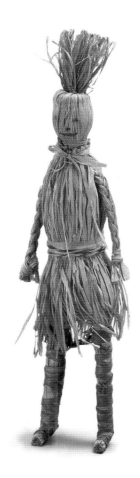

### Indian Doll

*c. 1900–30. Seneca; corn husk and cotton thread. Private collection.*
The Iroquois, and particularly the Seneca tribe, made corn husk dolls which were both playthings and ritual objects designed to encourage agricultural productivity.

### Indian Cradleboard Doll

*c. 1850–75. Blackfeet or Crow; wood, cotton, and deer skin. Strong Museum, Rochester, New York.*
Cradleboards were used by many North American tribes, but those produced by the Plains Indians were frequently the most colorful.

### Indian Doll

*c. 1890. Navajo; leather and muslin with cotton fabric clothing. Brooklyn Children's Museum.*
This doll's costume reflects the impact of non-Native styles on Native American dress, though the form remains traditional.

dried-apple heads, which might be shaped and painted, while other woodlands tribes began to carve heads and rough bodies from wood and embellish them with human or horse hair. The making of cornhusk dolls is a viable cottage industry today among certain tribes, particularly New York State's Mohawk.

## DOLLS FROM SOUTHERN TRIBES

In the South, the Seminole of Florida and the Cherokee of Georgia and the Carolinas produced dolls greatly influenced by contact with settlers. The former quickly adopted the cool cotton garments worn by the settlers, and this change in costume was reflected as well in their dolls, whose palmetto-fiber bodies were clothed in colorful cotton fabrics pieced together in elaborate patchwork designs. This development was facilitated after 1870 by the introduction of sewing machines, which greatly reduced the time spent in sewing.

Cherokee dolls show a marked outside influence. Bodies are of cut and sewn stuffed cloth with painted or embroidered features (the "rag doll" familiar to every pioneer child) while the long cotton gowns and pants and jackets bear a distinct resemblance to mountaineer costume.

The impact of European styles, materials, and methods was felt throughout the continent. In the Southwest, the Navajo—who had previously made dolls of untanned hide, dressed in printed trade cotton and with elaborately styled hair (human, horse, or of thread)—began in the 1860s to produce trade dolls that reflected their interpretation of the clothing worn by the non-Native women present at Fort Sumner, New Mexico, a place of tribal confinement during the period.

Female dolls were clothed in long, brightly colored calico skirts and velveteen blouses while males wore shirts of the same fabric but trousers of drab cotton or buckskin and boots of the same material. Both sexes wore tin and turquoise jewelry reflecting an even more important craft, silver making, which the tribe was developing at the time.

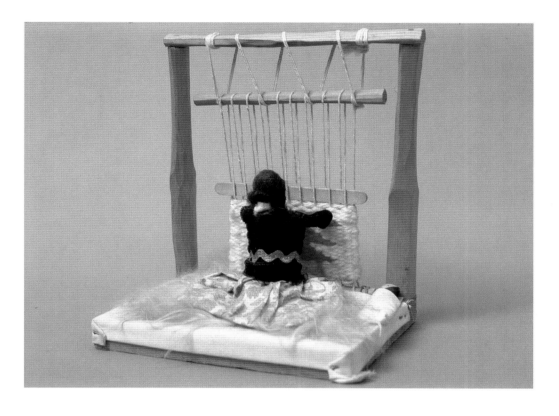

**Indian Weaving Doll**

*c. 1940–50. Navajo; cotton cloth and wool with wooden loom. Private collection.* Made for the tourist trade, these dolls accurately depict the way in which a Navajo rug was woven.

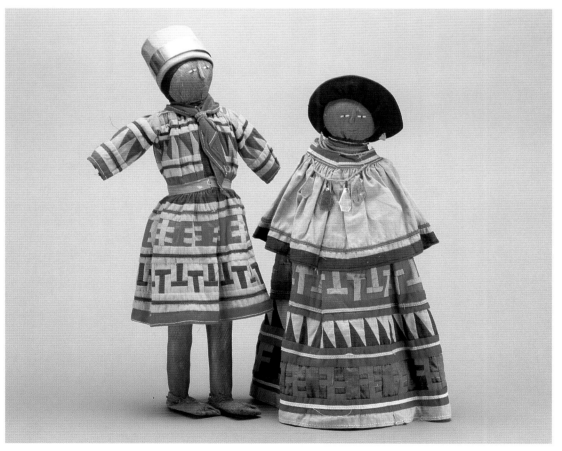

**Indian Dolls**

*c. 1915–25. Seminole; palmetto fiber with cotton clothing. Private collection.* These male and female dolls are garbed in the unique patchwork designs developed by Seminole women in the late nineteenth century.

49

## Indian Doll

*c. 1910–20. Made by Gebruder Heubach, Germany;*
*leather and cloth with trade beads and bisque*
*porcelain head. Strong Museum, Rochester, New York.*
Though made by a European firm,
this doll accurately portrays a turn-of-
the-century Plains Indian woman.

## DOLL MAKING
## IN THE PLAINS

The dolls made by the Plains Indians, such as the Sioux and Cheyenne, were something entirely different. The bison and the deer upon which they depended for sustenance also provided the raw material for doll making. Doll bodies were made of buckskin, with features painted or modeled by stitchwork. Clothing might range from a red trade cloth gown to an elaborate fringed dress of deerskin. A horse, bison, or deer might provide the doll's hair, and before commercial cotton thread became available (around 1850) animal sinew was used in stitchery.

A few existing early Plains Indian dolls wear clothing decorated with flattened and dyed porcupine quills sewn to the material in abstract geometric patterns. This is a traditional form of decoration that lingered well into the nineteenth century.

What most distinguishes the Plains-area dolls, however, is the use of beadwork. Every doll is decorated with some beads and the better examples are literally covered with the same complex beadwork patterns found on adult clothing. As discussed in another chapter, the size and type of beads as well as decorative subject matter and style may be employed to date a doll from this region.

Like other Native American children, Sioux and Cheyenne girls often made their own dolls and, for them, this was the first step in learning the complex beading techniques, which by the 1890s were providing, through sales to outsiders, a substantial part of tribal income. The ethnologist, Frances Denmore, in her *Chippewa Customs* (1929), noted that for a native child "her first lesson in applied beadwork was the decoration of her doll's clothing, straight lines . . . being the easiest patterns from which she progressed to diagonal patterns and the familiar 'otter tail' pattern."

### Indian Doll

*c. 1889. Rosebud Reservation Sioux; muslin*
*with horse hair, glass trade beads, metal "danglers,"*
*and leather. Brooklyn Children's Museum.*
This is an early doll that accurately
portrays Sioux dress of the period.

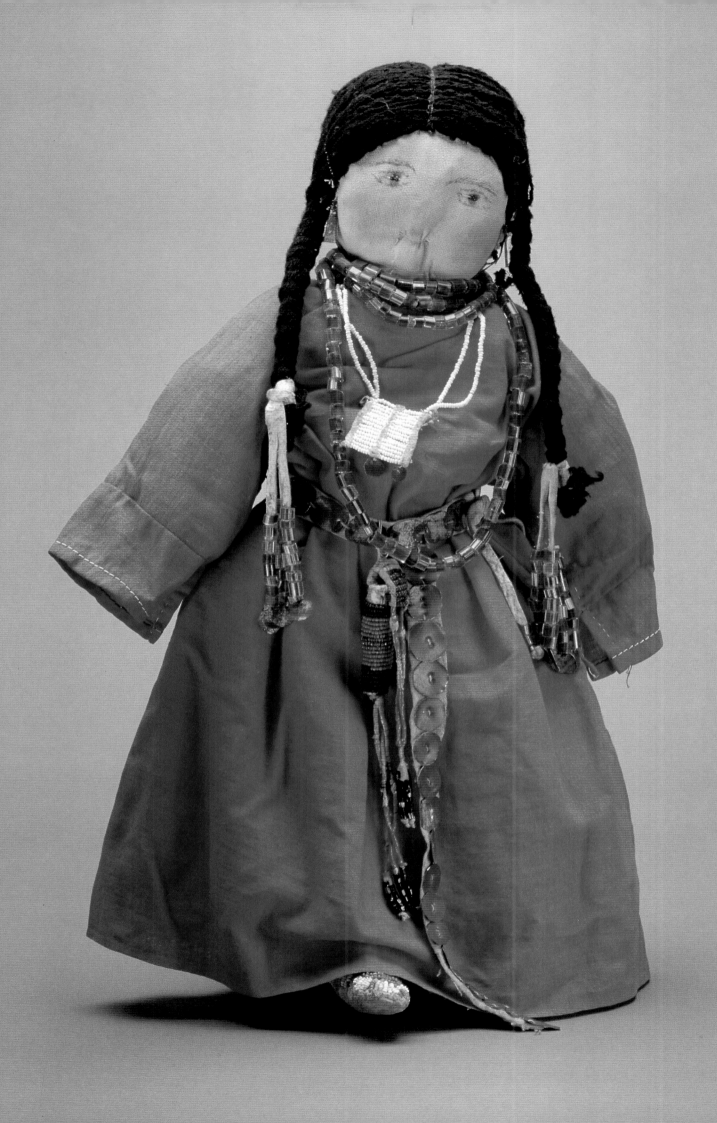

### Inuit Dolls

*c. 1900–10. Inuit, or
Eskimo; seal fur and hide
with carved ivory faces.
Brooklyn Children's Museum.*
Dolls such as these
were made for sale to
tourists as early as the
1850s. Today, legal re-
strictions on the use
of ivory have brought
an end to the trade.

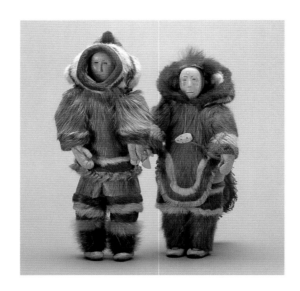

### Kachinas

*c. 1940–60. Hopi; carved and painted cottonwood
with yarn, string, leather, and feathers. Private collection.*
The figure at left is called *Chakwaina Wolf;*
that at right, *Chaveyo.* Both are important
figures in the Hopi pantheon of animal deities.

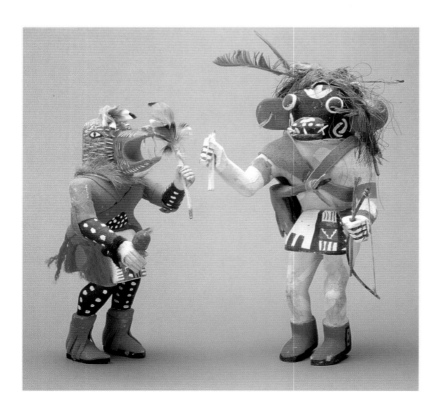

## DOLLS POTTED
## OR PAINTED

In the valley of the lower Colorado River
along the Arizona-California line dwell two
small tribes, the Yuma and the Mohave. Both
make dolls of molded clay, baked in above-
ground fires and then decorated with paint.
Though embellished with trade beads, cotton
cloth, and horsehair, these figures are most
notable for their detailed body painting and
hairstyles which mimic those practiced by
members of the tribes.

Pottery dolls were also made by the Yurok
of Oregon, while other Northwest coast
tribes employed a bewildering variety of
materials including clamshells, steamed and
shaped leather, pebbles hammered into a
rough humanoid shape, and, once available
through trade, cloth to be formed into the
familiar rag doll.

Most of these creations are of more ethno-
graphic than artistic interest, but one form,
the carved and painted "doll" of the Haida of
British Columbia and Tlingit of Alaska, are
among the finest wooden sculptures created
on this continent. Indeed, though often
thought of as dolls by collectors, they were
not created as playthings but as objects of
power—ritual objects with abstract features
and stylized expressions. Among the earliest
(c. 1840) are puppets utilized in seasonal
ceremonies and shamans' dolls with highly
developed faces, hands, and feet; their often
less elaborate bodies were clad in a simple
cloth gown.

## HOPI KACHINAS

The problem of defining exactly what a doll
is has been an age-old one. Doll-like figures
found in ancient Chinese and Egyptian
tombs have long puzzled ethnologists. Are
they religious idols or fetishes, happier sub-
stitutes for former human sacrifices or simply
toys? This obscurity is heightened when, as
with the Northwest coast carvings, non-
Native traders or tourists encourage tradi-
tional carvers to reproduce and alter ritual
objects for a foreign audience.

The most notable example of this confu-
sion has occurred with the Kachina, small
doll-like figures produced by the Hopi of
Arizona, and to a more limited extent by the

Zuni people of the same area. To understand the Kachina it is necessary to perceive its three-fold nature: the term itself, which embodies a limitless number of helpful spirits; their periodic personification in the form of costumed men of the tribe; and the hundreds of small stylized carved representations of these latter. The carvings alone are what collectors commonly refer to as Kachinas or "Kachina Dolls."

All are elements of the Kachina Cult, a system of rituals and beliefs through which the various deities make themselves manifest at certain periods of the year in the form of the costumed impersonators; they watch over the people through the Kachina figures, which are analogous to the religious carvings common in, among others, Catholic churches and Buddhist temples.

While all Hopi and believing Zuni are members of the Kachina Cult, women are excluded from the secret rituals, held in underground chambers termed kivas, and are only observers at the ceremonial dances held periodically from January through July. However, there *is* a place for them in the religious system. The carved and painted Kachinas or Kachin' tihu, made by initiated men, are presented to women throughout their lives to protect and aid them. For example, a barren wife might obtain a fertility Kachina from a male relative and this placed on a cradle board or beneath her waist sash is intended to encourage conception.

At an early stage both boys and girls receive small flat or two-dimensional Kachinas called puchtihu, which are both playthings and learning tools. However, the boys'

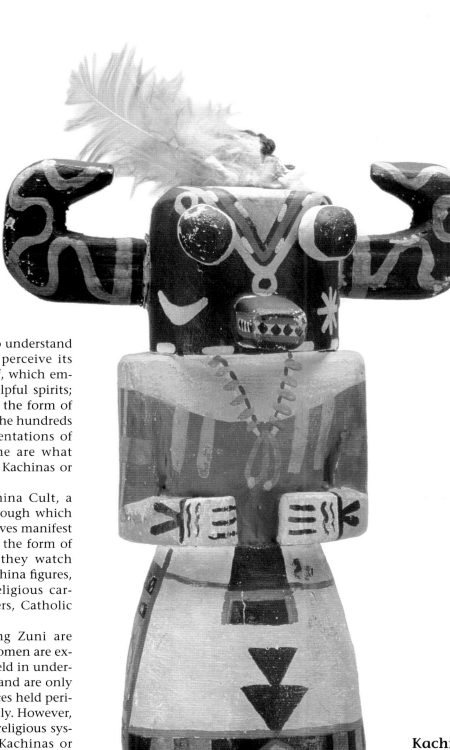

### Kachina

*c. 1930–40. Hopi; carved and painted cottonwood with feathers. Private collection.* This figure, *Sike A Hote*—though sometimes referred to as a "toy"—like other Kachinas is actually a deity figure used in teaching religious practices to children.

53

## Skookum Doll

*c. 1913–20. By Mary
McAboy, Missoula,
Montana; cloth and wood
with Pendelton blanket
and head made from dried
apple. Private collection.*
The earliest Skoo-
kums had dried-apple
heads. Such examples
are rare today.

indoctrination into the cult assures that by the age of seven or eight they can identify many of the important Kachinas, while most women remain largely ignorant of such religious specifics throughout their lives.

The Kachina carvings, of concern here, vary in height from 3 or 4 inches (8–10 centimeters) to a few rare "giants" of 4 or 5 feet (1.2–1.5 meters). Most are less than 1 foot (30 centimeters) tall. If authentic, they are carved from roots of the cottonwood tree. Earlier

examples (one dating to 1857 is known) are quite simple in form with arms folded over the chest, legs scarcely separated, and the barest suggestion of feet. They are painted with natural hues obtained from plants, clays, and metallic ores.

Body paint and the figure's costume, made of leather, hair, shells, metal, and feathers, identified him and his powers to the initiated. Feathers are particularly important as keys to function. A Kachina that brought rain, for example, would wear fluffy plumes from an eagle's breast to encourage cloud formation and the soft rainfall beneficial to crops.

As sacred objects Kachinas are supposed to be protected from nonbelievers, but outside power and persuasion soon resulted in their being made available to traders and collectors, who also provided more satisfactory tempera paints and encouraged the creation of more elaborate figures.

By the 1950s carvers had begun to use acrylic paints, to sign their work (something frowned upon at an earlier time), and to alter the traditional static form of the figurines. These so-called action dolls have a strong appeal to the collector and have resulted in a great expansion of the market for Kachinas. While not so long ago the standard market price for Kachina figurines was one dollar per inch, the work of Hopi artists like Dick Pentawa, Alvin J. Makya, and Willard Saki-estewa, as well as Navajos such as G. Yazzie, may now command prices in the hundreds of dollars. Though still venerated within the Hopi community as religious artifacts, Kachinas have become an important source of income as well.

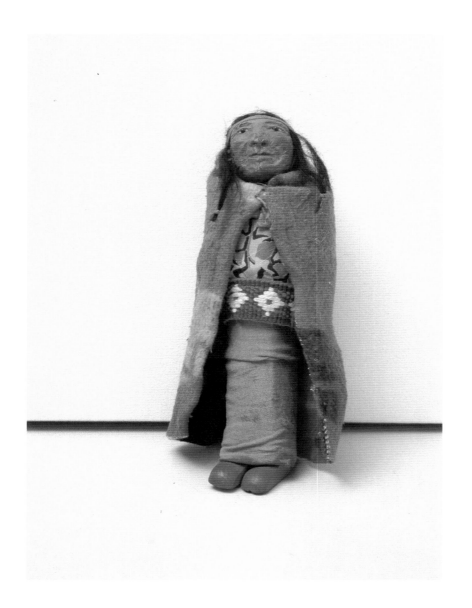

### Skookum Dolls

*c. 1920–30. Designed by Mary McAboy of Missoula, Montana, and
manufactured by H. H. Tammen Co., of Los Angeles; cloth and wood
with composition heads and Pendelton blankets. Private collection.*
Though not made by Native Americans, the Skoo-
kum dolls are extremely popular with collectors.

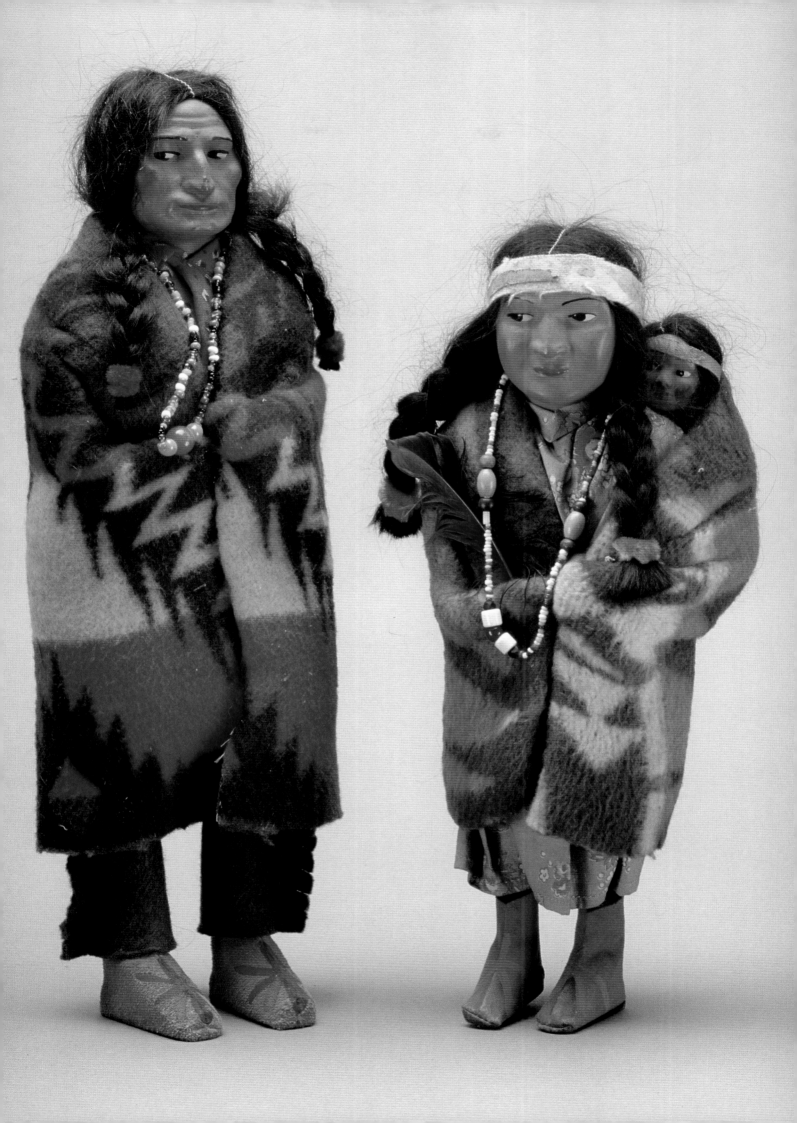

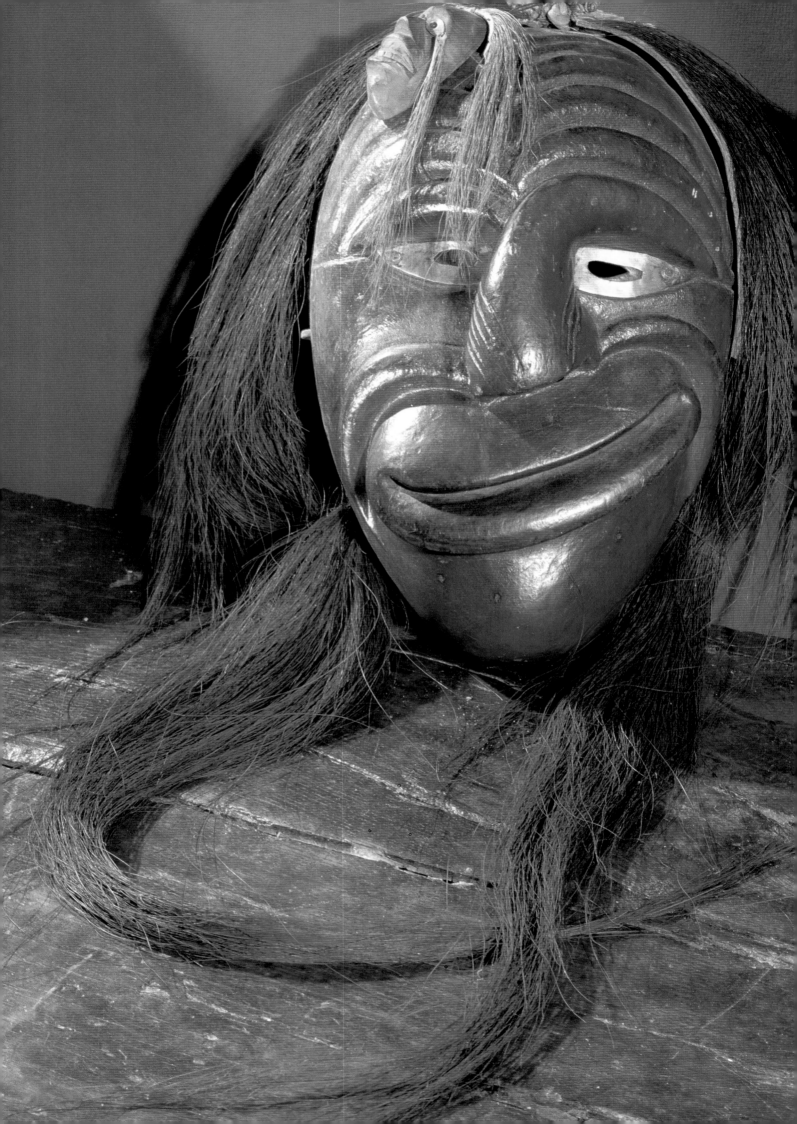

# SCULPTURAL FORMS

Native American sculpture, particularly that produced by Northwest coastal tribes, has long been recognized to be of great artistic quality. Yet, as noted by Frederick Douglas and Rene D'Harnoncourt in their *Indian Art of the United States*, "Fine art in the sense of art for art's sake is a concept that is almost unknown in Indian cultures." Carvings were not purely decorative; they had a specific, usually religious or communal purpose. This is particularly evident in their most ubiquitous form, the mask.

Masks, carved from wood, usually painted and sometimes embellished with feathers, shells, metal, and other materials, were ritual objects of great power thought by wearer and audience to transform one into the deity or animal represented. Masks and the ceremonies associated with them were once probably universal among Native Americans. Traditional usage, however, has ceased except among the Iroquois and Cherokee of the East, the Hopi of the Southwest, and the Northwestern tribes.

## IROQUOIS RITUAL MASKS

The earliest surviving examples are a group of some twenty painted masks excavated in

### False Face Society mask

*c. 1870–1900. Iroquois; carved and painted pine with horse hair. Werner Forman Archive.*
Shaped to represent supernatural beings, these masks were worn at ceremonies designed to insure good harvests and ward off natural disasters.

1896 from a Key Marco, Florida, swamp where they had lain since the fifteenth century. Attributed to the long extinct Calusa tribe, these are more realistic in nature than the majority of ritual masks, including not only human features but also likenesses of deer, alligators, and wolves.

While the Calusa are long gone and one can only guess at the events their masks witnessed, among the Iroquois of central New York and Canada, the mask maintains its place as central to shamanistic "false face" rites designed to cure and purify. The first Europeans to penetrate the area in the sixteenth century found the Huron carving such ritual face coverings, and the ancient tradition continues today, particularly among the Cayuga, Seneca, and Onondaga.

Unlike those of the Calusa, Iroquois masks are highly stylized. Carved of basswood, maple, or pine, their twisted features appear as caricatures to the uninitiated, though they are instantly recognizable to believers. In theory, since the features of such a mask may come to its maker in a dream, there is an unlimited repertory; in fact, the general categories are well defined, often by the appearance of the mouth. These include the crooked, spoon-lipped, straight-lipped, hanging, and smiling mouths as well as the whistler and the mouth with protruding tongue. There are also divided masks painted red and black or black and white to reflect a spirit's dual nature, as well as a variety of masks designed to cure specific illnesses like smallpox or syphilis.

Form and painted decoration may often denote a mask's purpose. For example, the

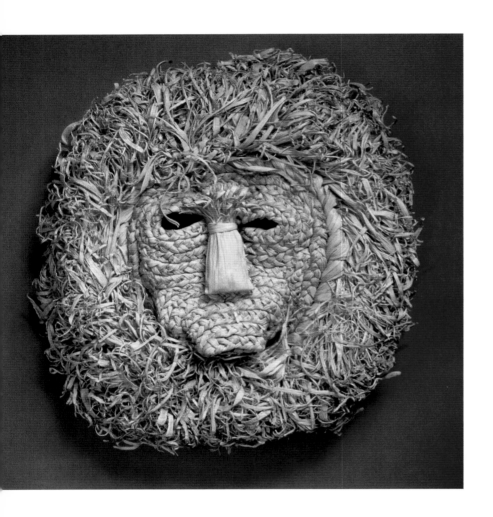

### Cornhusk Mask

*c. 1900–30. Seneca;*
*braided corn husk fiber.*
*Private collection.*
These masks are worn by members of the Husk Face Society at the midwinter festivals designed to insure abundant crops and ward off illness.

spoon-lip mask was worn by one who would symbolically blow curing ashes upon the ill. However, the mask would also appear at the tribal Midwinter Ceremony assisting in the ritual purification to ward off illness, evil, and deprivation.

Iroquois masks do not represent deities to be worshipped (unlike the Hopi and Zuni) but rather benign pastoral spirits which can aid the tribe's members but which are also dependent upon them for the tobacco and corn meal mush that they crave and cannot obtain on their own.

Corn is the basis of the second form of Iroquois mask, the gad-jeesa or husk face. Unlike the false faces, which are by tradition carved only by men, the husk masks are braided from

corn husks by the women of the community, who also own and work the tribal fields.

The Corn Husk Mask Society with which they are associated is open to both men and women (an extremely unusual occurrence in Native American society); and its members, in conjunction with the False Face Society, take part in the seasonal curing and purification rites. Also, in their role as agricultural and fertility spirits (in some legends they are credited with bringing corn to the Iroquois), the wearers minister to the sick.

Both carved-wood and corn-husk masks may be made either for community use or for sale to outsiders. In the former case, consecrated through ritual and fed with tobacco, they are considered to be objects of power, passed down from generation to generation or buried with their owners. In the latter instance, they are merely something to be sold, like Iroquois baskets, to tourists or collectors.

### CHEROKEE BOOGER MASKS

Though those Cherokee of North Carolina who avoided deportation to Oklahoma in the nineteenth century also carve masks, theirs are for a different purpose. These distant relatives of the Iroquois produce the so-called Booger Masks , relatively crude and naturalistic representations of either Indians or non-Indians which are used in the midwinter Booger or Bugah dance. Rather than religious, they are designed to ward off the malevolent influence of outsiders.

Characteristic of the dance's purpose is its central figure: a warrior with a coiled rattlesnake resting on his head who is termed, alternatively, "Angry" or "Apprehensive" Indian. The goal of the dance and the masks is to neutralize through satiric skits those things like illness and outside influences which are beyond tribal control.

### KACHINA MASKS

Though other masklike objects—carved from stone or large shells—have been found throughout the Southeast, their purpose

remains unknown; and it is to the Southwest that we must look for the next major mask-making society. The Kachina Cult established by the fourteenth century among the pueblo-dwelling Hopi and Zuni of Arizona is based on a belief that spirits from the underworld, the tribal dead, clouds, rain, and various aspects of their agricultural life appear among them at the several seasonal ceremonies embodied through costumed male cult members.

The actors in these religious rituals are dressed according to the Kachina they represent, and for many (though not all) the most dramatic aspect of their appearance is a large and elaborate mask. These rely more on painting and decoration—with feathers, hair, shells, seeds, and other vegetable substances—than they do on carving; and their appearance is often more fantastic than dramatically sculptural, as is the case with Iroquois and Northwest coast masks.

The Hopi and Zuni have, for religious reasons, been reluctant to either relinquish their Kachina Cult masks to outsiders or reproduce them for sale to tourists. As a consequence older examples, especially, are seldom seen outside museum collections.

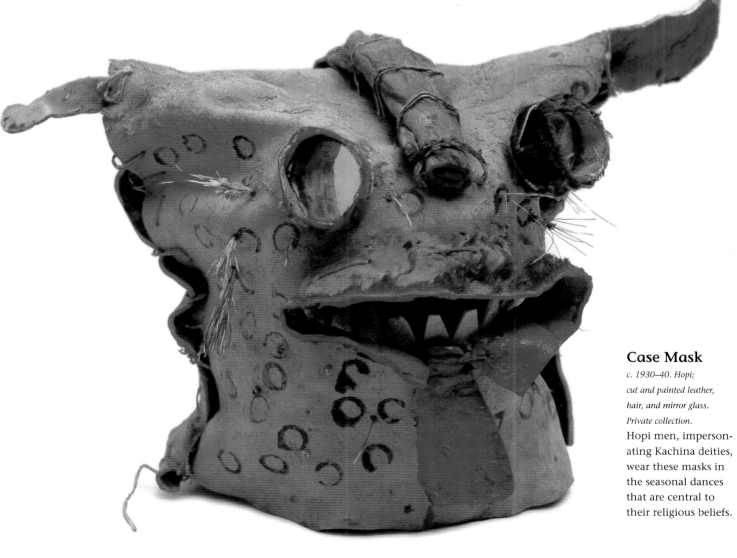

### Case Mask

*c. 1930–40. Hopi;*
*cut and painted leather,*
*hair, and mirror glass.*
*Private collection.*
Hopi men, impersonating Kachina deities, wear these masks in the seasonal dances that are central to their religious beliefs.

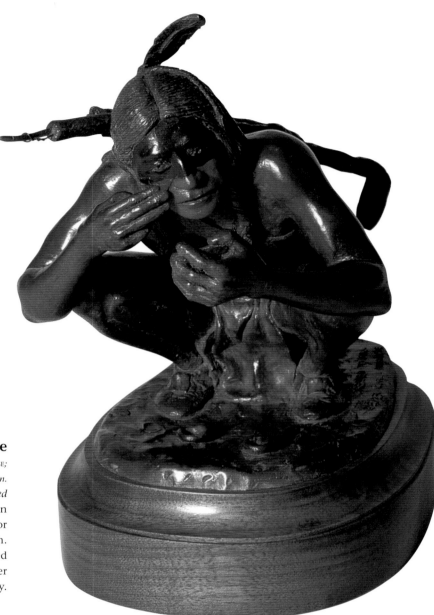

## Sculpture

*1978.* CARL PUGLIESE;
*cast bronze. Private collection.*
This work, entitled *Dressed to Kill*, portrays an Indian warrior painting his face prior to taking to the warpath. Facial paint was designed both to protect the wearer and to frighten the enemy.

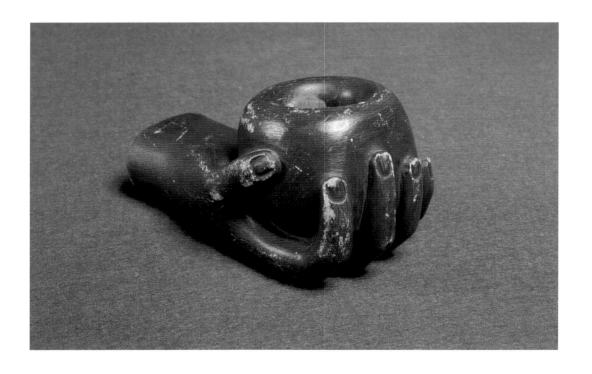

## Pipe Bowl

*c. 1860–80. Oglala Sioux; carved catlinite. Private collection.*
Tobacco smoking was regarded as a sacred ritual by Native Americans, and was required to mark an important occasion; each male had his own pipe with hand-carved bowl and stem.

## War Club

*c. 1920–40. MicMac or Penobscot; carved and gilded tree root. Private collection.*
At one time used in combat, such clublike effigy sculptures have for some time been made for sale to tourists.

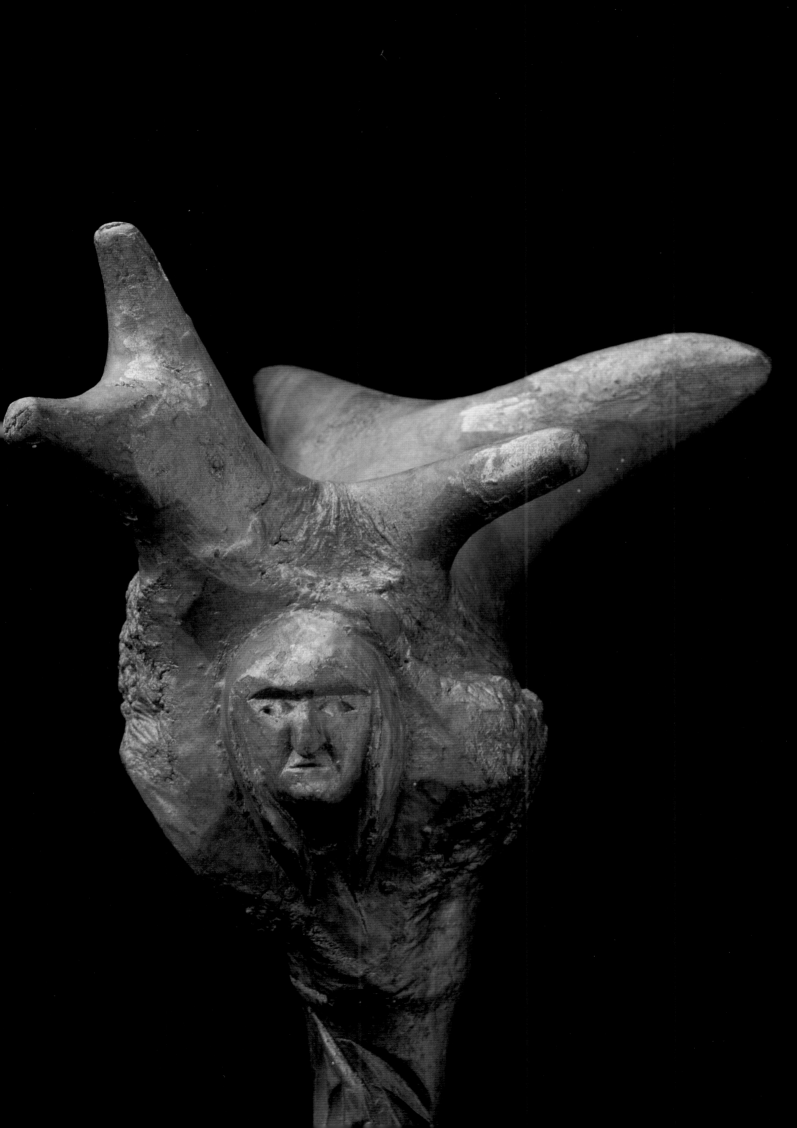

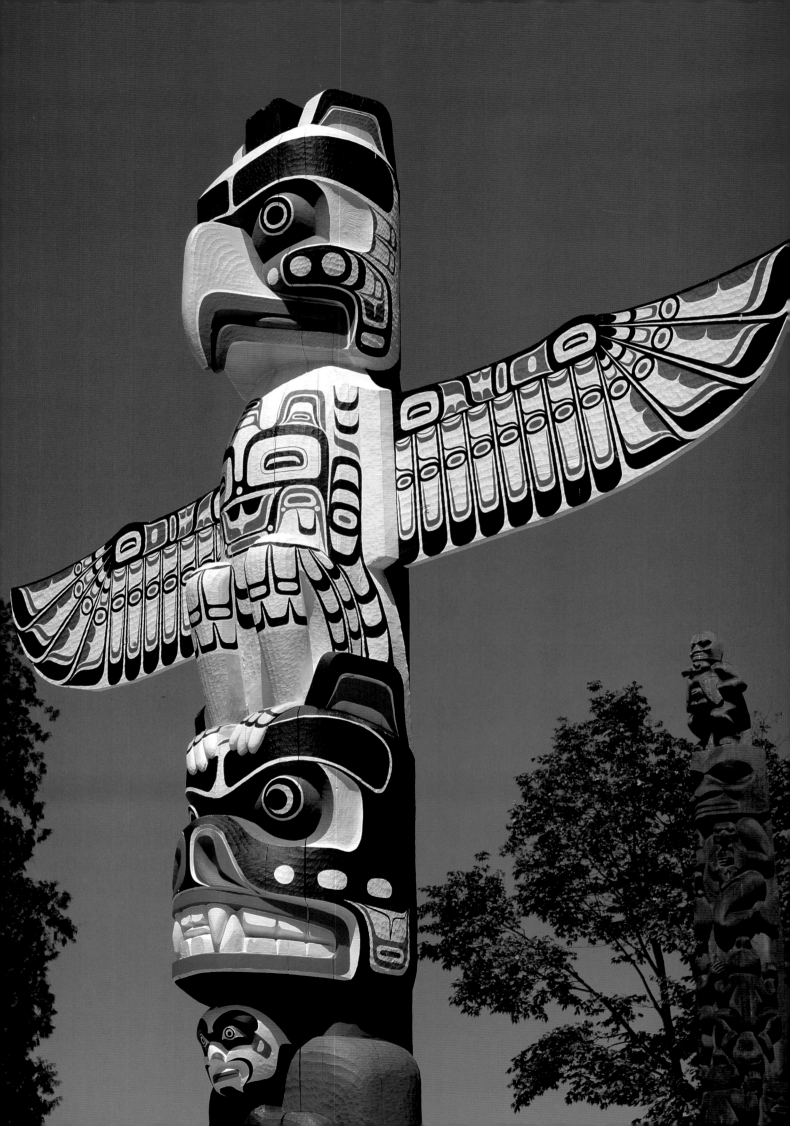

## MASKS AND TOTEMS OF THE NORTHWEST COAST

Such cultural exclusivity has never been the case with the great sculptors of the Pacific Coast, who as early as the 1860s were carving masks and numerous other objects for sale to foreign traders and visitors.

Among tribes such as the Tlingit, Haida, Kwakiutl, Salish, and Tsimshian, whose territory stretched from Washington to Alaska, mask carving was not an art separate from but part and parcel of an elaborate sculptural tradition embracing everything from gigantic totem poles to tiny amulets and charms.

Nor was their function exclusively religious. Within this wealthy, highly stratified society, masks were a symbol of social status. The right to carve or own them was a prerogative of the exalted few who could claim an ancestor that had conquered or befriended a dangerous or helpful beast or supernatural foe, and the masks were worn by performers who reenacted in song and dance this historic event.

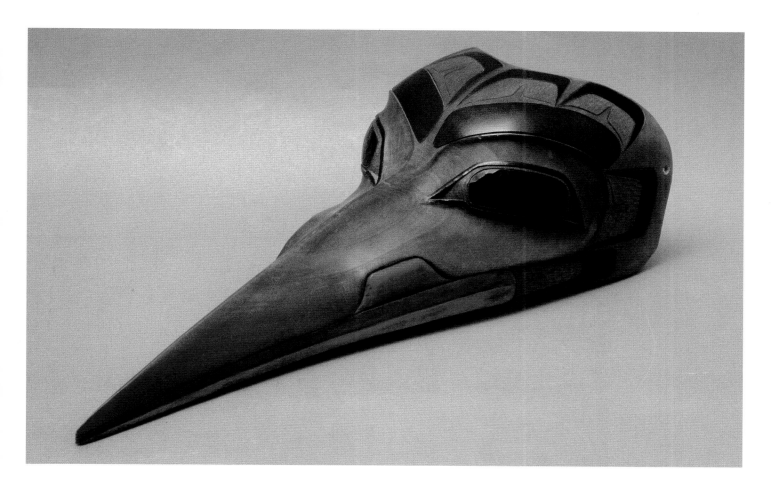

### Totem Pole

*c. 1880–1910. Haida; carved and painted cedar tree trunk. Private collection.*
Totem poles, erected before the homes of prominent members of Northwest Coast tribes, were not true religious icons but rather visual family histories upon which were recited family lineages and their sacred protectors.

### Dance Mask

*c. 1970–80.* FRANCIO HOME, *Alaska; carved and painted cedar. Private collection.*
This mask is designed to represent the mosquito, an insect and totem with power far exceeding its minuscule size.

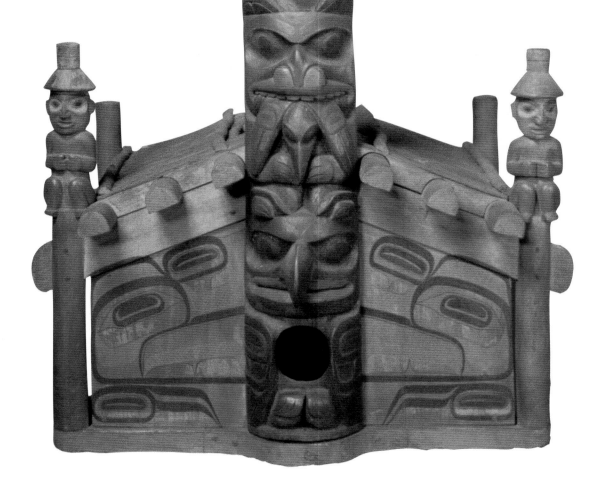

## Model House and Totem Pole

*c. 1890–1910. Haida;
carved and painted cedar.
Private collection.*
Great totem poles,
reciting the family lin-
eage, dominated the
entrances to homes in
the Northwest. The
hole in the pole's base
was also the house's
entrance and reflected
a belief that in ancient
times the people
emerged from a
hole in the earth.

Unlike elsewhere, the Pacific carving tradi-
tion seems also to have flowered late and to
have been greatly abetted by settlers and
traders. The first of these, arriving in the last
quarter of the eighteenth century, found the
Native Americans painting their house posts,
ridge crests, and canoes with natural colors
but mention little about sculpture.

By the mid nineteenth century, however, a
complex sculptural tradition had developed
based both on the new availability of settler-
supplied iron and steel carving tools and the
great riches accruing to chiefs and shamans
through the burgeoning fur trade. Much of
this wealth was spent on the traditional pot-
latch, a ceremony through which a digni-
tary acquired greater prestige by giving
away or destroying valuable items. This ritual
required a vast quantity of precious objects,

## Detail of Speaker's Staff or Talking Stick

*c. 1970–80.* JOE DAVID,
*Nootka; carved and painted
cedar. Private collection.*
Such staffs are carried
by chiefs, shamans,
and other dignitaries at
ceremonial functions.

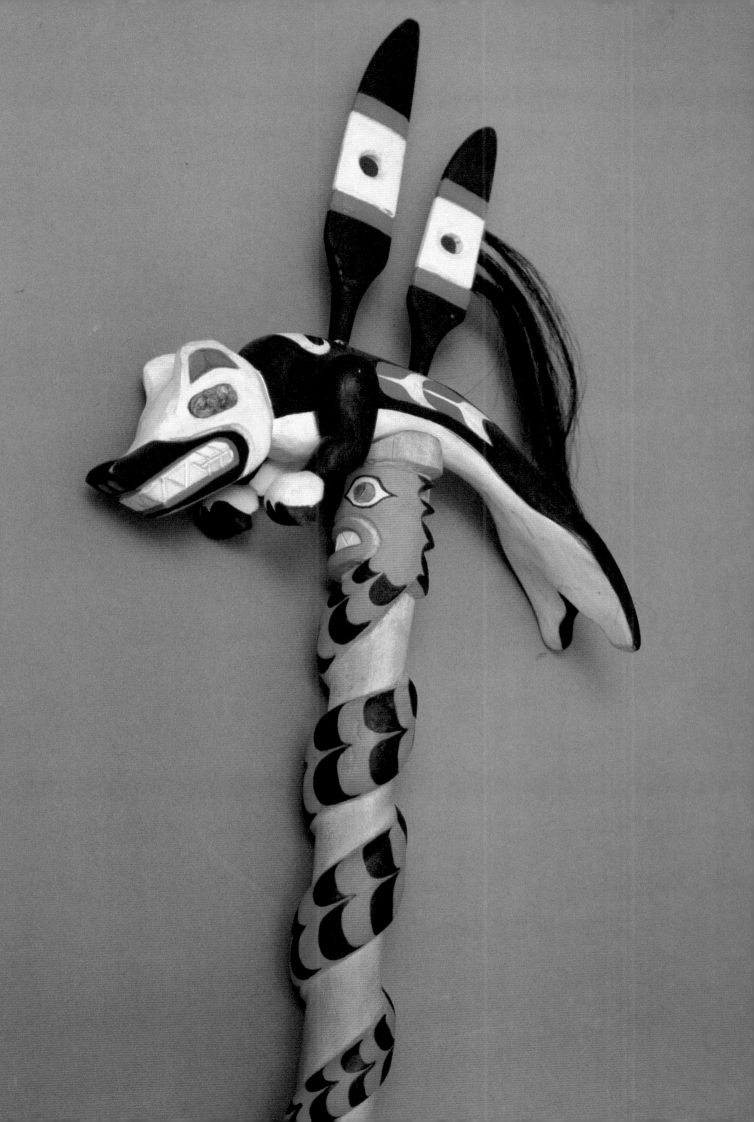

## Dance Mask

*c. 1880–1900. Bella Coola;
carved and painted cedar
with shredded cedar bark
and cotton cloth.
Private collection.*
Because of its great
size, speed on the
wing, and keen
eyesight, the eagle
was regarded by
coastal tribes as a
powerful totem.

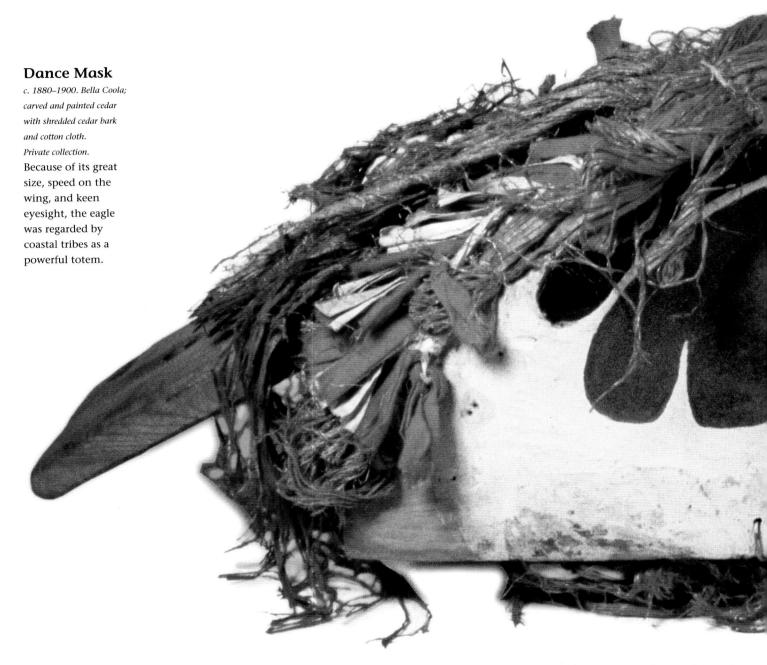

many of which were sculptural in nature, and led to the proliferation of a class of skilled artist-suppliers.

These men developed a unique artistic style in their use of abstract symbolism. The subject matter—spirits, humans, or familiar animals—was common to many Native Americans, but the treatment was distinct. Subjects were rarely depicted in their entirety but rather were reduced to conventional or shorthand representations within a unified field.

The beaver was identified by its large teeth, the bear by its great claws, the eagle by its curving beak. The animal might be viewed from several angles in the same composition, when, for instance, picturing both sides as though splayed for drying; these details would be outlined in heavy black borders, termed "form-lines" by art historians, creating an overall design. In this composition S-forms might denote bodies, U-form curves, bird feathers or animal ears and ovals eyes or joints, while similar shapes might bind the entire work together. Color, primarily black and red, augmented carving,

and seen as a whole the composition has an astonishing unity.

The earliest of these sculptures seem to have been house-front poles, more commonly termed "totem poles." As tall as 60 feet (18.3 meters), they were erected to honor deceased chieftains and often embodied a family's sacred history. They were always carved from the indigenous cedar tree as were most other Northwestern coast figures. Today, miniature or "model" totem poles are among the most popular tourist items offered by the tribes.

Masks were also developed early, perhaps arising from the carved and painted wooden helmets used as far back as the early 1800s in intertribal warfare, related to the conical clan hats which were frequently inlayed in abalone shell and surmounted with an effigy of the family totem. Some of these were articulated (a Raven Clan hat had wings which could be flapped by pulling a string) while others had a long spike on which woven rings, signifying the number of potlatches the owner had given, could be stacked. Another prerogative of the wealthy was the

carved, painted, and abalone-inlaid frontlet or forehead mask, of which the right to wear was inherited from the maternal line. Unlike most indicia of office, these could be worn by women of the proper lineage.

In addition, there were the fully developed carvings, such as elongated, skeletonized figures, bearing a remarkable resemblance to Polynesian work, made as grave markers by the Salish, and the carved, life-size human figures representing chiefs or their speakers (formal representatives), which the Kwakiutl displayed on roof tops or within the family lodge at potlatch time. Finally, black slate or argillite was used by the Haida in small human and animal sculptures sold to tourists.

## ANCIENT NATIVE SCULPTURE

While no body of Native American sculpture can equal that produced on the Northwest coast, it is evident that a tradition of figural sculpture once existed widely throughout North America. Among the few examples that have survived the ravages of time are the stone images of ancient dignitaries which have been excavated from burial mounds in Georgia and Tennessee. Often showing traces of red and black pigment, these are sometimes found enclosed in boxlike stone compartments and are thought to represent deceased chieftains and their wives.

Better known are the realistically carved stone birds, animals, and humans associated with what is often termed the culture of the Mound Builders, for the tendency of these diverse peoples to erect large earthen mounds for burial or ritual use. Though centered in Ohio, traces of this culture were found in surrounding states, and archaeological evidence indicates that mounds were still being built when the first foreigners reached the area. Yet little is known of these sculptors. Unlike the Iroquois and the coastal tribes of the Northwest, they were unable to perpetuate either themselves or their art.

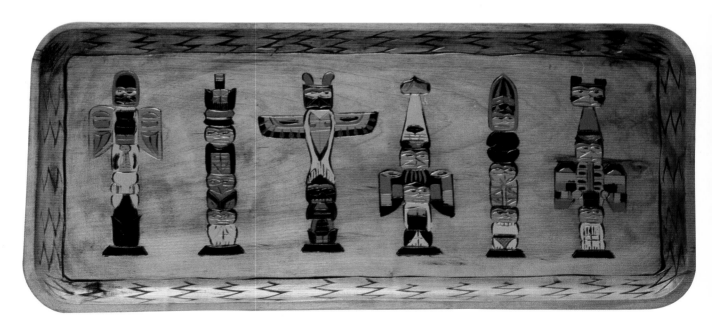

### Tray

*c. 1940–60. Haida; carved and*
*painted cedar. Private collection.*
Adorned with various totemic figures, this tray was made for sale to tourists. It bears little resemblance to traditional Northwest Coast dining utensils.

### Group of Model Totem Poles

*c. 1900–40. Northwest Coast; carved and painted cedar. Author's collection.*
Model totem poles, mimicking the larger examples, have been made for sale to tourists by all Northwest coastal tribes for over a century.

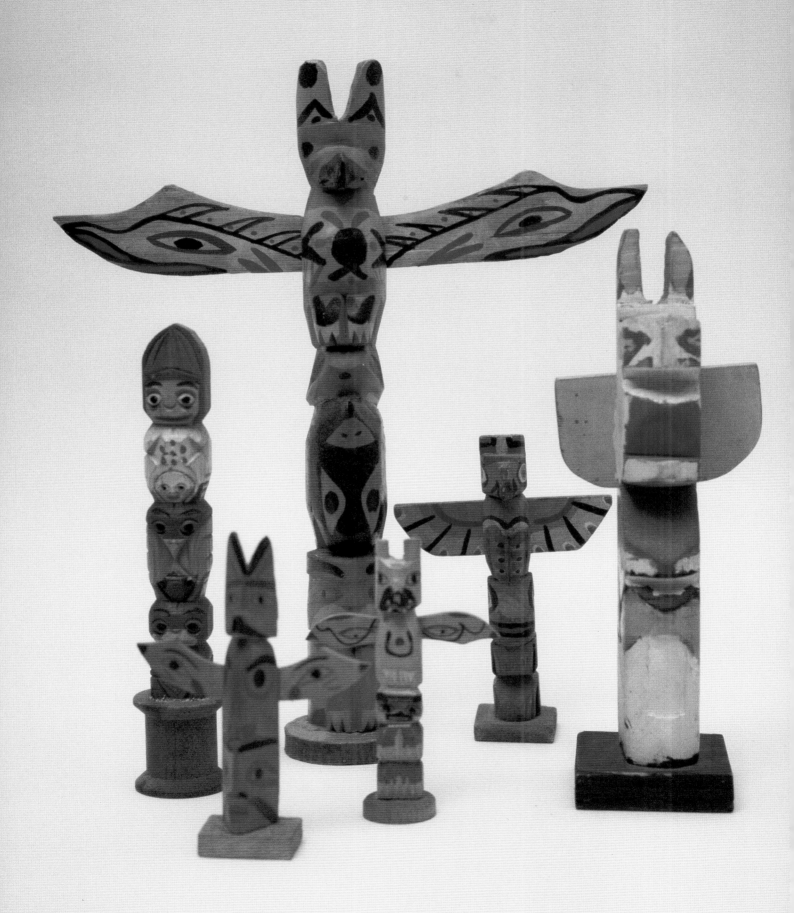

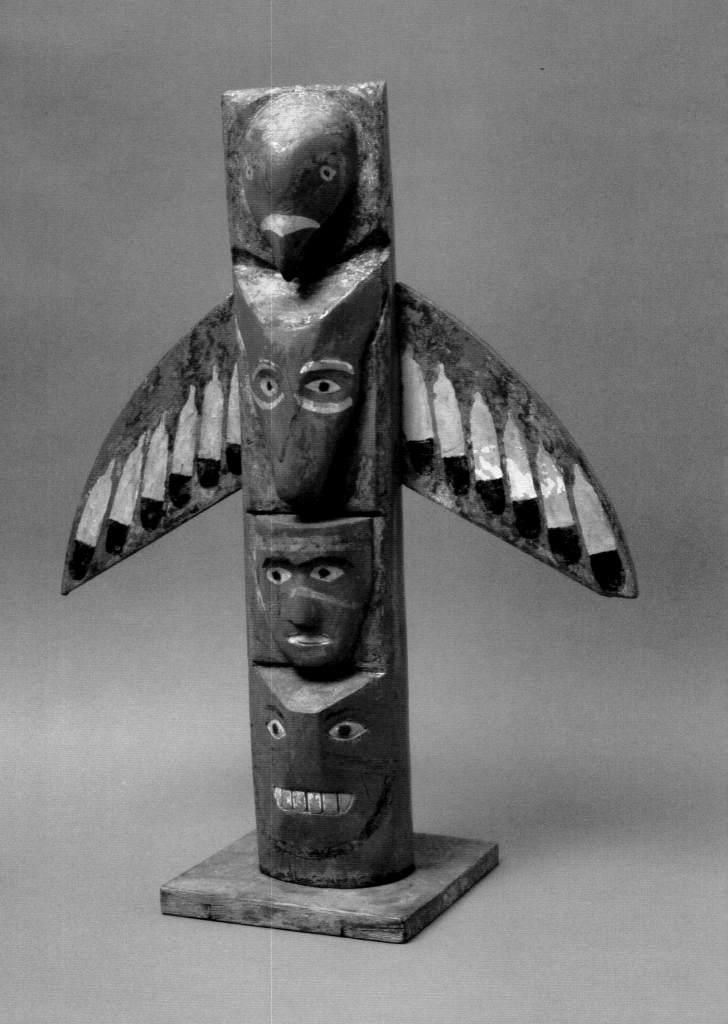

## Shaman's Rattle

*c. 1950–70. Haida; carved and painted cedar. Private collection.*
This rattle, in the form of a raven regarded as a supernatural counselor, was used in religious rituals and curing ceremonies.

## Shaman's Rattle

*c. 1900–30. Tlingit; carved and painted cedar. Private collection.*
Depicting the sacred sparrow hawk, this rattle was filled with seeds so that the sound might arouse the shaman's supernatural allies.

## Model Totem Pole

*c. 1920–50. Northwest coastal tribes; carved and painted cedar. Private collection.*
This piece was found in Seattle and, due to a similarity in carving, it could be attributed to any one of several tribal groups.

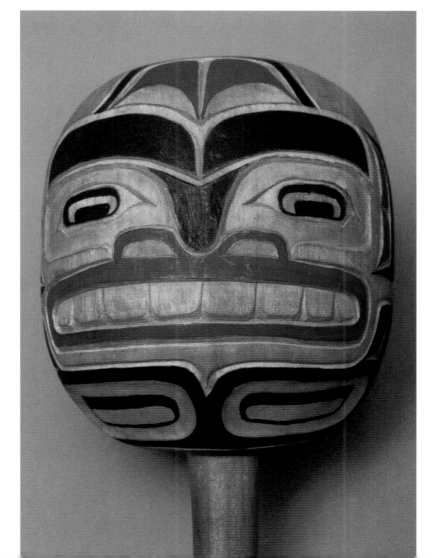

*FOLLOWING PAGE:*
## Eagle Dance Mask

*c. 1970–80. PETER MOON, Kingcome Inlet, British Columbia; carved and painted cedar with shredded cedar bark. Private collection.*
Contemporary Indian artists are continuing the great Northwest Coast sculptural tradition.

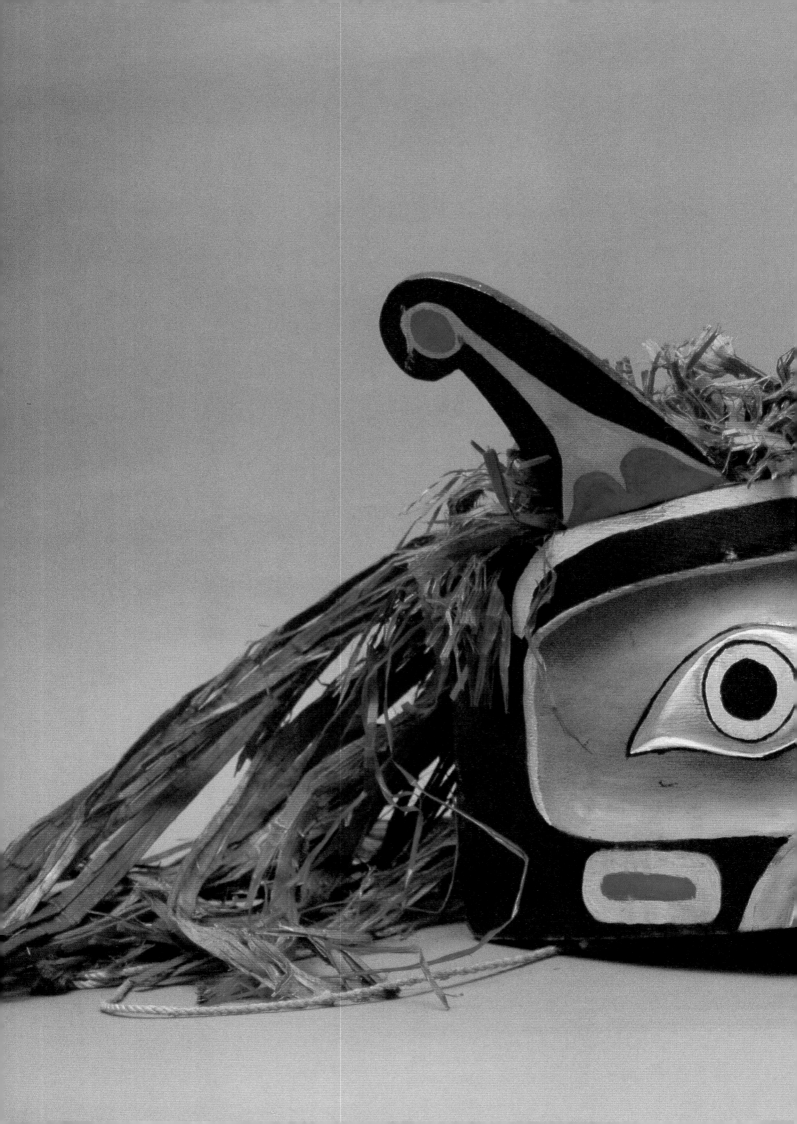

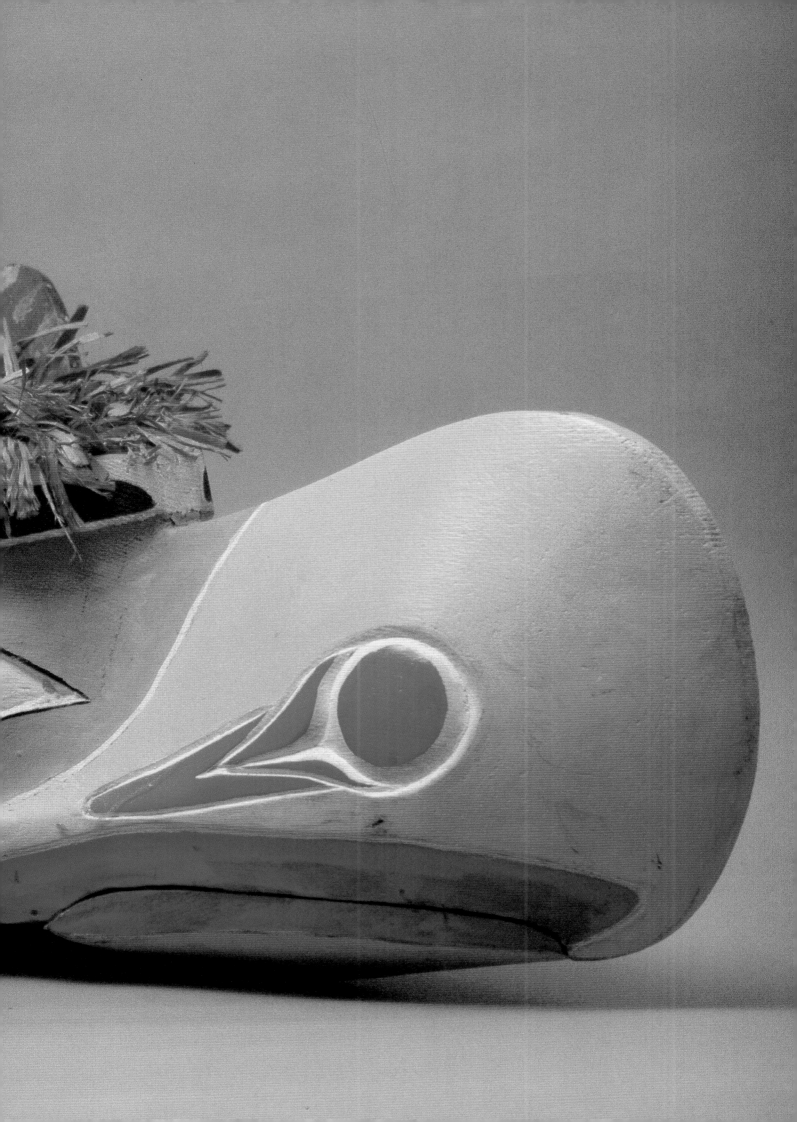

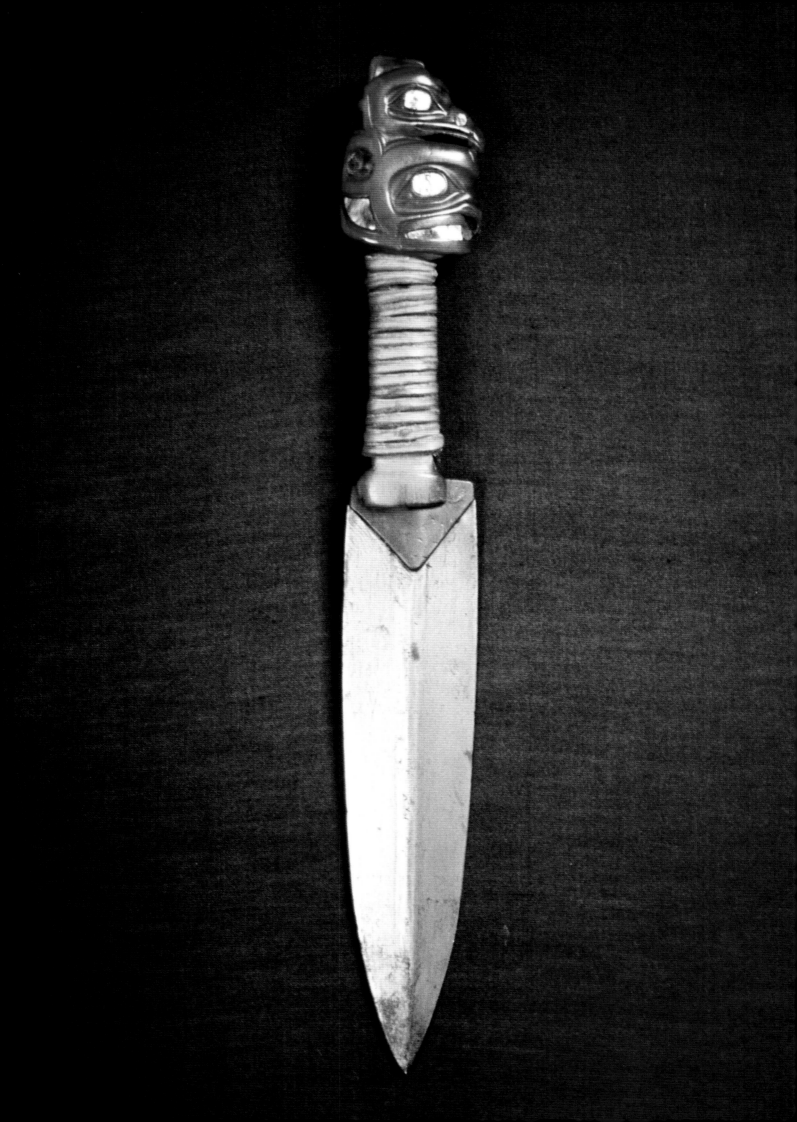

# COMMUNITY ARTS: HOUSEHOLD AND HUNT

**T**hough they managed with far less than we, Native Americans had a surprisingly wide variety of household implements, weapons, and even musical instruments. Many of these were purely functional and not particularly attractive. In instances where domestic craft reached the level of fine art, the pieces involved were usually those that had a dual purpose—as useful object and ritual icon.

What is now referred to by some as the "material culture" of North American Indians was (excluding basketry, pottery, and textiles discussed elsewhere) manufactured primarily from wood, stone, bone, and, rarely, metals. Since only stone survives indefinitely, much of this heritage has disappeared. Only on the Northwest coast can we obtain a clear picture of the great number of household objects which once must have graced many Native American communities.

## MATERIAL CULTURE OF THE NORTHWEST COAST

The Tlingit, Haida, and other groups inhabiting the area from Washington north into Alaska were unique in several ways. They were not intruded upon by foreign cultures until late in the eighteenth century; a benign climate and rich resources allowed them to devote much of their time to activities other than food gathering; and their animistic religion incorporated rituals such as the potlatch ceremony, which required a large number of finely decorated vessels and implements.

Most Northwest coast food bowls were carved from a solid block of alder wood, often in the shape of a totemic animal—bear, frog, or a bird such as the raven—and inlaid with white operculum shells. Other bowls as well as large ladles and smaller eating spoons were shaped from black goat or yellow mountain-sheep horn, which was carved with the same form line designs seen on totem poles. Maple was also employed in spoon making, particularly after 1850 when both spoons and forks (the latter previously unknown to the area) were carved in great numbers for sale to tourists. Unique bowls and large storage boxes of cedar were made by steaming and bending a single plank into a square or oblong shape, pining a bottom to it, and covering the top and sides with elaborate carved and painted totemic images.

Even the most ordinary objects became things of beauty. A wood and metal halibut hook was made in the shape of a god thought to favor fishermen. A young woman's wooden comb was surmounted with a complex representation of the bear deity, while a simple hand adze with metal or stone blade included a handle wrought in bird or animal form.

Stone, more durable but harder to work than wood, was less widely used. Massive food-grinding mortars in the form of stylized beaver heads might have pestles of human form; and, before glass was available, a mirror could be improvised from polished slate. Best known today of the stone products are the

## Fighting Knife

*c. 1870–90. Tlingit; steel and copper shaft, and carved wooden handle inlaid with abalone shell. Museum of the American Indian, New York.* Northwest Coast tribes produced some of the finest sculptural forms found on the North American continent.

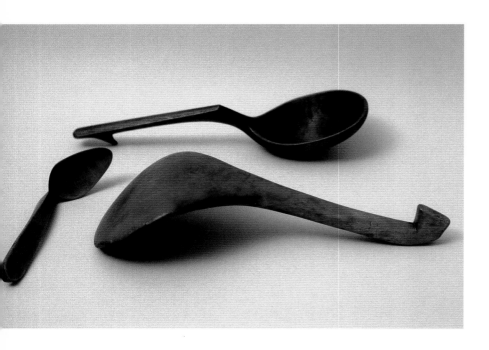

## Eating Spoons

*c. 1860–80. Eastern woodlands Indians; carved birch, maple, and pine. Private collection.*

All Native Americans produced cooking and eating utensils from wood, bone, or horn. Like these, most are plain; however, some are shaped in human or animal forms.

black slate or argillite platters and covered serving dishes made by the Haida for sale to tourists. Often carved in fantastic bird, fish, or other animal shapes, they were not used within the native community.

## OBJECTS FROM THE CALIFORNIA COAST

Little has survived from the nomadic tribes that lived farther south along the California coast. They shaped useful objects from bone, shell, and wood, but their domestic art never reached the level of that produced by their northern neighbors. Most attractive of their surviving wares are large round storage jars carved from soapstone and inlaid with bits of shell. The form most ubiquitous to the area is the ovoid or donut-shaped mortar of sandstone or lava which was used with a tubular pestle of the same material to grind acorns.

Wooden objects from this region are scarce. There are interesting carved wooden mush paddles from northern California which somewhat resemble canoe paddles and were used for stirring soups and stews as they cooked, while earlier records also speak of carved and decorated wooden bowls and of

fish hooks cleverly contrived from wood and abalone shell.

## EASTERN INDIAN WARES

In the East the great wood carvers are to be found among the Algonquin and Iroquois of New England and New York. Using abundant supplies of fine-grained maple and birch as well as burl, they wrought a variety of wooden receptacles for cooking and food storage. Particularly sought after today are bowls made from burl—the large insect-produced lumps seen on ash and hickory trees, which have a convoluted grain making them close to unbreakable as well as very attractive when polished. Native American carvers would cut off the burls, burn out their interiors, and carefully finish the hulls to produce dishes for both secular and ceremonial use. Traditionally, the carvers were men and the vessels were often intended as gifts for their wives or other female relatives.

Though early settlers were captivated by these "dainty wooden bowls," few survive today. Many were lost or destroyed during the numerous Indian Wars, or, as one colonial source reports, supposedly burned for fuel by owners so stricken by disease during the seventeenth-century small pox epidemics that they could not go out to gather fire wood.

To carve these vessels, as well as various eating plates, ladles, and spoons, the Eastern Indians devised a tool, the "crooked knife," which itself was something of a work of art, particularly among the Penobscot and Passamaquoddy of Maine and New Brunswick. The handles of these short, curved blades often terminate in human or animal heads, hands, or whole figures, and they are often painted or inlaid in bone or metal.

## Maple Sugar Mold

*c. 1880–1920. Penobscot; carved pine. Private collection.*
Though they had long made maple syrup and sugar, the Northeastern tribes learned the molding of sugar cubes from non-Native settlers.

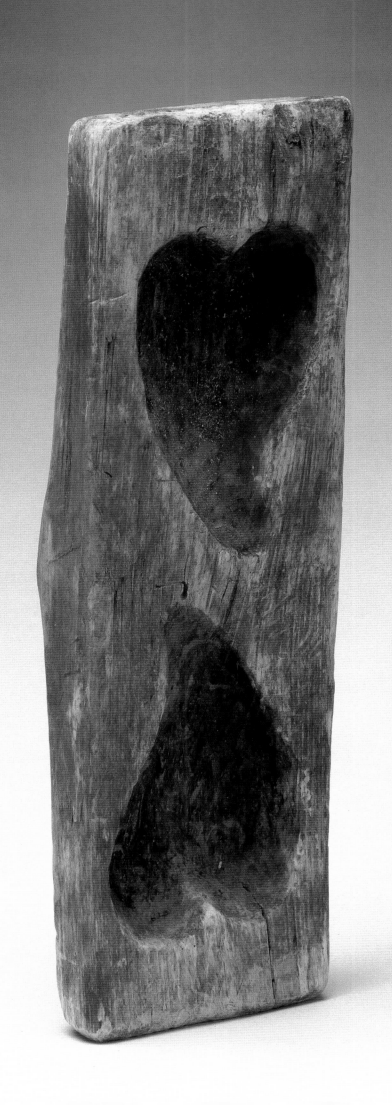

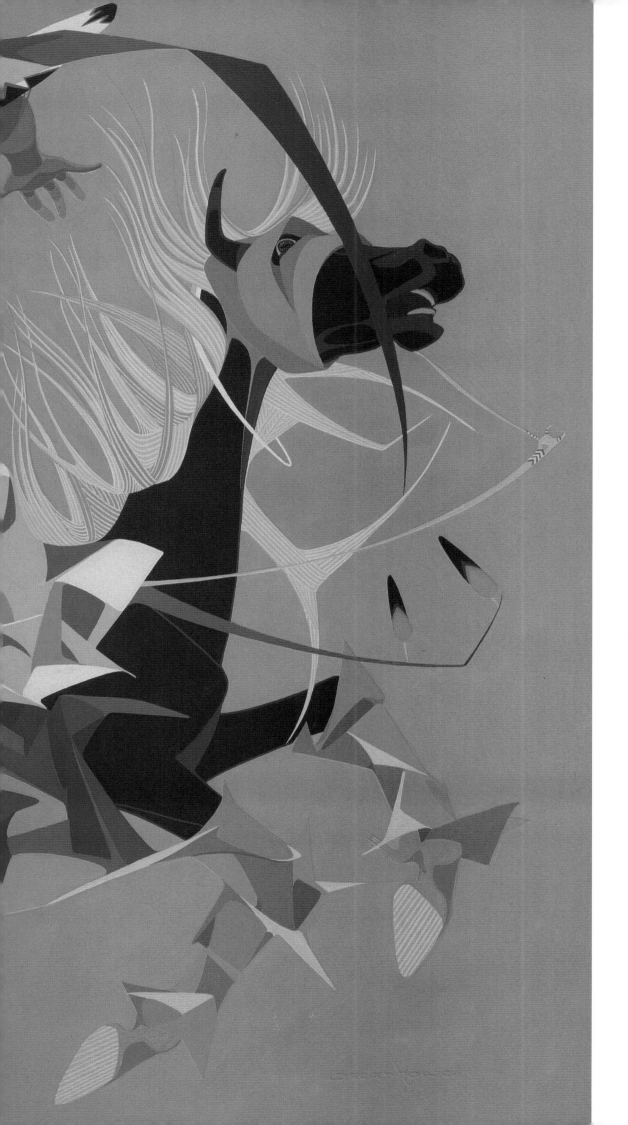

### Horse Dancer

*1956.* OSCAR HOWE,
*Yanktonai Sioux, watercolor*
*on paper. University of*
*South Dakota Art Galleries.*
This work, from
Howe's Cubist period,
reflects the artist's
bold attempt to meld
European technique
with traditional Na-
tive American themes.

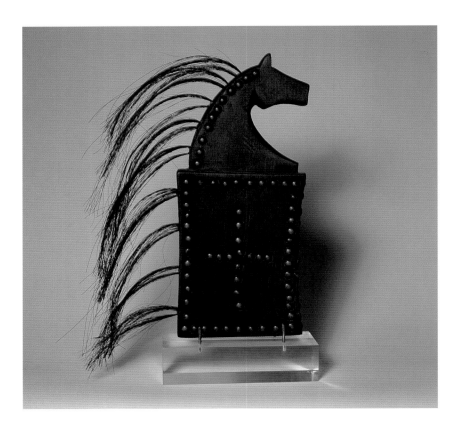

## Dance Board

*c. 1880–1900. Omaha Sioux;*
*carved wood embellished with*
*horsehair, leather, and brass*
*tacks. Private collection.*
Held in the hand
while performing
a sacred dance,
such a board was
thought to impart
wisdom and power.

## MATERIALS
## FROM THE PLAINS

Among the tribes of the Plains wooden eating bowls, including those of burl, were produced, as were spoons including those shaped from animal horn. These latter lacked the fine carving found on many examples from the Northwest coast but those intended for use at feasts were sometimes decorated with beadwork and tin danglers.

Storage vessels were frequently made of

bark from the birch tree, particularly in Canada and along the northern woodlands where the raw material was readily available. The Cree in south-central Canada would fold a large piece of bark into a square or oblong shape, stitch it together with roots from the cedar tree, and then decorate it by scraping away the white surface to reveal the brown undercoat. Both Canadian and American tribes continue to use birch bark to make a variety of salable souvenirs, from picture frames to teepees and model canoes.

The most romanticized of all Native American domestic products is the so-called peace pipe, and smoking one or a mixture of the dozen or so tobaccolike herbs native to this continent was almost universal. The artist George Catlin, on his first visit to the upper Missouri River in 1832, found that every brave carried his own pipe, usually of his own making, and that pipes were considered sacred and all smoking (not just at peace conferences) ceremonial in nature.

The bowls of pipes used by Plains and Eastern woodlands tribes were carved from catlinite, a soft reddish stone which was quarried in southwestern Minnesota and traded among tribes throughout North America. Catlin was supposedly the first non-Native to visit this holy site, and the mineral now bears his name. Its ritual importance among Native Americans is reflected in the legend associated with the quarry as retold by the artist:

> The Great Spirit . . . at an ancient period
> here called the Indian nations together,
> and standing on the precipice of the red
> pipestone rock, broke from its wall a piece,

## Baby Carrier
## or Cradleboard

*c. 1880–1910. Comanche, Oklahoma;*
*buckskin with shaped and painted*
*wooden frame inlaid with brass tacks.*
Native American babies
were typically confined in
such carriers, which kept
them close to the mother
while allowing her to con-
tinue working or traveling.

and made a huge pipe by turning it in his hand, which he smoked over them, to the North, the South, the East, and the West; and told them that this stone was red—that it was their flesh . . .

## THE PEACE PIPE

It is fair to say that pipe making is the most important plastic art associated with the Plains Indians. While the basic form is a "T" or elbow shape, there are many variations, and important pipe bowls may be inlaid in lead or skillfully carved in the form of human or animal figures. Larger ones, some weighing as much as three pounds, were owned by the tribe and reserved for important occasions. The carved and painted wooden pipe stems were also highly valued, often used alone as dance or prayer wands; however, due to their fragile nature most of these have been replaced over the years.

Red catlinite pipe bowls are found throughout New York and New England and as far south as Virginia and Georgia indicating the importance of trade in this sacred

and valuable substance. Few of these, however, attain the artistic quality of the Plains Indians examples.

Nor should we assume that the elbow-type pipe bowl with wooden stem was the universal choice. Archaeological exploration and historic references make it clear that a different form, tubular or cigar shaped, of carved stone and combining bowl and stem in a single body, was produced earlier. These pipes are found throughout the South and West and into the Midwest. Though often of unusual form and sometimes shell decorated, they have little appeal to most collectors.

The most complex of all Native American pipes were those carved by the Northwest coastal tribes. Yet these people, when first discovered by Europeans, were chewing rather than smoking tobacco. Quickly adopting the more universal custom, they turned out remarkable carved wooden pipes in which bowl and stem were part of a single sculptural unit. Mimicking the form of sacred rattles, they were often inlaid in abalone shell. In the Native American

### Spoon

*c. 1870–90. Salish; carved and shaped buffalo horn with glass trade beads, textile ribbon and pigment. Gift of J. R. Simplot, Buffalo Bill Historical Center, Cody, Wyoming.*
A decorated spoon like this would be preserved for use at special feasts and rituals.

81

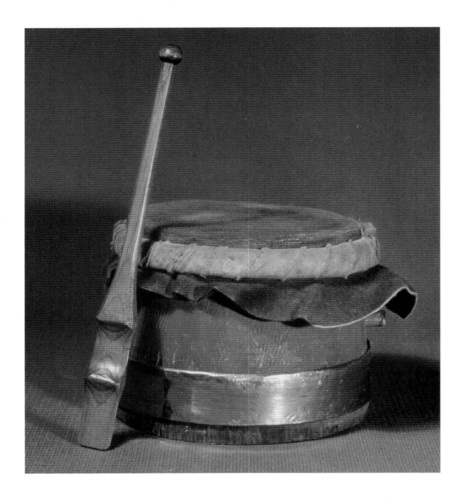

## Drum

*c. 1900–20. Onondaga;*
*wooden body with*
*leather and steel ban-*
*ding accompanied by*
*a carved wooden paddle.*
*Museum of the American*
*Indian, New York.*
Drums were often
used to accompany
Native American
dances and sacred
ceremonies.

tradition, such pieces were reserved for sacred or ceremonial occasions.

When visitors found the pipes attractive, artisans began to reproduce them in argillite, the black slate which was later used to make model totem poles and souvenir dishware. The material lent itself to complex, highly organized sculpture equal to that found in the finest wooden totems, dance masks, and rattles. The makers of these pieces, however, preferred wooden pipes. They sold the pipes made from argillite to tourists.

## NATIVE AMERICAN MUSICAL INSTRUMENTS

Native American music is more closely related to that of the Orient than to European forms, and the instruments employed are fewer and less complex. The two basic types are percussion and wind; the former represented by drums and rattles, the latter by whistles and flutes.

Like pipes, drums have long been associated in popular culture with Indians. It is true that drumming played an important part in the war-dance ritual, but drums had a far greater religious significance within the Native American community and were employed in most ritual observances, such as the Hopi seasonal dance ceremonies.

The Hopi preferred double-headed drums stretched over bentwood hoops, the drum heads often painted with Kachina dance figures. Smaller versions have long been made for sale to tourists. Decorated drums were also produced by the Northwest coastal tribes, but their most artistic creations were rattles.

Groups such as the Tlingit and Salish turned out a wide range of rattles, though they generally fell into two forms: bird effigies and those that are round or oval in shape. The former, sometimes referred to as "chief's rattles," featured often highly complex stylized depictions of cranes, gulls, or herons. The latter, usually less elaborately carved and painted, represented a shaman or his helping spirits.

Such rattles produced noise through bits of stone, bone, or seed which rattled about within the hollow interior. Among the Iroquois this effect might be produced within a dried turtle shell. The Menominee employed a barrel-like rawhide cylinder mounted on a shaped stick; the Apache and Pomo achieved the same effect with dried-out insect cocoons; and some Pueblo Indians preferred gourds.

Wind instruments are primarily simple flutes or whistles, though the materials from which they are made may vary widely. California tribes made flutes from bone or water reeds, while the Omaha and other Mississippi Valley tribes carved the instruments from wood, which might be painted or decorated with beading. Whistles made from stone are found from the west coast to New York State, and pottery was favored in the Southwest.

### The Singer

*1979.* ALLAN HOUSER, *Chiricahua Apache; print,*
*poster paper. The Heard Museum, Phoenix, Arizona.*
Houser is a successful artist and teacher,
and has worked in a variety of mediums.

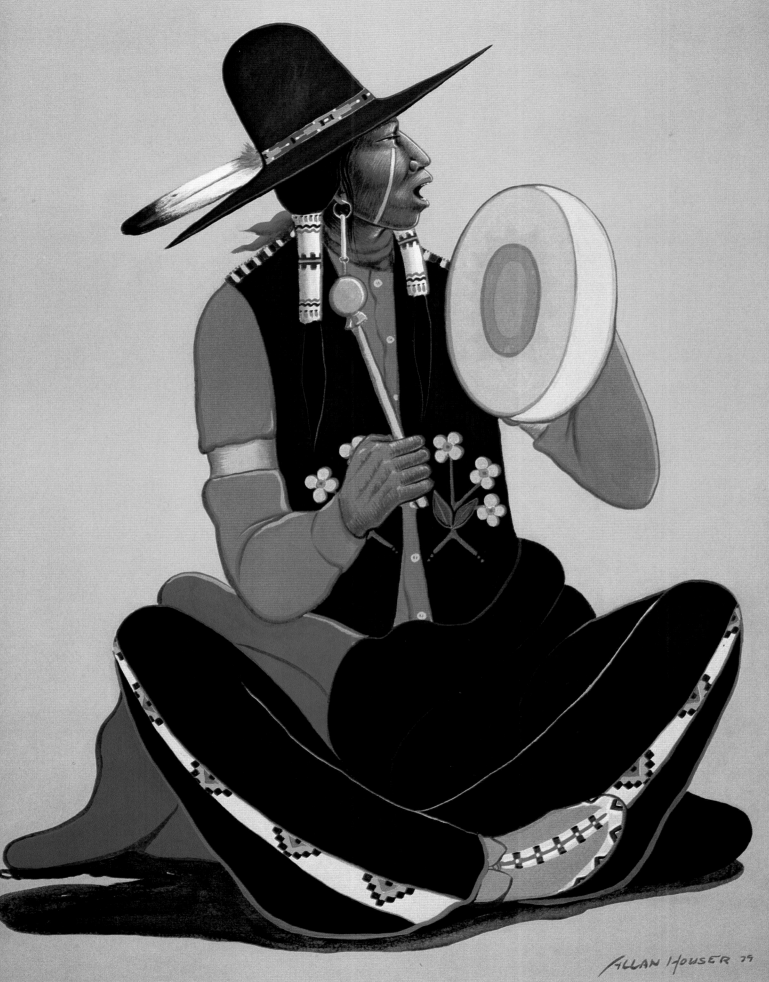

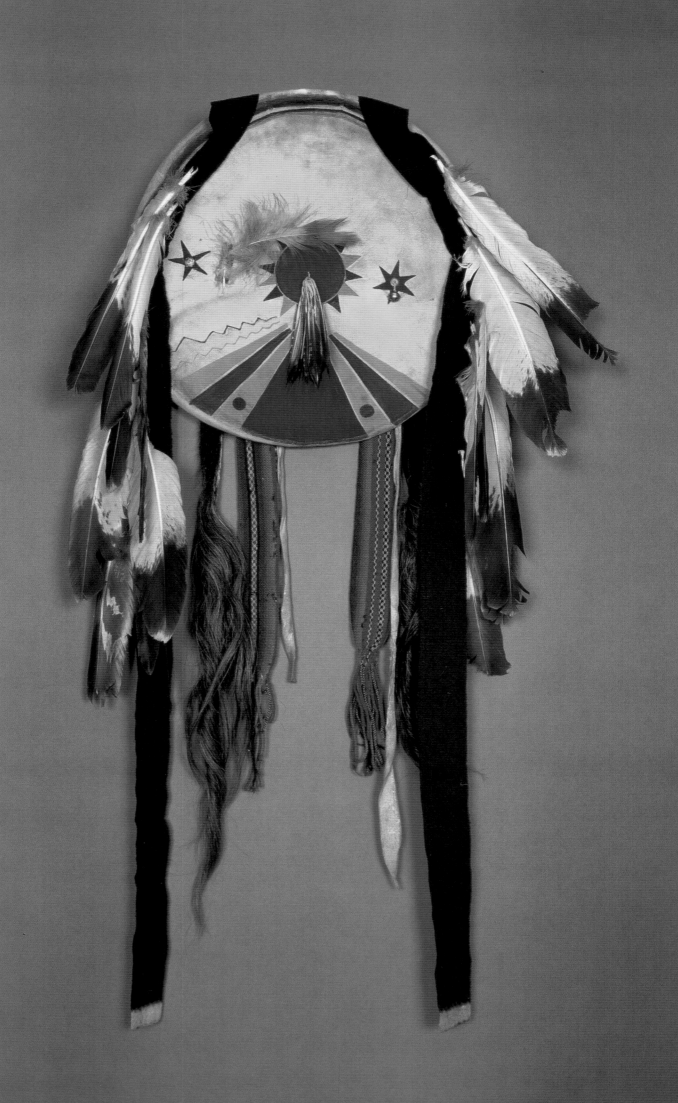

## WEAPONRY

Even the lethal instruments used in hunting and warfare often show some artistic merit. Among the finest are the decorated Plains Indians shields discussed elsewhere and the deadly but beautifully carved and decorated war clubs used as a primary weapon in hand-to-hand combat among the Iroquois and other Eastern woodlands tribes. These latter take two forms, the ball-headed club, sometimes shaped as a human effigy, and the "gunstock" club (named for its resemblance to a rifle stock), which might be painted and decorated with brass tacks (as well as inset with an iron spike). A more folky club, employed among Maine's Penobscot, was shaped from a young tree—the heavy root ball, often given human features, supplied the potent ingredient.

Daggers or knifes also were commonly produced as weapons, and the finest of these were made on the Northwest coast where bone and later steel blades were topped by elaborately carved, painted, and ivory- or abalone-inset handles. The Nootka and other groups from this area are known too for magnificently carved war clubs of whalebone or yew wood.

The Native American love of decoration was transferred as well to those instruments of death acquired from the European invaders. Spears had always been decorated with feathers and quillwork; and, when glass beads became available, they were used to embellish these as well as arrow and knife sheaths, gun cases, and iron tomahawks. This decorative art reached its highest state among the Plains tribes. Today, a rather lucrative business in spurious "old" weapons for sale to tourists has grown up in the same area.

### Projectile Points

*c. 2,000 B.C.–1,200 A.D. Northeastern United States; chipped flint and quartz. Private collection.*
Points such as these, commonly known as "arrowheads," are fairly easy to come by, yet few realize how old they really are.

### Shield and Shield Covers

*c. 1880–90. Comanche; paint decorated deer-hide embellished with knitted woolen yarn, sinew, and horse hair. Fred Harvey Collection, The Heard Museum, Phoenix, Arizona.*
Great horsemen and ferocious warriors, the Comanche ranged the southern plains until the late nineteenth century.

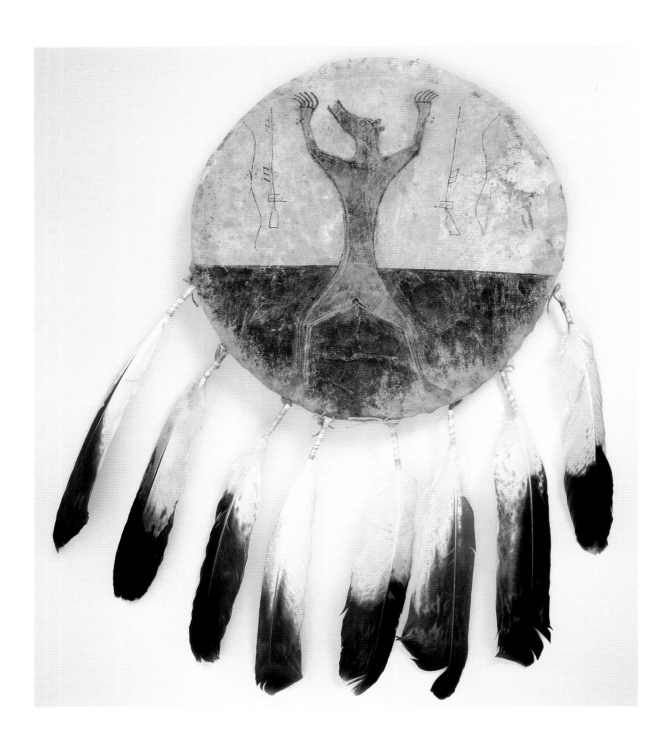

## Shield Cover

*c. 1860–70. Hidatsa; paint decorated deerhide*
*bound with sinew and embellished with eagle feathers.*
*Buffalo Bill Historical Center, Cody, Wyoming.*
The Hidatsa of the upper Missouri River were
bold warriors who ranged as far west as the
Rockies in their perpetual war with the Sioux.

## War Club Quirt

*c. 1870–80. Sioux; carved wood with paint,*
*feathers, and leather. Private collection.*
With the head carved in human
form, this piece served both as a wea-
pon and a goad to the warrior's horse.

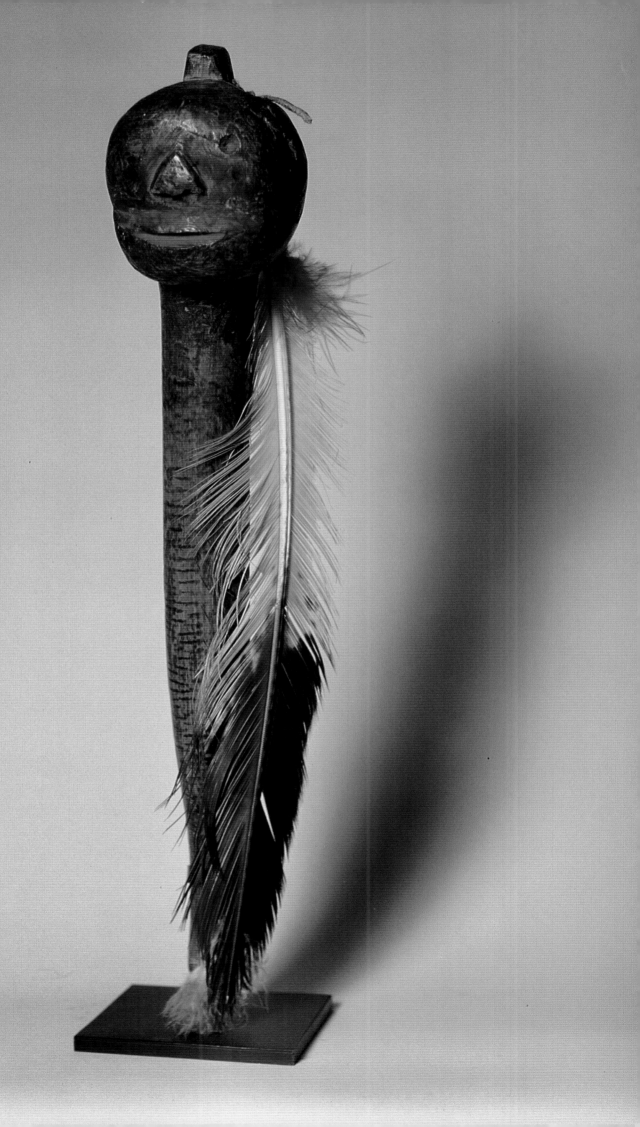

# BEAD- WORK AND JEWELRY

**T**he craving for ornament, in dress and body, is universal, and Native Americans were not exempt from such desires. Archaeological research indicates that as far back as the thirteenth century the pueblo dwellers of Arizona and New Mexico were undertaking long and perilous journeys in order to trade for the abalone, clam, cone, and olive shells which they cut and shaped into decorative beads, while the illustrious Captain Cook, on his first visit to the Northwest in 1778, was greeted by two Nootka Indians wearing spoons of Spanish silver which they had obtained in trade along the southern coast of California.

## DECORATIVE BEADS AND OTHER ORNAMENT

By the mid 1800s the Haida, Kwakiutl, and Bella Coola were making trade silver bracelets, earrings, brooches, and hair ornaments, incorporating the same traditional

### Ear Spools

*c. 1250. Oklahoma; carved bone.*

*The Smithsonian Institution, Washington, D.C.*

Used as jewelry, these spools were inserted in the earlobes of the early inhabitants of the North American southwest. Like most early material they were recovered from a burial site.

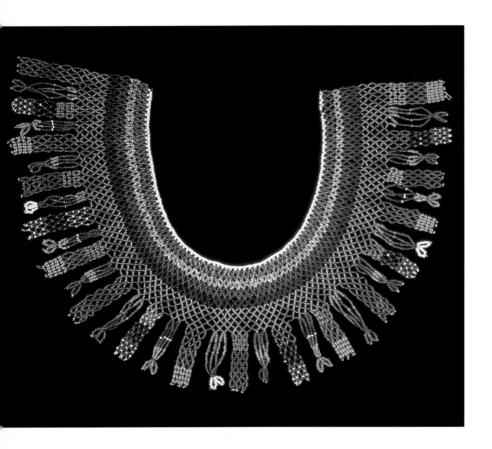

## Collar or Choker Necklace

*c. 1900–10. Mohave;
glass seed beads
and netting. The
Heard Museum,
Phoenix, Arizona.
Though not as
well known for
their beadwork
as some tribes,
the Mohave of
California have
created some un-
usual and highly
attractive pieces.*

design motifs utilized on carved and painted objects as well as some, like the American eagle (acquired from a design on silver dollars), of distinctly non-Native origin.

Most Native American artisans, however, employed more humble materials. Even the Haida and Tsimshian were content to use scrap iron, salvaged from wrecked Asiatic ships which had drifted ashore, to make brightly polished hair ornaments inset with haliotis shell or copper plating from the same source for earrings and pendants.

Excavations in the Mississippi Valley area of the United States have uncovered body ornaments of thin sheet copper hammered flat and then shaped into human, bird, and animal forms; similarly, the ancient Hopewell people of Ohio used mica, a more unusual material, the thin sheets of which they cut into both abstract and naturalistic forms and then sewed to clothing.

The Eastern woodlands Indians laboriously cut, shaped, and ground pieces of slate, quartz, or sandstone to produce round or elongated beads. They were drilled with a hand drill so that they might be strung on animal sinews. Pierced bird and mammal bones or teeth could be used in a like manner. And among the Plains Indians bits of dried buckskin or cut-up hoofs and horns might be strung together to form a necklace.

The digger Indians of California gathered pine nuts, seeds, and bits of shell to decorate braided straw or bark, while the Seminoles combined a variety of materials—pine cones, stones, animal claws, and fire-hardened pottery—in their neck, arm, and wrist ornaments.

Salt- and freshwater shellfish, however, provided the most widely employed decorative material. Prehistoric burial mounds in Tennessee, Georgia, and neighboring states have yielded numerous round shell disks incised or pierced with representations of humans, birds, rattlesnakes, and even insects, all in a style so similar to the art of Mexico and Central American as to leave little doubt but that there was contact between the cultures.

These disks, called gorgets—usually less than 4 inches (10 centimeters) in diameter—were worn on a cord around the neck and are the forerunners of the engraved silver presented by non-Natives to Indian notables, often to commemorate the signing of a peace or land-cession treaty. In California similar ornaments were made from the indigenous abalone shell. They lacked engraving, but the blue-green iridescent sheen of the shell alone was highly decorative.

## WAMPUM

The best known of Native American shell beads is wampum, small rounded, pierced disks or ovals cut usually from the shells of freshwater mussels and strung together to serve not only as decoration but also as a

## Gorget

*c. 1200–1300. Oklahoma; carved bone.
The Smithsonian Institution, Washington, D.C.
A gorget was worn about the neck like a pendant. The artistic style reflects contact with
Mexican or Central American craftsmen.*

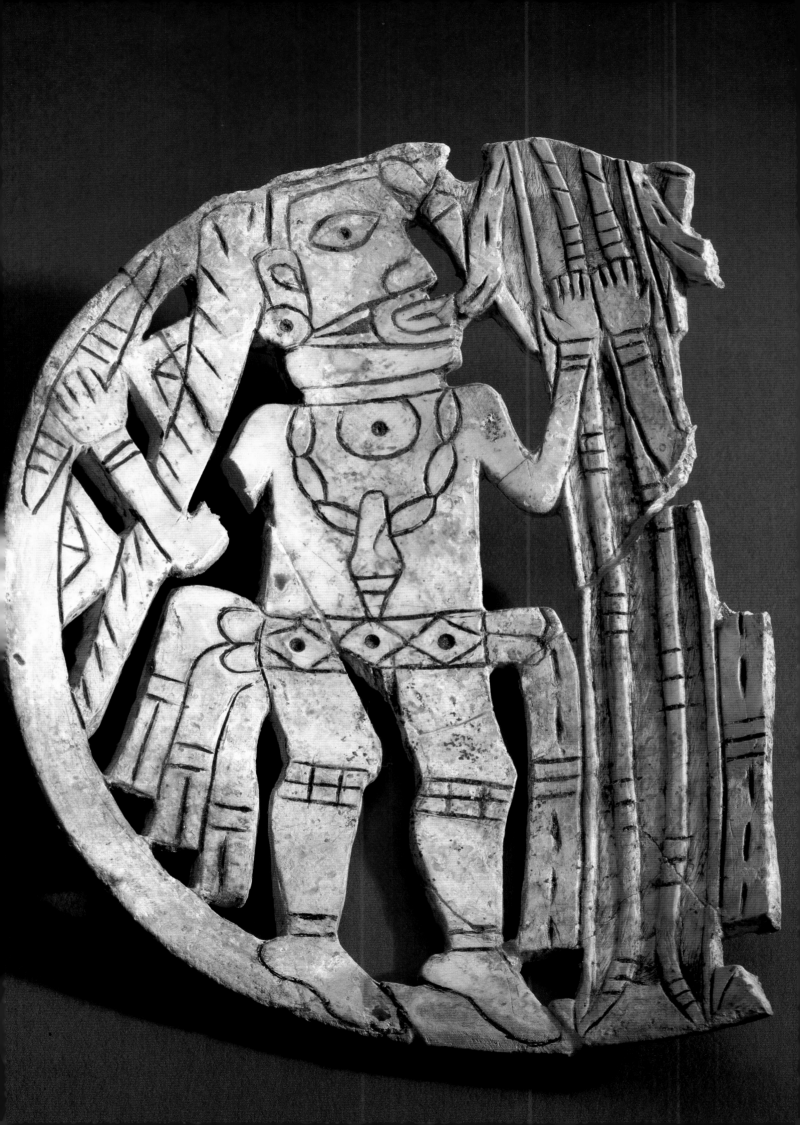

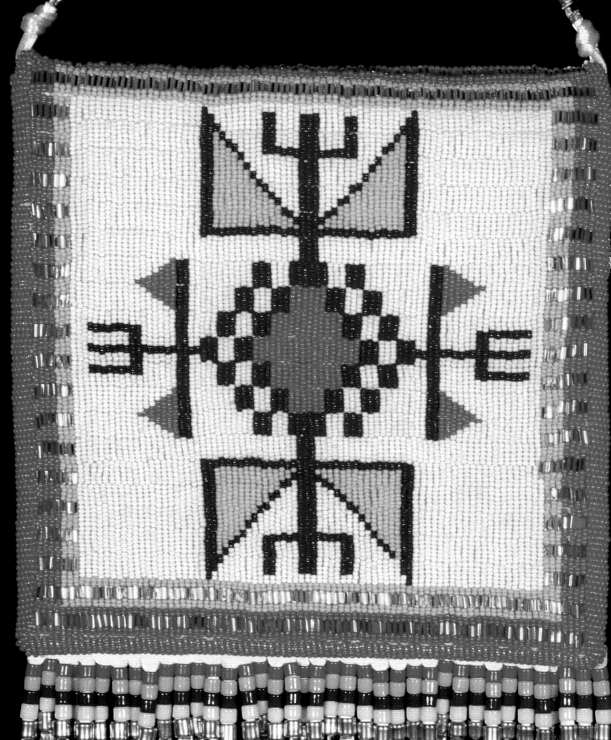

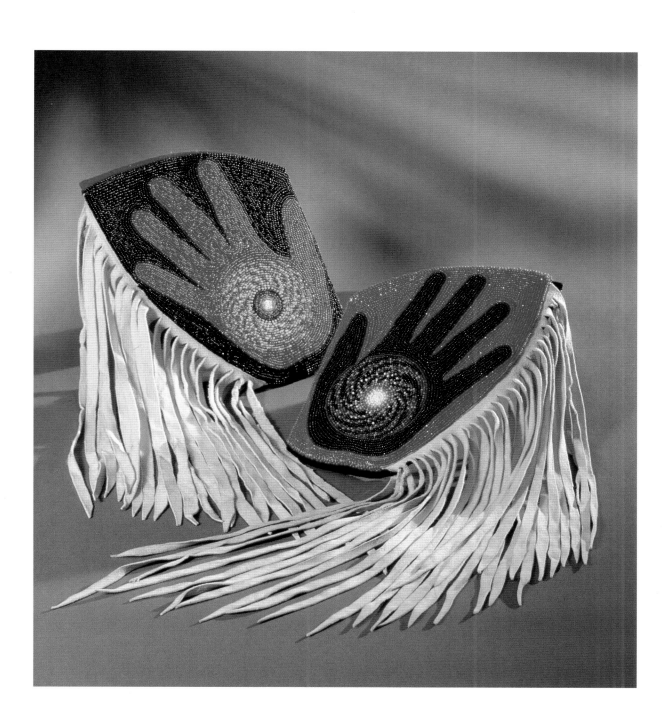

## Cuffs

*modern.* MARCUS AMERIMAN, *Choctaw; colored beadwork design surrounded by leather fringe. Institute of American Indian Arts Museum, Santa Fe, New Mexico. CHO-33.*
The contrasting colors of the left and right hands, each with a swirling pattern in the palm, hint at the symbolism and perceived magical powers of the human hand.

## Bag or Purse

*1994.* WANDA LEHNER, *Ogala Lakota Sioux; leather bag beaded on both sides with white, red, yellow, and blue Sioux design, strap of braided rope. Institute of American Indian Arts Museum, Santa Fe, New Mexico. S-297.*
Bright and shiny in its newness, this contemporary bag would not have seemed unusual in its design to Sioux craftsmen of the past.

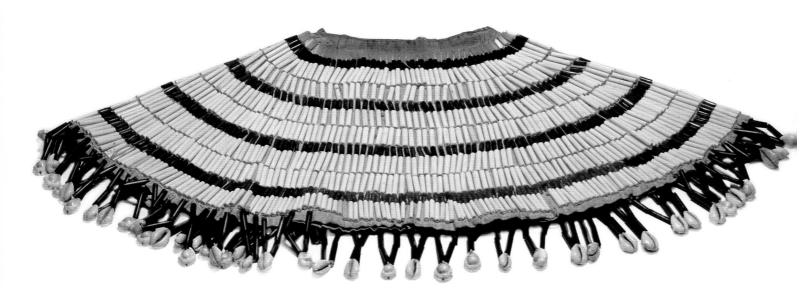

## Cape

*c. 1890–1910. Plains Indians; cowrie shells and cylindrical glass trade beads on buckskin. Private collection.* An uncommon form, this cape was probably made for tribal use rather than for trade.

form of currency widely recognized among many nations, from the Eastern woodlands to the Plains as well as among the settlers who dealt with them. Over ten thousand of these tubular purple and white beads were sewn together in the famous Washington Covenant Belt.

Over 6 feet in length (1.8 meters), this belt has a design of human figures with linked hands, to signify friendship and commemorates a late-eighteenth-century treaty between George Washington and certain members of the Iroquois Confederation. Another famous wampum belt, the Hiawatha Belt, associated with establishment of the Iroquois League, contains some seven thousand wampum beads.

## QUILLWORK AND BEADED EMBROIDERY

For the decoration of clothing, moccasins, and various important domestic or ritual items such as pipe or tobacco bags, bow sheaths, and medicine storage pouches, porcupine quill embroidery was preferred by both the Eastern woodlands Indians with whom it originated and the Plains tribes to which the art spread during the nineteenth century. As with wampum, value reflected the amount of effort that went into creating the decoration. Porcupines were uncommon, and preparation of the raw material was a time-consuming task.

The quills, which in their natural state are 3 to 4 inches (8–10 centimeters) long and vary in color from white to brown, must be plucked, dyed with natural colors, and flattened while moist. They are then pieced together in a continuous band and sewn onto leather, usually buckskin or bison, in a form of appliqué work. While the nature of the material dictated a largely geometric format, a skillful worker might incorporate human and animal figures.

So demanding was the work and so high the standards that its practitioners were held to, that among some tribes such as the Cheyenne, quillwork was the exclusive domain of a guild of women, the *moneneheo* or "selected ones," who in tribal prestige equaled the most seasoned warrior.

Quillwork continues to be practiced to this day, but by the early nineteenth century it was being replaced with beaded embroidery utilizing commercially manufactured glass beads made in Europe and supplied by traders. The first of these, the "pony beads" of Venetian blue or white glass, were supplanted

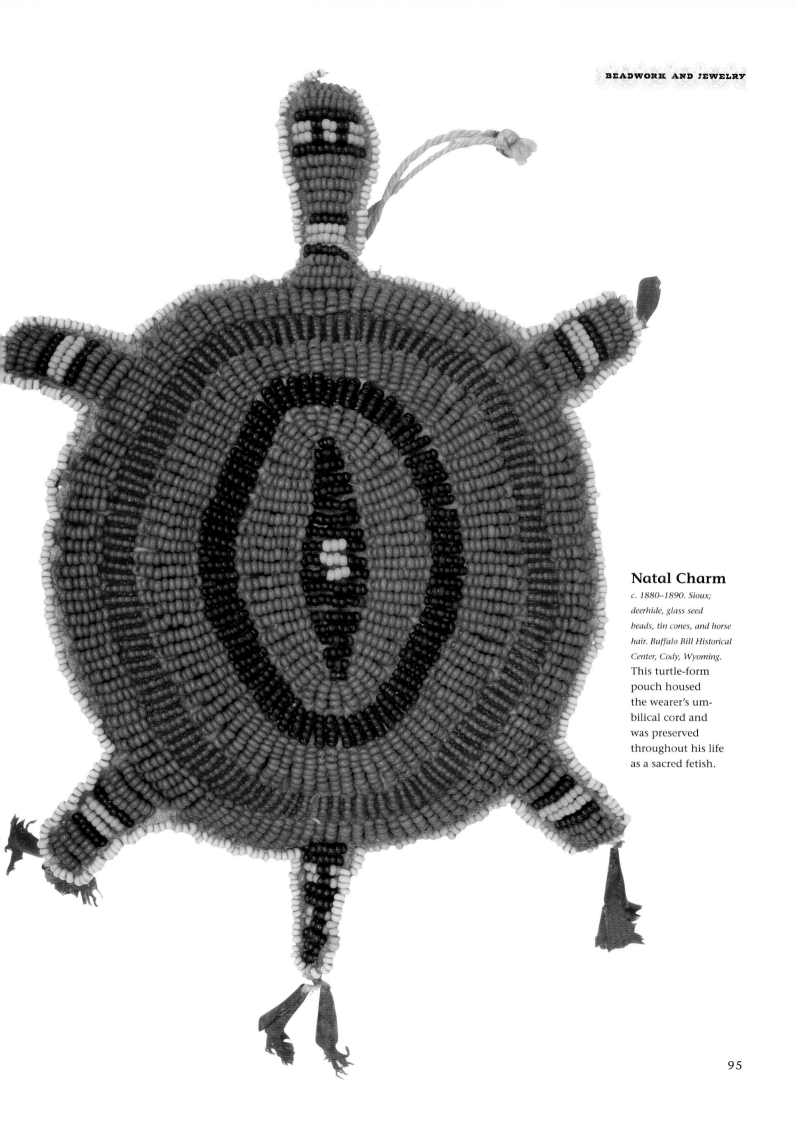

## Natal Charm

c. 1880–1890. Sioux;
deerhide, glass seed
beads, tin cones, and horse
hair. Buffalo Bill Historical
Center, Cody, Wyoming.
This turtle-form
pouch housed
the wearer's um-
bilical cord and
was preserved
throughout his life
as a sacred fetish.

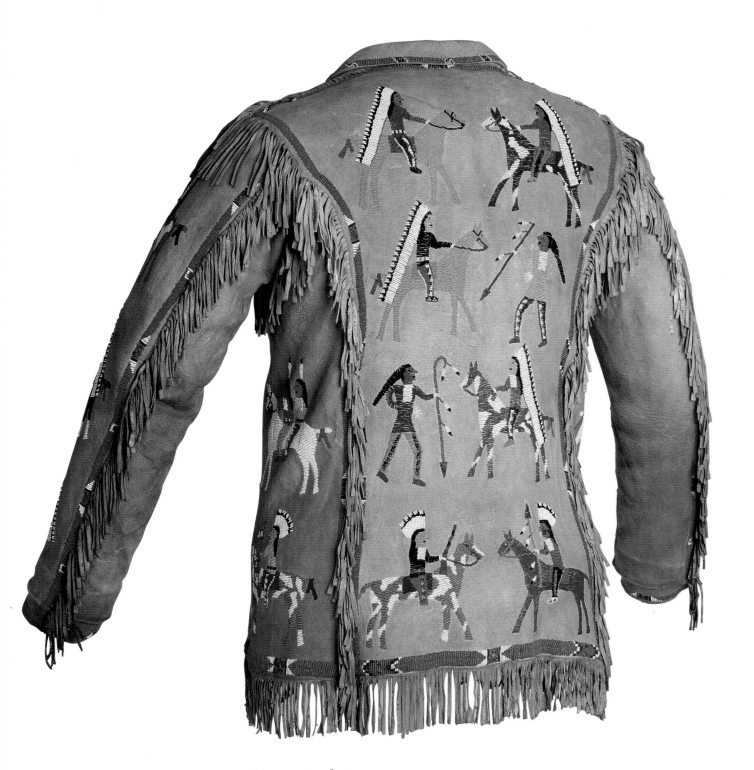

### Coat or Jacket

*c. 1910–20. Northern Plains Indian; fringed
deerhide decorated with scenes in glass
beads. Gift of Mrs. Howell Howard, Buffalo
Bill Historical Center, Cody, Wyoming.*
Such elaborate garments were
usually made for sale to non-
Natives. The figures are similar
to those seen in ledger drawings.

### Necklace

*c. 1870–1900. Plains Indian; bear claw, antelope
horn, and glass trade beads. Gift of the Coe Foun-
dation, Buffalo Bill Historical Center, Cody, Wyoming.*
As killing a grizzly bear was regarded
as a great feat, only the bravest
warriors wore a necklace like this.

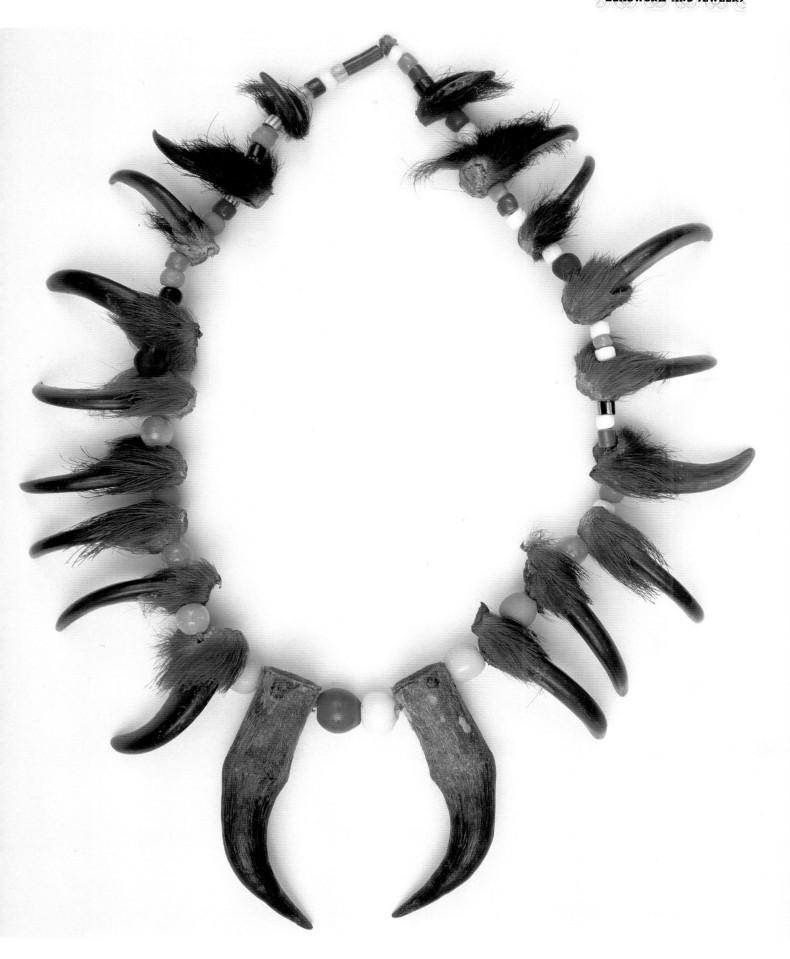

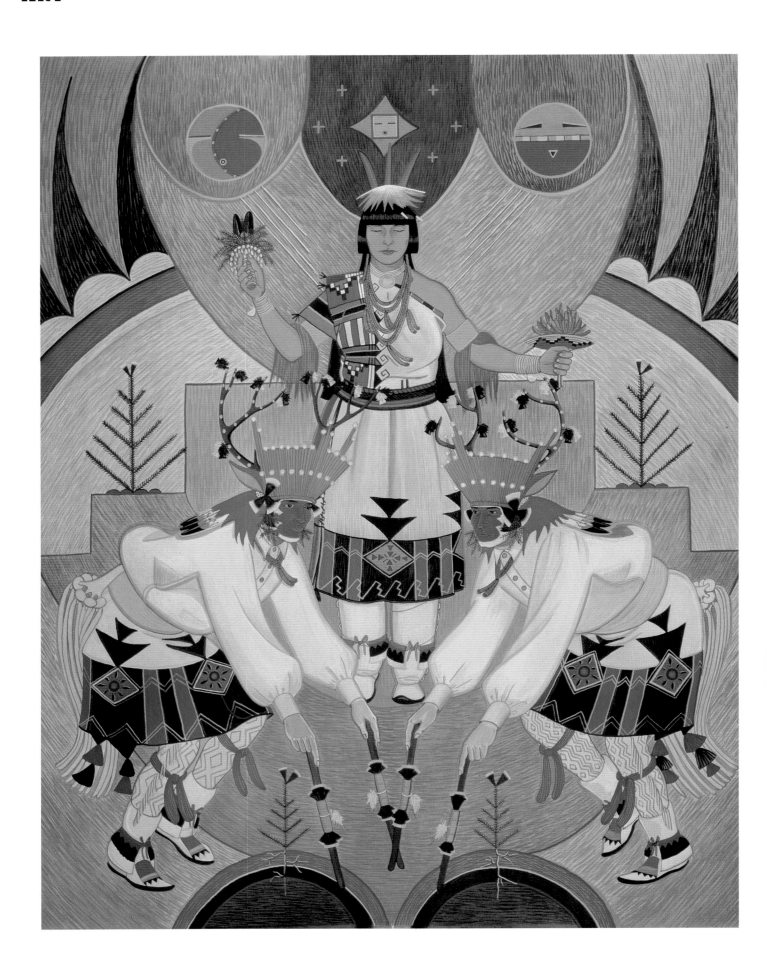

in the 1850s by tiny multicolored Bohemian- or Italian-made "seed beads."

Where the larger pony beads had been relatively costly and used somewhat sparingly, seed beads were inexpensive (a buffalo robe was worth some eighty strings of beads, each 8 inches [20 centimeters] long) and their availability led to a new decorative style in which entire objects (moccasins, pipe bags, even skirts) might be covered with a polychrome beaded embroidery. Initially geometric in pattern, such work, under non-Native influence, became progressively more curvilinear so that just as with quillwork flowers and human or animal figures gradually replaced the earlier solid bands, diamonds, and squares.

Both Indians and the new settlers were fascinated by this art. In the East Iroquois and Penobscot artisans produced beaded Victorian souvenirs such as heart- or shoe-shaped pin cushions to be sold to tourists at scenic sites like Niagara Falls; while in the Plains

states Sioux, Blackfoot, and Cheyenne women turned out a remarkable array of bead-decorated objects and clothing: belts, gauntlets, gloves, and leggings for the tourists and cradle boards, saddle covers, capes, and dresses for their own use.

The beadwork of the Northwest coastal tribes, while less well known, is equally remarkable. Utilizing tooth shells and glass or metal beads obtained from Russian and English traders, craftsmen first decorated religious and ritual regalia with abstract designs similar to those found on carvings and silver from the same area. However, encouraged by visitors and traders they soon began to produce brightly colored patterns incorporating more naturalistic animal and human figures and sewn to red or blue trade blankets. As in the Northeast and on the Plains reservations, beadwork embroidery remains an important form of artistic expression among the Tlingit, Kwakiutl, and other Northwestern groups.

### Blessing of the Deer Dancer

*1964. GILBERT ATENCIO, San Ildefonso Pueblo; watercolor on paper. The Philbrook Museum of Art, Tulsa, Oklahoma.* Atencio's work blends traditional Pueblo society subject matter with the Central and South American mural tradition.

### Sheath or Knife Case

*c. 1880–90. Blackfoot; deerhide decorated with glass seed beads and tin cones. Adolph Spohn Collection, gift of Larry Sheerin, Buffalo Bill Historical Center, Cody, Wyoming.* Both the beads and the cones in this piece would have been obtained from settler traders.

## Wall Pocket

c. 1890–1910. Iroquois; glass beads on cotton cloth mounted over a cardboard framework in the shape of a Victorian shoe. National Museum of American Art, Washington, D.C. Made in great quantity, novelty items like this were often sold to tourists at Niagara Falls and other popular sightseeing areas.

## Tie and Collar

1987. RUSSELL BOX, JR., Ute, Central Plains; glass seed beads mounted on leather backing. Institute of American Indian Arts Museum, Santa Fe, New Mexico. U-3. A brightly colored border offsetting a landing eagle and a triple feather design transforms this most ordinary fashion accessory, the four-in-hand tie.

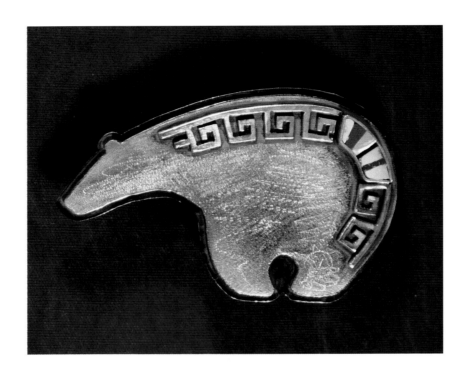

## Belt Buckle

*1985.* Jennifer Parriette, *Sioux-Ute, Northern Plains; silver inlaid with turquoise, jet, pipestone, and coral. Institute of American Indian Arts Museum, Santa Fe, New Mexico. S-213.* The curving, forward-thrusting outline of this bear suggests the animal's weight and ponderous movement.

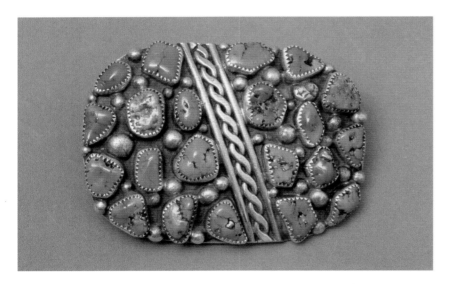

## Breast Pin

*c. 1930–40. Zuni; cast silver with silver wire work and turquoise inlay. Private collection.* Associated in their religion with sky and water, turquoise is an important material for Pueblo craftsmen.

## SOUTHWEST SILVER

Many tribes have used both iron and copper in their jewelry making, as well as silver, and Eastern woodlands tribes likewise hammered silver coins into decorative pieces. However, when most collectors think of silver jewelry they look to the Southwest, where the Navajo, Hopi, and Zuni have long been famed for their artistic work in this medium.

The first Spanish explorers came into this area seeking silver. They found none, but they did discover artisans making attractive mosaic pendants, rings, and bracelets of white shell, jet, and native turquoise inlaid into large clam shells. Turquoise was particularly prized by the pueblo dwellers, both for its beauty and its religious significance. In Pueblo belief predominantly blue pieces were associated with sky and water, while shades of green symbolized vegetation.

Spanish settlers introduced silver to these gifted craftsmen, and by the mid-1800s they began to create jewelry which combined this metal with their beloved turquoise. The combination found immediate favor not only within the tribal communities but also with tourists and traders.

The first major producers were a group of Navajos who had been imprisoned by the United States government during the 1860s and, seeking a way to earn some money, began to make silver jewelry for sale to military personnel and their wives. They developed a tradition of massive hammer-formed or sand-cast pieces, often with little or no turquoise, in simple, naturalistic designs, which continues to be the hallmark of

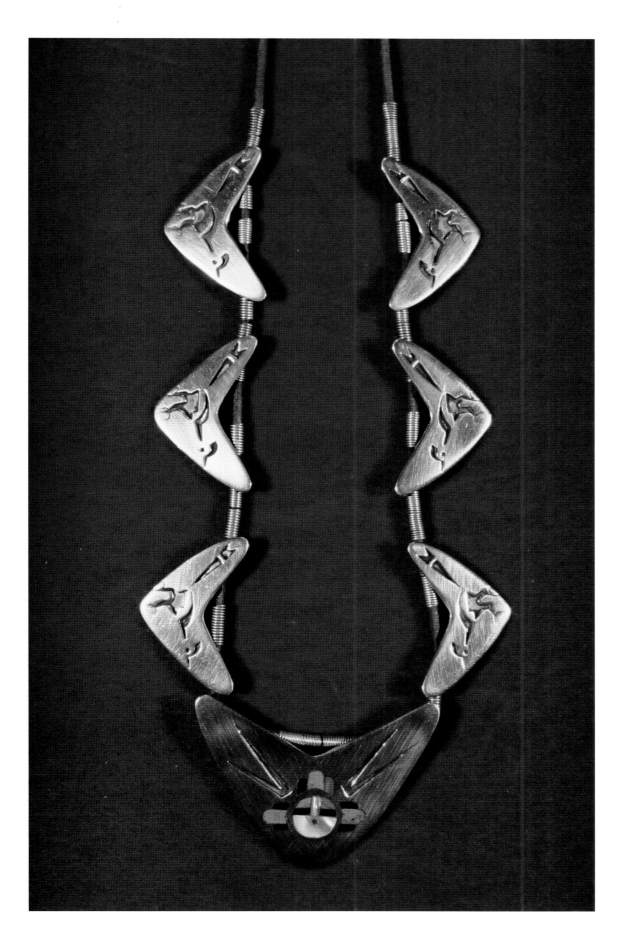

*FOLLOWING PAGE:*
**Bracelets**

*c. 1900–30. Navajo and Hopi; cast and worked silver with turquoise. Private collection.* Pueblo silversmiths work in various styles, several of which can be seen among this group of bracelets.

**Necklace**

*c. 1962–72. Silver inlaid with turquoise and jet, leather strung. Institute of American Indian Arts Museum, Santa Fe, New Mexico. Prop-392.* Pieces like this one, though fairly new, are so strong in tradition and craftsmanship that they are sought after by collectors.

103

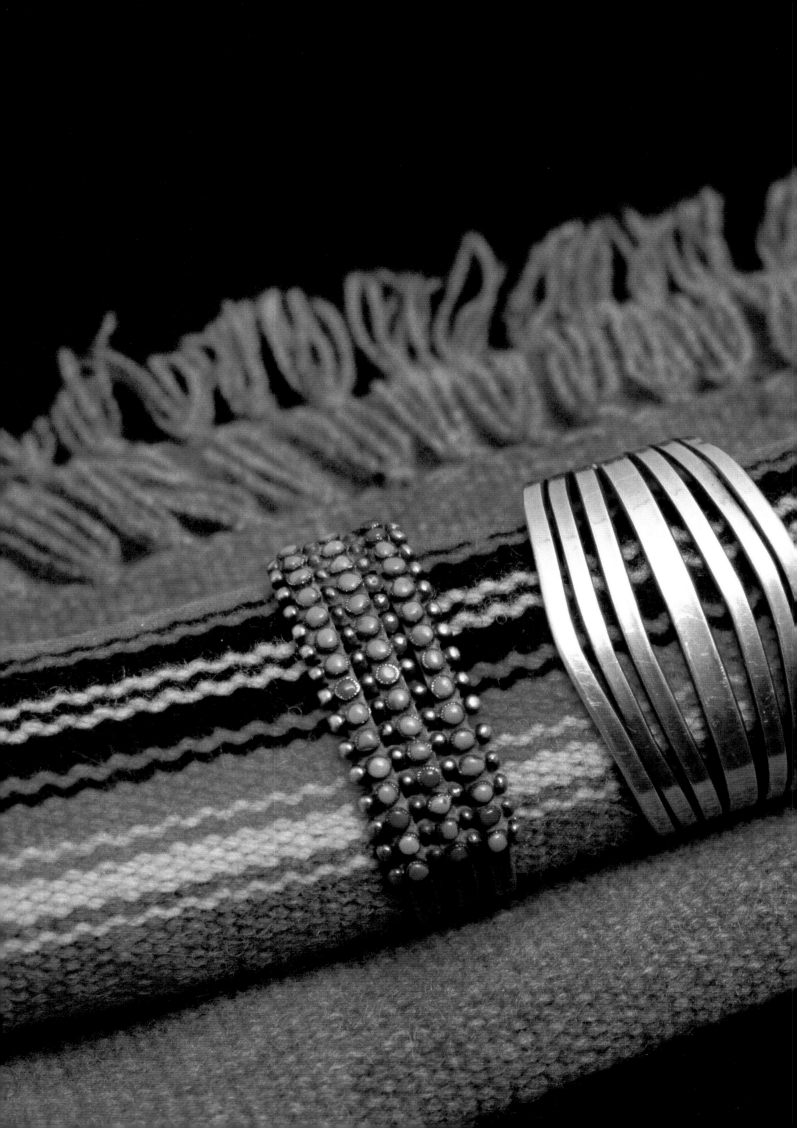

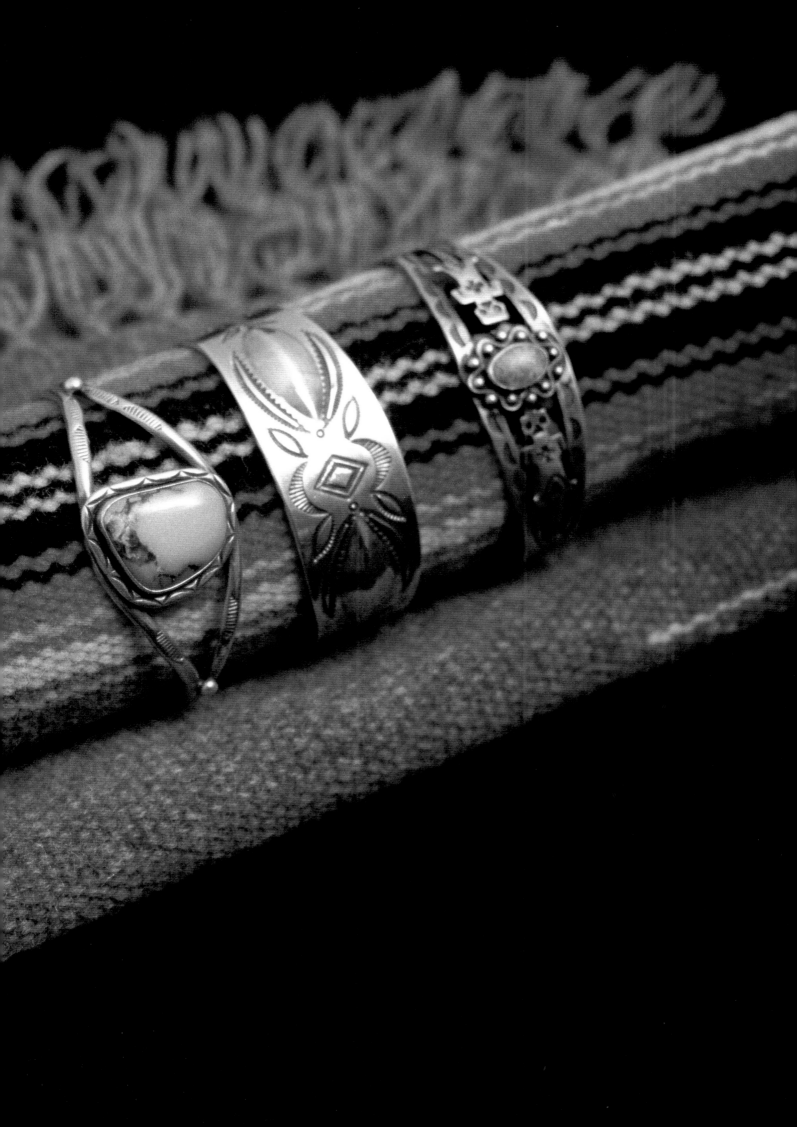

Navajo work. Concho belts and the squash blossom necklace are among the better known forms associated with this style.

Zuni craftsmen were next to enter the field. They had been making brass and copper jewelry since the 1830s, and around 1870 they began to employ silver, usually as a mere framework for extensive inlay in turquoise, jet, and shell. In a sense this Zuni work is a continuation of the prehistoric mosaic tradition, but with the addition of silver as a matrix. The Hopi, who became active in this craft in the 1890s, are known for technique, cutwork, engraving, and overlay, enhancing the silver, and seldom employ turquoise or other stones.

Contemporary Navajo, Zuni, and Hopi silversmiths carry on the ancient tradition, producing a myriad of traditional and modern designs. Electric emery wheels have replaced bits of sandstone for grinding and polishing; casting is more sophisticated; and silver or even turquoise may be purchased from a commercial supplier rather than from a local miner. Yet there is no lack of inspiration—or customers for such beautiful work.

### Kiksadi Pin

*1995.* BERNICE DAHL, *Tlingit; copper with brass overlay. Institute of American Indian Arts Museum, Santa Fe, New Mexico. TL-34.* This whimsical frog pin was created by a student artist for an "Earth Spirits" show in Santa Fe, New Mexico.

### Necklace

*1975.* JAY BOWEN, *Skagit; cast and worked silver. Institute of American Indian Arts Museum, Santa Fe, New Mexico. SKG-2.* Though thoroughly contemporary in style, the central ram's-head pendant recalls an ancient tradition of depicting wildlife and the spirits of the natural world.

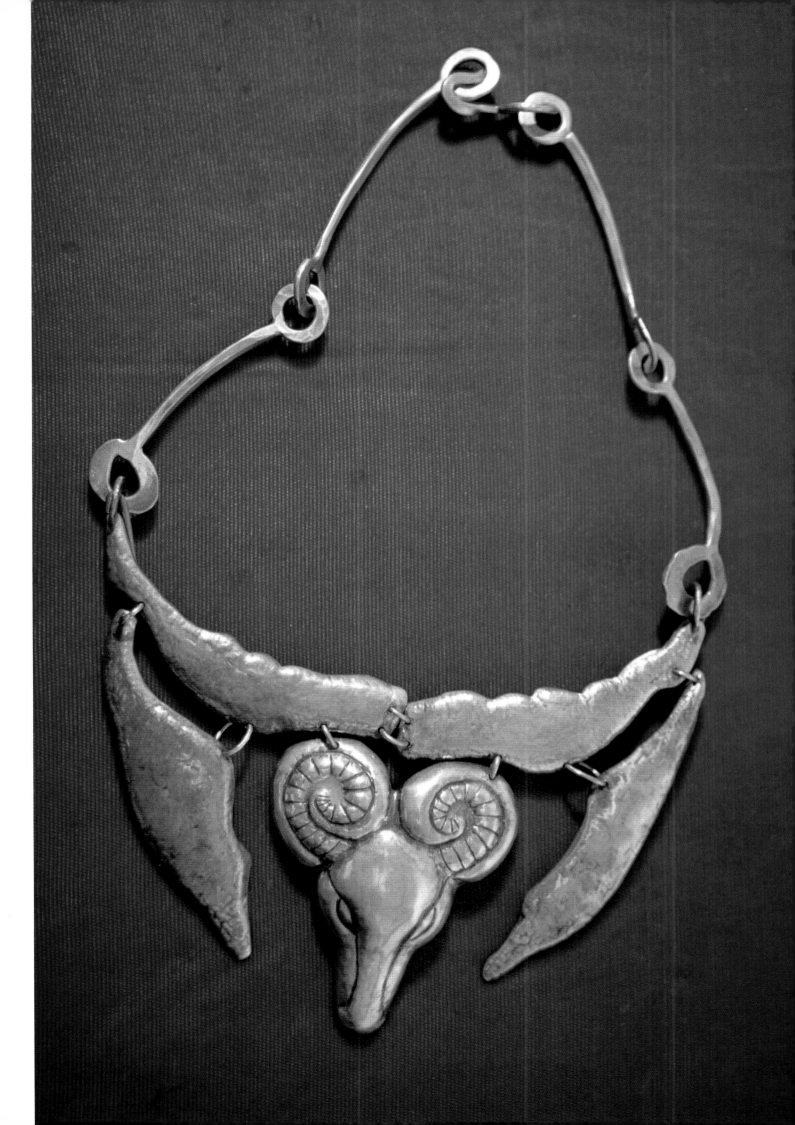

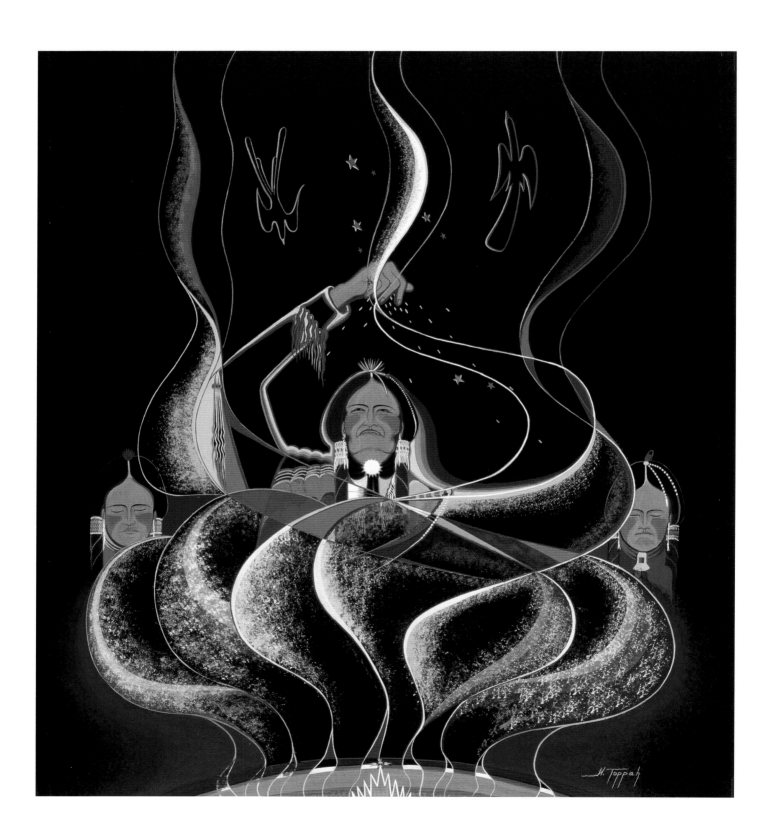

# CHAPTER EIGHT

# THE NATIVE AMERICAN ARTIST

Two-dimensional pictorial—as opposed to three-dimensional sculptural—art has always been widespread among Native Americans. That relatively few older examples exist today simply reflects the fragility of the medium. Among a people torn by strife and often subject to being uprooted and driven hundreds or even thousands of miles from their homes, the survival of drawings on skin, wood, or paper is problematical.

## CAVE PAINTING

The most ancient examples of pictorial art to come down to us are in, or rather on, the most durable surface-stone. For well over a thousand years (the dates of the earliest works have so far not been ascertained) Native American artists have drawn, painted, scratched, or gouged pictures into the walls of caves and rock shelters. While traces of such art work have been found throughout the country, the best preserved examples are found in the hot, dry western regions of the continent.

Though usually referred to as pictographs, reflecting the fact that they are often characterized by stick figures representing humans and animals, such drawings range widely in both design and technique. Some are quite realistic, others stylized but recognizable, and a third group completely abstract. Experts have suggested that certain examples represent territorial boundaries, commemorate important events, are offerings to propitiate the hunting or harvest gods, or serve as memory aids to storytellers and priests. In truth, no one can be sure.

Among the better known examples of rock art are the large and extremely realistic life-size human figures found in Utah, the rough drawings of the Pueblo area which evolved into the later kiva murals, and the incredibly complex, colorful, and predominantly abstract art of the Chumash of Southern California, believed to have been created by shaman-artists under the influence of the hallucinogenic datura plant. Some of the Chumash paintings, executed in natural pigments (primarily red, black, yellow, and white), are as long as 40 feet (13 meters) and reflect a highly developed artistic sensibility.

It is a wonder that any rock paintings exist today. Subject to exposure and vandalism (many Chumash works have been destroyed by souvenir hunters) and by their very nature difficult to remove to a safer setting, they remain merely a suggestion of a once widespread art form.

## WALL MURALS

Closely related to the rock paintings are the murals covering the walls of the kivas or sacred chambers of the ancient Hopi settlements of Awatovi and Kawaika-a on Antelope Mesa in Arizona. An archaeological expedition in the 1930s uncovered some eighteen kivas, whose walls were covered with stylized representations of men, animals, and Kachinas, in a series of paintings dating from approximately 1300 until 1600.

While rock art, gouged or pecked into the stone (termed petroglyphs) and associated with the earlier Basket Maker culture, is found throughout this area, these bright mineral pigment works were the first true

*Peyote Ceremony*

c. 1963. HERMAN TOPPAH, Kiowa; watercolor on paper. The Philbrook Museum of Art, Tulsa, Oklahoma. The use of hallucinogenic plants is central to the religious cultures within several Western tribes.

109

paintings related to the Pueblo peoples. Later, similar art was discovered at two other sites, Kuaua and Pottery Mound, both several hundred miles east of the Hopi territory.

Perhaps, the most interesting thing about these murals is that once completed they were not left in place but were obliterated in due course by later paintings on the same surface, suggesting that they were created as part of the Hopi seasonal ceremonial cycle. In one kiva, anthropologists were able to uncover over a hundred successive paintings and repaintings ranging from early highly abstract symbols through later quite naturalistic representations of men, animals, and deities.

## SAND PAINTING

Some authorities suggest that the murals were forerunners of an even later Southwestern art form: the dry or "sand" paintings, produced by the Hopi and, especially today, by the Navajo of New Mexico and Arizona. Sand paintings are created by sprinkling finely pulverized stone and natural colors over a predetermined pattern upon a bed of carefully smoothed tan sand in order to depict the legendary tales of ancient heroes and deities.

Essentially a form of pictorial prayer, these ephemeral works of art are created as a part of various healing rituals or chants designed to restore mental or physical health during a

### *Whirling Logs*

*early twentieth century.*
*Navajo, Arizona;*
*patterned, colored sand.*
*Private collection.*

Sand paintings are utilized by both the Hopi and the Navajo people in their religious ceremonies. Much about them still remains secret, though several Native American artists have produced variants on the sacred themes.

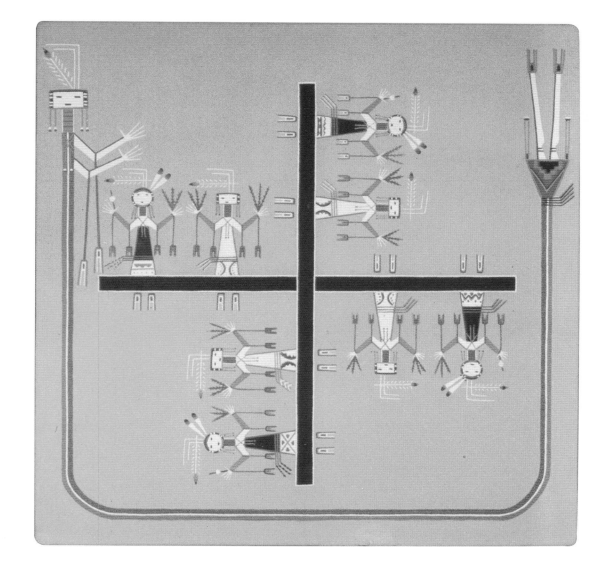

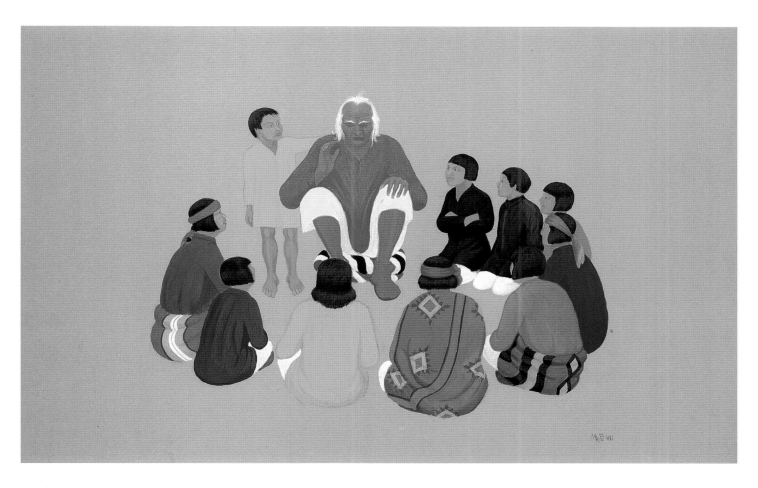

curing ceremony. They are in themselves holy, and traditionally must be destroyed at the completion of the ceremony.

Sand paintings vary in size from 1 square foot (.3 meters square) to as much as 18 feet long (5.5 meters) and take various forms—squares, circles, or rectangles. They are, for the most part, symmetrical with content that varies from clearly recognizable representations of men, animals, and Kachinas to complex abstractions symbolizing thoughts, stories, or relationships between deities and men.

Needless to say, despite prohibitions regarding preservation or reproduction of these works, non-Natives found them fascinating. During the 1930s Anglo artists such as Mrs. Franc J. Newcomb copied them in watercolors; and even before that, in 1919, a famous Navajo medicine man, Hosteen Klah, wove the first textile image. Today, many contemporary tribal artists make small permanent sand-painting copies on board. Though visually arresting, each of these always contains slight variations from the original in order to avoid offending either tribal mores or the gods.

## HIDE PAINTING (THE WINTER COUNT)

Pictorial art took a different course among the Plains Indians. In 1541 members of a Spanish expedition to what is now Arkansas reported that their teepees were "canopied with colored deer-skins, having designs drawn upon them, and the ground was likewise covered in the same manner as if with carpets . . ." Throughout this vast area the roving tribes used buffalo, deer, elk, and antelope hide, not only for clothing and shelter but also as a ground upon which to paint highly naturalistic pictographs, the earliest surviving of which is a Mandan buffalo robe collected in 1805 by the Lewis and Clark expedition.

*Story Teller*

c. 1925–35. VELINO "SHIJE" HERRERA (Ma Pe Wi), Hopi, Zia Pueblo; gouache and pencil on artist's board. National Museum of American Art, Washington, D.C. Herrera, one of the first Pueblo artists to depict sacred ceremonies and Kachina figures, was sharply criticized by tribal elders for such work.

### Floating Feather

*1970–75.* Frank Day, *Maidu;*
*oil on canvas. The Heard*
*Museum, Phoenix, Arizona.*
A man lies asleep on a
feather which is suspen-
ded in mid-air. Beneath
him are various creatures,
including a spider, a
lizard, and an armadillo.

Though little Native American art is
without some religious content, hide
drawings often had a primarily secular
purpose. The one given to Lewis and Clark
celebrated a great victory of the Mandan
over the Sioux, and other early examples
memorialize successful hunts, events in
community life, or the exploits of great
warriors and statesmen. A second form,
the "winter count," documents tribal

history in a highly schematic manner
with years dated from first to last snow-
fall. The best-known winter count was
created by the Brule Sioux chieftain, High
Hawk. It covers a period extending from
1540, when the mythical White Buffalo
Woman presented the tribe with its sacred
pipe, until 1905, a year marked by the
death from alcohol poisoning of High
Hawk's closest friend.

Another sacred category of hide paintings included both the teepee liners for religious lodges, which might be viewed by initiates only, and the protective shields carried by warriors. Though the shields, of fire-hardened bison hide, could turn an arrow, it was their painted sacred symbols that were regarded as most effectual. This belief culminated in the Ghost Dance period of 1890–91, when Sioux warriors clad in "ghost shirts" decorated with sacred symbols hurled themselves against the gatling guns of the United States Army. (Lest we imagine that belief in the magical efficacy of sacred art died at Wounded Knee, in late 1996 Hutu warriors in Zaire charged into rocket and machine-gun fire secure in the knowledge that the protective signs painted on their bodies by medicine men would render them immune to gunfire.)

**Water Test**

*c. 1970–75.* Frank Day, *Maidu; oil on canvas. The Heard Museum, Phoenix, Arizona.* Day, whose work has a distinct surreal quality, is a member of the Maidu, a California tribe that has produced few artists.

113

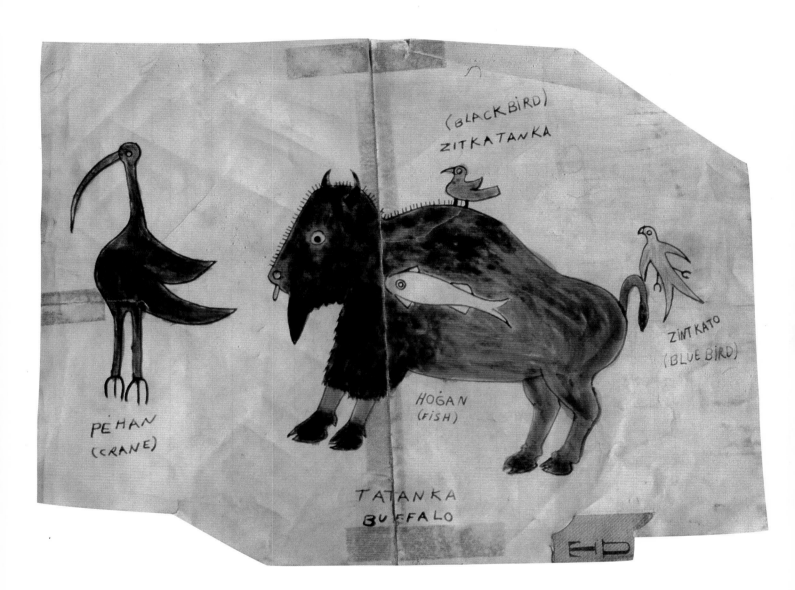

**Ledger Drawing**

*c. 1880–1900. Lakota Sioux; pen, crayon, and watercolor on paper. Private collection.* Done by an unknown tribal artist, this work identifies its subjects in both English and the Lakota language.

## FROM LEDGER DRAWINGS TO "MODERN" ART

With the loss of hunting grounds and hide sources and the increasing availability of art materials supplied by outsiders—such as paper, crayons, pencils, and water colors—Plains Indian art evolved. At first it was simply a matter of transferring the pictographic style to a new medium (the great Mandan chief and artist, Mato-tope, was working in water colors by 1832), but by the 1870s the ledger drawings (so-called, as many were executed on lined notebooks) of Howling Wolf, Squint Eye, and other Indian artists had begun to show the influence of the academic art of the conquering culture.

The stylized pictographic profile was replaced by more fully developed figures, and a greater variety of commercial colors were employed; the use of individual ledger book pages allowed artists who previously had to work on a single large hide to organize their compositions by specific scene or topic.

The ledger drawings, first brought to public attention during the 1870s when a group of Plains Indians imprisoned at St. Augustine, Florida, began to sell them to staff and visitors, marked the beginning of what might be called "modern" Native American art.

### Navajo Women with Blankets

*c. 1962.* RUDOLPH C. GORMAN, *Navajo; mixed media. The Philbrook Museum of Art, Tulsa, Oklahoma.*
Gorman's work remains Native American only in subject matter.
His technique reflects a full understanding of contemporary art forms.

**End of the Trail**

*c. 1955.* WOODROW (WOODY) CRUMBO, *Creek/Potowatami; silkscreen on paper. The Heard Museum, Phoenix, Arizona.* Crumbo, like many contemporary Native American artists, often addresses issues relating to the conflict between Indian and non-Native cultures.

### Eagle with Snake

*c. 1925–30.* AWA TSIREH
*(Alfonso Royball), Hopi, San
Ildefonso Pueblo; watercolor
on paper. National Museum of
American Art, Washington, D.C.*
Tsireh's paintings combin-
ed traditional Hopi themes
with modern techniques
and appealed strongly
to non-Native buyers.

### Ledger
### Drawing

*c. 1880–90.* Old White
Woman, *Southern Cheyenne;
pen, crayon, and watercolor
on paper. Private collection.*
As in all ledger draw-
ings, the action here
flows from right to
left across the page.

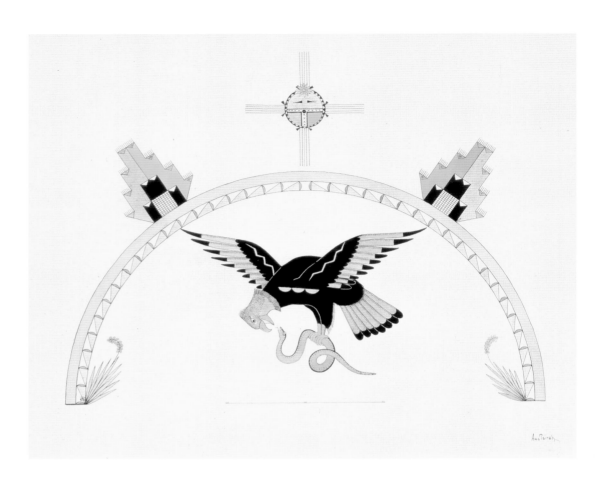

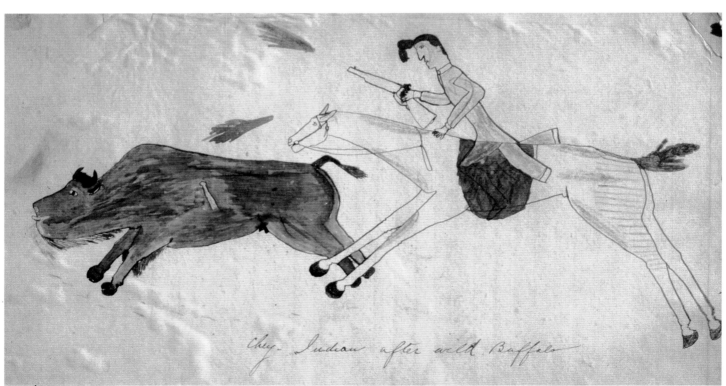

Early artists employed a linear, highly decorative style and focused on traditional themes—genre scenes, folk history, and ceremonial life. By the early 1900s a greater mastery of European techniques began to emerge, as artists such as Ernest Spybuck (1833–1949) replaced the flattened figures and pictorial spaces of the ledger artists with sculptural forms set within a perspective-enhanced background.

Subject matter, however, did not change as the traditional themes appealed both to the artists who saw in them the reality of their lives and to their patrons, who could not envision an Indian art without Indian subjects. In fact, Anglo proponents of one early-twentieth-century Native American artistic style, the so-called San Ildefonso Watercolor Movement, advised artists to work in a retrograde manner, encouraging a bright palette and a flat, linear style (harking back to the ledger drawings) along with the traditional genre and ceremonial scenes.

By the 1930s the Federal government as part of a somewhat more enlightened approach to the tribes began to support their artistic development through establishment of the first studio-painting classes at the Santa Fe Indian School. Under the guidance of Dorothy Dunn, an Anglo artist and teacher, students were encouraged to work in

*Elk*

c. 1925–30. AWA TSIREH (Alfonso Royball), Hopi, San Ildefonso Pueblo; watercolor on paper. National Museum of American Art, Washington, D.C.
Tsireh, one of the first Hopi painters to gain a livelihood with his art, held high tribal positions and was instrumental in shifting his pueblo's economic base from farming to crafts production.

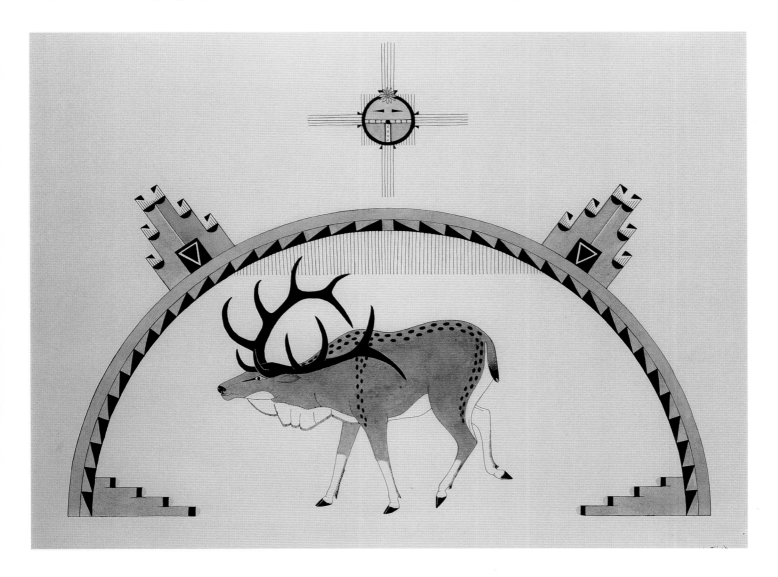

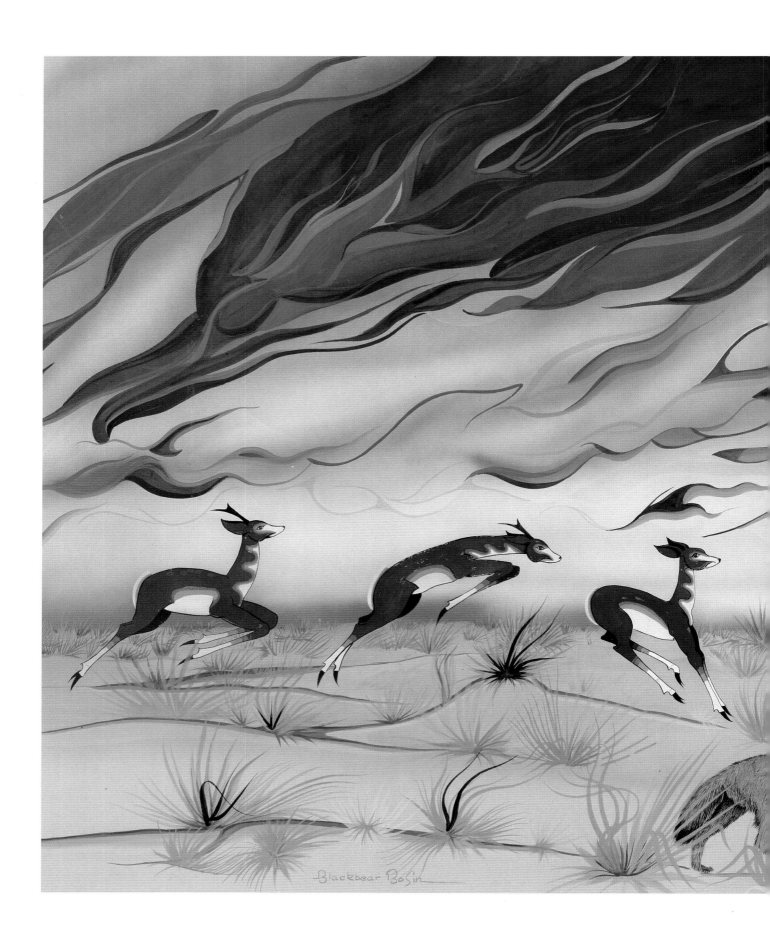

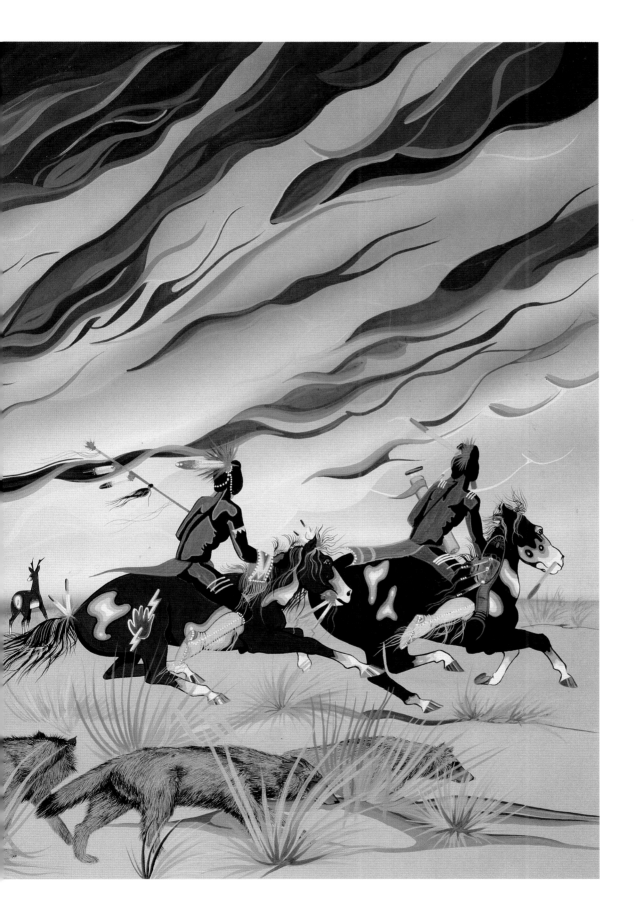

### Prairie Fire

*1953.* BLACKBEAR BOSIN, *Kiowa/Comanche; watercolor on paper. The Philbrook Museum of Art, Tulsa, Oklahoma.* Bosin worked in the Santa Fe Studio style of realistic Native American art; his *Prairie Fire* is perhaps the best known American Indian painting.

*Eve*

1996. KAY WALKING STICK,
*Native American; oilstick*
*on artist's board. June*
*Kelly Gallery, New York.*
This abstract work
owes more to
modern academic
painting than to
the Native American
artistic tradition.

the flat, two-dimensional manner popularized by the San Ildefonso watercolorists—a style dubbed "Traditional Indian Painting" but ridiculed by later Native American artists, who rejected its bland themes as "Bambi Art."

Among the better known of Dunn's students are Allen Houser (1915–94), Fred Kabotie (1900–86), and Pablita Velarde (1918– ). While Houser is known for his depictions of war and hunting and Kabotie for traditional images of ritual dancing, Velarde, one of the first noted female artists, recorded the lives of women on the reservations.

Parallel developments in Native American art took place in Oklahoma. While themes and styles similar to those developed among the Pueblos predominated, a more political content also appeared. Unlike the Hopi and Navajo, who had lived long on their reservations, the Indians of Oklahoma represented various tribes, all of whom had been displaced from former homes.

Kiowa artists like Stephen Mopope (1898–1974) developed a dramatic, colorful style featuring images, dance, ritual, and dream, from the precontact era. Bucolic genre scenes were almost entirely ignored. Cherokee and Choctaw artists such as Valjean Hessing (1934– ), on the other hand, focused on legends of the forced march to Oklahoma, memorializing their "Trail of Tears" in paintings hardly likely to comfort non-Native patrons.

After World War II radical change began to emerge in the field of Native American art. Traditional genre painting declined (though it is still widely practiced) and was replaced by new developments. The most important of these—termed "Non-Traditional" or "New" Indian painting—reflected artists' exposure to modern movements in academic art like Abstract Expressionism and Pop Art.

One of the early proponents of the "New" art was Oscar Howe (1915–83), who broke away from the strictures of his training with

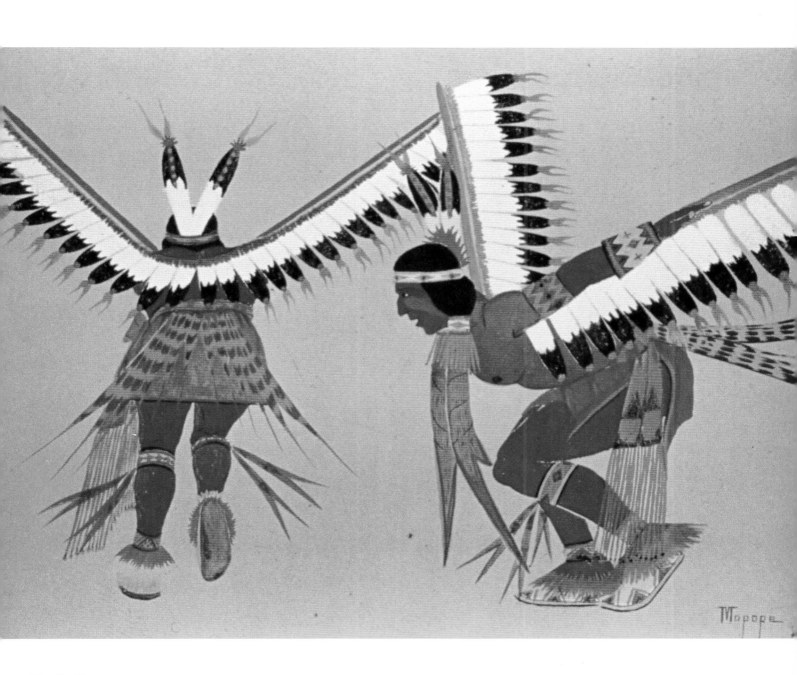

### Eagle Dancers

*c. 1945.* STEPHEN MOPOPE, *Kiowa;*
*watercolor on paper. Museum of*
*the American Indian, New York.*
One of the group of artists termed
the Kiowa Five, Mopope's work
reflected Native American
themes in an Art Deco style.

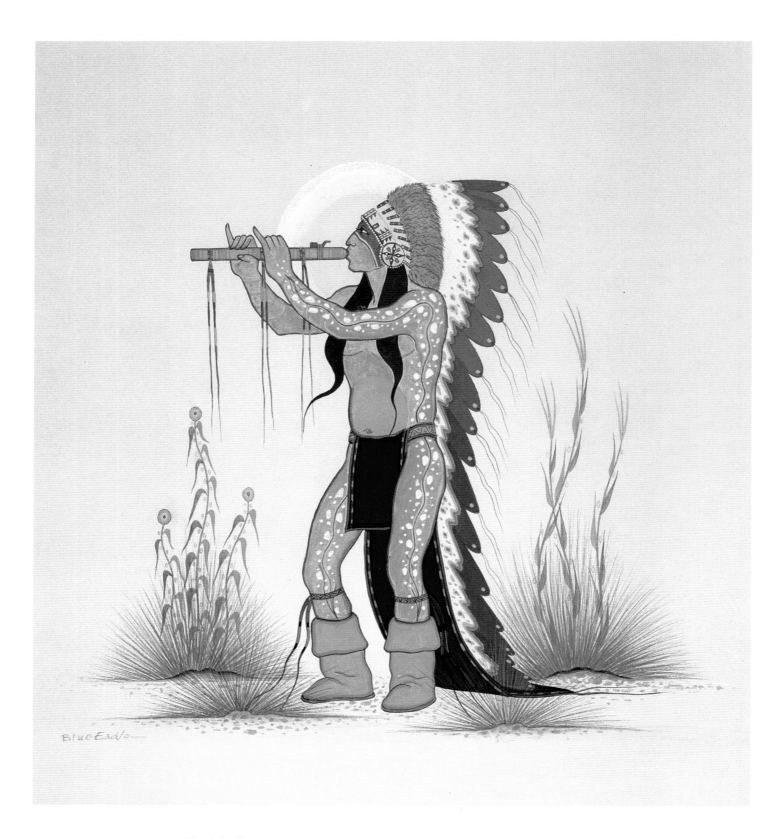

### Untitled

*undated.* Blue Eagle *(Acee), Pawnee/Creek; watercolor on artist's board. The Heard Museum, Phoenix, Arizona.*

Blue Eagle, one of the best known practitioners of the so-called Bambi School of traditional Native American art, was a popular book illustrator.

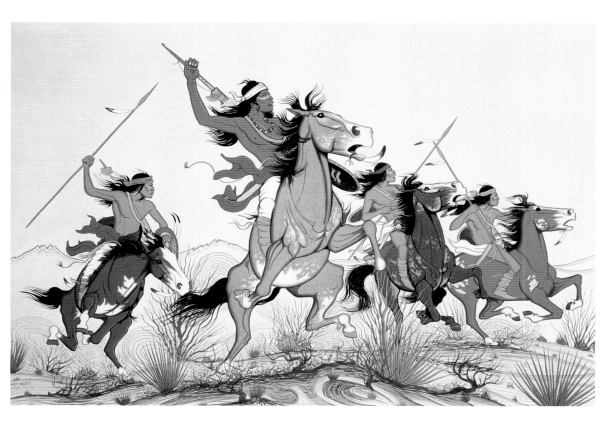

### Apache War Party

*1960.* ALLAN HOUSER, *Chiricahua Apache; watercolor and casein on board. The Heard Museum, Phoenix, Arizona.* Known for his dynamic depictions of Native American life, Houser is also well known as a sculptor.

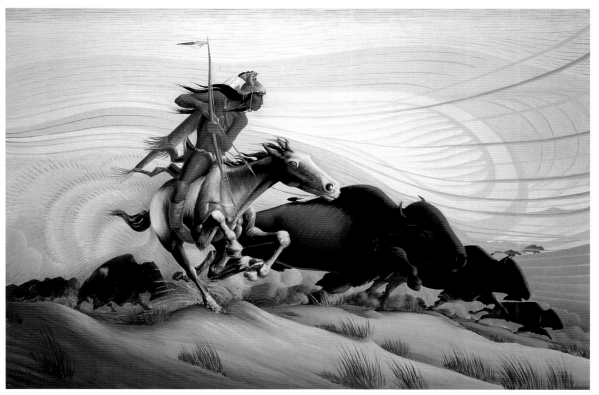

### When Meat Was Plentiful

*1970.* ALLAN HOUSER, *Chiricahua Apache; oil on canvas. The Heard Museum, Phoenix, Arizona.* Houser's subject matter—war parties and hunting expeditions—falls within the ambit of traditional Native American painting, but his fluid style and sense of drama add another dimension.

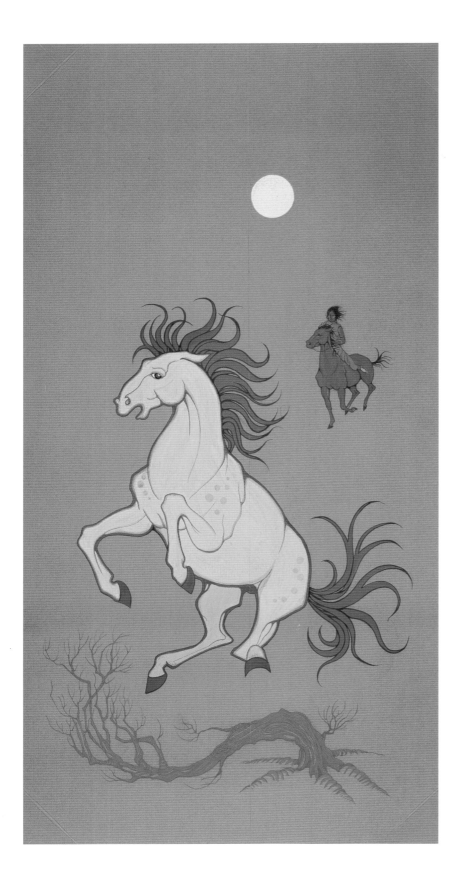

Dunn to blend his Sioux beliefs with a Cubist style in an attempt, in his words, "[to] objectify the truths in Dakota culture and present them in an artistic way."

Howe's work, and that of other nontraditionalist Native American painters, was initially greeted without much enthusiasm by traditional patrons of Indian art. It wasn't "Indian enough," or it was too "derivative" of Euro-American styles. But this did not deter the artists. And while critics, collectors, and dealers continue to argue about what style, subject matter, or even ethnic origin defines "authentic" Native American art, the work continues to evolve.

Harry Fonseca, for instance, has combined elements of Dadaistic "Funk Art" with Indian humor revolving about Coyote, the universal trickster, to reveal the foibles of contemporary Indian and non-Indian worlds. Other artists, such as Bob Haozous (1943– ), have used the illustrator's pen to mock the patronizing collectors of Native American art and artists.

It is fair today to say that fragmentation of vision and individual self-expression is as much a part of the Native American art world as it is of the art of other cultures. There is even what might be accurately called folk art, the work of untrained or self-taught artists from widely scattered regions of the country who continue to produce a narrative genre-painting revolving about tribal life, legend, and history, conforming to the tenets of neither the new nor the traditional painting of Native America. This art, like its creators, reflects a variety of experience and a multitude of points of view.

### Prime Catch

*1968.* VALJEAN McCARTY HESSING,
*Choctaw; watercolor on board.*
*The Heard Museum, Phoenix, Arizona.*
Though she works largely in
the manner of traditional Indian
painters, Hessing infuses her work
with a powerful emotional aspect.

### The Blanketed One

*1983.* VALJEAN MCCARTY HESSING, *Choctaw; opaque watercolor on board. The Heard Museum, Phoenix, Arizona.*
Hessing is best known for her depictions of women and the Choctaw "Trail
of Tears," when, in 1838, they were driven west away from their ancestral lands.

# INDEX

Page numbers in **boldface** indicate picture captions.

Acoma Pueblo pottery, 28, **28**, **30**, 32
Algonquin, 7, 13, 76. *See also* MicMac; Penobscot
Ameriman, Marcus, 93
Anasazi pottery, 21, 21-22
*Animal Designs* (Tsireh), 27
Apache, 14, 15, 16, **17**, 82, 125
*Apache War Party* (Houser), **125**
arrowheads, 85
Atencio, Gilbert, 99
Attu basketry, 17

baby carrier (Comanche), **80**
Bambi School, 122, **124**
Basket Maker culture, 17, 35, 109
basketry, 7-17, **7**, 11, **12**, 13, 14, 15, 16, 17
beadwork, 50, 89, 90-99, **90**, 93, 94, 95, 96, 99, 101
Bella Coola, 66, 89-90
Blackfeet, 47, 99, **99**
*Blanketed One, The* (Hessing), **127**
blankets, 36-37, **37**, 43, **43**
*Blessing of the Deer Dancer* (Atencio), **99**
Blue Eagle, **124**
Booger Masks, 58
Bosin, Blackbear, **121**
Bowen, Jay, **106**
bowls, 15, **22**, 23, **28**, 31, 75, 76, 80
Box, Russell, Jr., **101**
bracelets (Navajo and Zuni), **103**
Brule Sioux winter count, 112
buffalo robes, 99, 111-12
burl, 76, 80

Caddoan pottery, 21
California Indians, **14**, 16, 16-17, 43, 76, 82, 90
Calusa masks, 57
Catlin, George, 80
catlinite pipes, 80-81
Cayuga masks, 57
Cherokee, 48, 57, 58, 122
Cheyenne, 36, 50, 94, 99, 118
*Chilkat blankets* (Tlingit), 43, **43**
*Chippewa Customs* (Denmore), 50
Chiracahua Apache painting, **125**
Choctaw, 93, 122, **126**, **127**
Chumash, 16, 109
clothing, 35, 36-37, **37**, **44**, 96
Cochiti Pueblo pottery, 28, **28**
Codero, Helen, 28, **28**
collars, **90**, 101
Comanche, **80**, 85, **121**
Cook, Captain, 89
Corn Husk Mask Society (Seneca), 58, **58**
cradle, basketry (MicMac or Penobscot), **12**
cradleboards, 47, **80**
Cree storage vessels, 80
Creek painting, 117, **124**
"crooked knife," 76
Crow, 47, **47**
Crumbo, Woodrow "Woody," **117**

Dahl, Bernice, **106**
dance board (Omaha Sioux), **80**
David, Joe, **64**
Day, Frank, **112**, 113
Denmore, Frances, 50
DesJarlait, Patrick Robert, **8**, **18**
D'Harnoncourt, Rene, 57
doll cradle, basketry (MicMac or Penobscot), **12**
dolls, 28, 47-54, **47**, **48**, **49**, 50, **52**, **54**
*Double Woman* (Howe), **24**
Douglas, Frederick, 57
*Dressed to Kill* (Pugliese), **60**
drums, 82, **82**
Dunn, Dorothy, 119-22, 126

*Eagle Dancers* (Mopope), **123**
*Eagle with Snake* (Tsireh), **118**
Eastern Woodlands Indians, 21, 80, 90, 94, 102
  basketry, 7-13, **7**, **11**, **12**, 13
  dolls, **47**, 47-48
  household objects, 76, **76**
  weaponry, 85, **85**
  *See also* Iroquois
eating utensils, 75, 76, 80, **81**
effigy jars, pottery, 21
*Elk* (Tsireh), **119**
*End of the Trail* (Crumbo), **117**
epica, 82
*Eve* (Walking Stick), **122**

face paint, 60
False Face Society masks, 57, **57**, 58
figures, carved, 68
fish hooks, 75, 76

*Floating Feather* (Day), **112**
flutes, 82
Fonseca, Harry, 126

Ganado, Arizona, textiles, **39**
Ghost Dance, 113
gorgets, 90, **90**
Gorman, Rudolph C., **115**

Haida, 52, 63, **63**, **64**, 68, **68**, **71**, 75, 76, 89-90
hair ornaments, 89-90
Haozous, Bob, 126
Havasupai basketry, 15
Herrera, Velino "Shije," **111**
Hessing, Valjean McCarty, 122, **126**, **127**
Heubach, Gertrude, 50
Hiawatha Belt, 94
Hidatsa, 86
hide painting, 4, 111-13
High Hawk, 112
Hohokum pottery, 15, 21-22
Home, Francio, 63
Hopewell clothing ornaments, 90
Hopi, **4**, 35, 59, 82, 102, 103, 106, 122
  basketry, 15, **15**
  Kachina masks, 57, 58, 59, **59**
  Kachinas, **52**, 52-54, **53**
  painting, **4**, 27, 109-10, 111, **118**, **119**
  pottery, **4**, 23-28, **23**, **27**, **28**, **30**, 32
  sand paintings, 110, **110**
*Hopi Snake Dancer* (Tsireh), **4**
*Horse Dancer* (Howe), 79
household objects, 75-80, **76**, **81**
Houser, Allan, **82**, 122, **125**
Howe, Oscar, **24**, 79, 122-26
Howling Wolf, **114**
Hupa basketry, 16, 17
Huron masks, 57
Husk Face Society mask (Seneca), 58, **58**

*Indian Art of the United States* (Douglas and D'Harnoncourt), 57
Inuit dolls, 52
Iroquois, 7, **7**, 21, 47, **47**, 76, 82, 85, 94, 99, **101**
  ritual masks, 4, 57-58, **57**, **58**, 59

jars, 16, 21, 23, **30**, 32, 76
jewelry, 89, 90, **90**, 96, 102
  silver, 89-90, 102-6, **102**, **103**, **106**

Kabotie, Fred, 122
Kachina Cult, 35, 53-54, 59
Kachina masks, 58-59, **59**
Kachinas, 27, 52-54, **52**, **53**, 82, 109, 111, **111**
Karok basketry, 16
Kiksadi pin (Dahl), **106**
Kiowa, 47, 109, 121, 122, **123**
kiva murals, 109
Klah, Hosteen, 111
Klamath basketry, 16
knife case (Blackfoot), **99**
knifes, 75, 76, 85
Kuaua kiva murals, 110
Kwakiutl, 63, 68, 89-90, 99

Lakota Sioux, 93, **114**
ledger drawings, 114, **114**, **118**, 119
Lee, Dat So La, 17
Lehner, Wanda, 93
Lewis and Clark expedition, 111-12
Linderman, Frank B., 47

McAboy, Mary, 54
Maidu, **14**, 16, 17, **112**, 113
*Making Wild Rice* (DesJarlait), **8**
Makya, Alvin J., 54
Mandan painting, 111-12, 114
maple sugar mold (Penobscot), **76**
*Maple Sugar Time* (DesJarlait), **18**
Maricopa pottery, 28
Martinez, Julian, 27, **32**
Martinez, Maria, 23-28, **32**
masks, 4, 57-59, **57**, **58**, **59**, 63, **63**, 67-68, **66**, **71**
material culture, 75-85
  California Coast, 76
  Eastern Woodlands, 76, **76**, **82**, 85
  Northwest Coast, **75**, 75-76, 81-82, **81**
  peace pipe, 80-82
  Plains, **80**, 80-81, 85, 86
  *See also* musical instruments; weaponry
Mato-tope, 114
Menominee rattles, 82
Mexican influences, **8**, 21, 36, 90, **90**
MicMac, **11**, 12, 13, 13, 60
Mimbres pottery, 22, **22**
Mississippi Valley Indians, 21, 82, 90
Mogollon pottery, 21-22, **22**
Mohave, 52, **90**

Mohawk dolls, 48
Mono basketry, 16
Moon, Peter, **71**
Mopope, Stephen, 122, **123**
Mound Builders, 68
musical instruments, 71, 75, 82, **82**

Nampeyo, Jeannette, 23
Nampeyo, Leah, **4**, 23, **23**, 27-28
Nampeyo, Nellie, 23
Nash, Edith, 28
natal charm (Sioux), 95
Navajo, 28, **35**, 102-6, 103, 122, **115**
  basketry, **14**, 14-15
  dolls, 48, **48**, **49**, 54
  sand paintings, 4, 36, 110, 110-11
  textiles, 4, 35-37, **36**, **37**, **38**, **39**, **41**, 49
*Navajo Woman Weaver* (Tsinahjinnie), **35**
*Navajo Women with Blankets* (Gorman), **115**
necklaces, 90, **90**, 96, 103, 106, **106**
Newcomb, Mrs. Franc J., 111
Nootka, 85, 89
Northern Plains Indians, 96, 102
Northwest Coast Indians, 17, 21, 52, **75**, 82, 89-90, 99
  household items, 75-76, **81**
  knives, 75, 85
  masks and totems, 4, 57, 59, 63-68, **63**, **64**, **66**, **68**, **71**
  pipes, 81-82
  textiles, 42, 43, **43**

Oglala Sioux, 60, 93
Ojibwa (Chippewa) painting, **8**, **18**
Oklahoma Indians, 89, 90, 122
Old White Woman, 118
olla (J. Nampeyo), **23**
Omaha Sioux, **80**, 82
Oneida, 7-13, 47-48
Onondaga, 57, **82**

Pacific Coast textiles, 42, 43, **43**
painting, 109-27
  cave painting, 109
  hide painting, 4, 111-13
  ledger drawings, 114, **114**, 118, 119
  modern styles, **4**, **8**, **18**, **24**, 27, 35, 79, 82, 99, 109, 111, **112**, 113, 114-26, **115**, **117**, **118**, **119**, **121**, **122**, **123**, **124**, **125**, **126**, **127**
  sand painting, 4, 37, 110, 110-11
  wall murals, 109-10
Papago basketry, 15
Parriette, Jennifer, **102**
Passamaquoddy "crooked knife," 76
Pawnee, 36, 124
peace pipes, 80-82
Penobscot, **4**, **11**, **12**, 13, **13**, 21, 60, 76, **76**, 85, 99
Pentawa, Dick, 54
*Peyote Ceremony* (Toppah), **109**
Picuris pottery, 28
Pima basketry, 15
pin cushions, **11**, 99
pipes, 60, 80-82
Plains Indians, **47**, 80-81, 94, **102**
  beadwork, **4**, 50, **94**, **95**, 96, 99, **101**
  dolls, **47**, 50, **50**
  painting, 4, 111-13, 114, **114**, 118
  necklaces, 90, **968**
  weaponry, 85, **85**, 86
  *See also* Sioux
Pomo, 16, 16-17, 43, 82
porcupine work, 7-13
"potato stamp" baskets, 7, 7-13
potlatch, 64-66, **71**
Potowatami painting, **117**
pottery, 4, 21-28, **21**, **22**, 23, 27, **28**, 30, **31**, **32**, 52
Pottery Mound kiva murals, 110
*Prairie Fire* (Bosin), **121**
Pretty-Shield, 47
*Prime Catch* (Hessing), **126**
projectile points, 85
puchtihu, 53
Pueblo Indians, 35, 82, 89
  painting, **4**, 27, 99, 109-10, 111, **118**, **119**, **119**, 122
  pottery, 4, 23-28, **23**, **28**, 30, **31**, 32
  turquoise and silverwork, 102, **102**, **103**
  *See also* Hopi; Zuni
Pugliese, Carl, 60

quillwork, 50, 94, 99

rattles, 71, 82
Rivera, Diego, 8
rock painting, 109
rugs, Navajo, 36, 36-37, **38**, **39**, 41

Sakiestewa, Willard, 54
Salish, 17, 63, 68, **81**, 82

Samuel, Cheryl and Alena, 43
sand paintings, 4, 37, **110**, 110-11
San Ildefonso Pueblo, 23, 28
  watercolors, **4**, 27, 99, **118**, 119, **119**, 122
San Juan Pueblo pottery, 28, **28**
Santa Clara Pueblo pottery, 28, **28**, 32
Santa Fe Studio, **35**, 119-22, **121**
Santo Domingo Pueblo pottery, 28, **30**, **31**
sculptural forms, 57-68, **57**, **58**, **59**, **60**, **71**
  Northwest Coast, **4**, 52, **57**, 63-68, **63**, **64**, **66**, **68**, **71**
  *See also* Kachinas
Second Mesa, 15
Seminole, **44**, 48, **49**, 90
Seneca, 47, 47-48, **57**, **58**
Shasta basketry, 16
shields and shield covers, 85, **85**, **86**, 113
Sikyatki pottery, **4**, 23
silverwork, 89-90, 102-6, **102**, **103**, **106**
*Singer, The* (Houser), **82**
Sioux, **24**, 36, 50, **50**, **60**, 80, **86**, 93, 95, 99, **102**, **112**, 113, **114**, 126
Skagit silver necklace, **106**
Skookum dolls (McAboy), 54
Southeastern Indians, **12**, 13, 58-59
Southern Indian dolls, 48, **49**
Southwestern Indians
  basketry, 7, 14-16, **14**, 15, 16, 17
  pottery, 4, 21-28, **21**, **22**, 23, 27, **28**, 30, **31**, **32**
  silverwork, 102-6, **102**, **103**
  *See also* Navajo; Pueblo Indians
speaker's staff (David), **64**
spears, 85
spoons, 75, 76, 80, **81**
Spybuck, Ernest, 119
Squint Eye, 114
storage containers, **30**, 76, 80
  basketry, 7, 16, 17
*Story Teller* (Herrera), **111**
storyteller dolls (Cordero), 28, **28**

talking stick (David), **64**
Taos pottery, 28
tapica, 17
tea set, miniature (Southeastern basketry), **12**
teepee liners, 113
Tesuque Pueblo pottery, 28
textiles, 35-43, **36**, **37**, **38**, **39**, **41**, 42, **43**, 111
Tlingit, **14**, 17, 43, **43**, 52, 63, **71**, 75, **75**, 82, 99, **106**
Toppah, Herman, 109
totem poles, 63, **63**, **64**, 67, 68
"Traditional Indian Painting," 122
trays, 15, **15**, 16, 68
Tsimshian, 63, 90
Tsinahjinnie, Andrew, 35
Tsireh, Awa (Alfonso Roybal), **4**, 27, **118**, **119**
Tulare basketry, 16, 17
turquoise, 102, **102**, **103**

Utes, 15, **101**, **102**

Vancouver Island basketry, 17
vases, 11, 23, 32
Velarde, Pablita, 122

Walking Stick, Kay, **122**
wampum, 90-94
war club quirt (Sioux), **86**
war clubs, 60, 85
Washington Covenant Belt, 94
Washoe basketry, 16; 17
*Water Test* (Day), **113**
weaponry, 60, 75, **75**, 85, **85**, **86**
wearing blankets (Navajo), 36, 37, **37**
wedding baskets (Navajo), 14-15
wedding vases (Pueblo), 28, **32**
West Coast basketry, **14**, 16, 16-17
*When Meat Was Plentiful* (Houser), **125**
*Whirling Logs* (Navajo sand painting), **110**
whistles, 82
White, John, 47
winter counts, 112
Wounded Knee Massacre (1890), 47

Yanktonai Sioux painting, **24**
Yavapai basketry, 15
Yazzie, G., 54
Yokut basketry, 16
Yuma pottery dolls, 52
Yurok pottery dolls, 52
Yurop-Hupa textiles, 43

Zia Pueblo, 28, **111**
Zuni Pueblo, 28, **31**, 53, 58, 59, 102, **102**, 106